DRAWING THE FEMALE NUDE

GIOVANNI CIVARDI

CASSELL ILLUSTRATED

Cassell Illustrated
A member of Octopus Publishing Group Ltd
2-4 Heron Quays
London E14 4JP

This edition first published in Great Britain 1995
by arrangement with
Il Castello Collane Tecniche
via C. Ravizza 16, 20149 Milan
Italy

Reprinted 1996, 1997, 1998, 2003

Originally published in Italy 1992 as
Il nudo femminile
repertorio iconografico

British Library Cataloguing in Publication Data
A catalogue record for this book is available from
the British Library

ISBN 0-289-800-900

Illustrations by Grazia Cortese

English translation by Ardèle Dejey

Distributed in the United States by
Sterling Publishing Co. Inc.
387 Park Avenue South, New York 10016-8810

Printed and bound in Great Britain
by Martins the Printers,
Berwick upon Tweed

CONTENTS

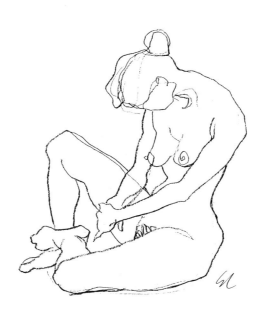

INTRODUCTION

The study of human anatomy applied to figurative art is useful only if it makes the artist 'look' at the model. Obvious as this may seem, it often happens that those who decide to draw, paint or model the human body experience difficulties, or at least uncertainties, even though these in themselves can often engender artistic awareness. Perhaps this happens because the artist sees only a model holding a pose, rather than the inner structure, be it the correspondence of related parts, or of those inside the body. Many modern teaching methods correctly insist on the intelligent observation of nature, whereby the artist's sensibility and feelings find their own mode of communication and expression. Nevertheless, the human body is extremely complex, both in its form and in its emotive aspects and, therefore, I believe that discerning observation must, if not given priority over, at least be accompanied by, a thorough knowledge of classically interpreted anatomy, essentially of the locomotor system (bones, joints, muscles) and the outer form.

I refer those who wish to go deeper into the subject to the other two books of this series, *Drawing Human Anatomy* and *Drawing the Male Nude*, in which I have stressed these points.

In this volume on the female nude I present a fairly wide selection of illustrations showing the model in poses useful for studies of the body and its movements. I have tried to provide an understanding of superficial anatomy and the locomotor apparatus, as well as give guidance on the usual techniques of life drawing (see *Drawing Human Anatomy*). I have chosen poses of the female nude, some of which are yoga positions, which show at a glance interesting anatomical conformations of use in art studies. I have put the poses into groups (standing, sitting, lying down, foreshortened, etc). They, of course, form only a small sample of the innumerable positions which the body can assume (anatomically, all share certain characteristics, typical of each group).

I advise students not to confine themselves to studying, however carefully, the drawings or to copying them. If it is within your means, and you can find one, get a professional model and see for yourself, *in vivo*, how the human figure looks in various poses. The short anatomical notes I have made by each illustration are intentionally only indications, aimed at pointing a way to 'find' and observe, through the body of the model, an understanding of the inner anatomy of the outer form.

It may be as well to explain briefly the techniques and procedures that I have used in illustrating this book. I have taken from life almost all the drawings, except for those which show the model in slightly off-balance or tiring poses, or those that cannot be held for more than a few moments. In these few cases I have sometimes made quick sketches and worked on them later, or else used photographs to supply muscular details that are of necessity transitory. To facilitate printing, each illustration which takes up two pages of the book was drawn in pencil (H, HB, B) on smooth Bristol board (40 × 60cm), in a more or less 'academic' style, that is, its didactic purpose was borne in mind. In short, I have avoided the use of different styles, which would have produced 'dramatic' or 'interpretative' drawings, so that questions of style or aesthetics would not interfere with the strictly anatomical. These artistic and expressive aspects will be dealt with elsewhere; here, the treatment of them is 'cold', but, precisely because of that they are more illustrative of, and apt for, the objective in mind.

Remember, however, that in drawing from nature (especially the human body) one must endeavour to go beyond purely realistic anatomical details to produce interesting, informative and sensitive drawings, but always consistent with your own artistic style. Simplicity and spontaneity, the signs of a mature artist, are the precious fruits of a long, dedicated training in observing, understanding and feeling.

STAGES IN DRAWING TECHNIQUE

Stage 1 Using charcoal or graphite powder with a brush (or your finger), outline the space the figure will take up on the paper. Try to catch the broad outline of the model's pose as you would see her against the light, ignoring the details.

Stage 2 Using a very soft pencil (3B or 4B) or charcoal, add the darker tones of shadow areas that you observe on the model's body.

Stage 3 With a very soft India rubber (or the soft inside of a loaf which, when kneaded into a ball, makes an excellent eraser), lighten the areas which are not in heavy shadow. Continue in this way, lightening or darkening the tones, until you have gone over the whole drawing, but without going into too much detail or making any parts too dark or too light. Finally, add the darkest shading and touch up the most highlighted parts, brushing away the residue of charcoal or chalk dust with a very clean India rubber or a soft brush.

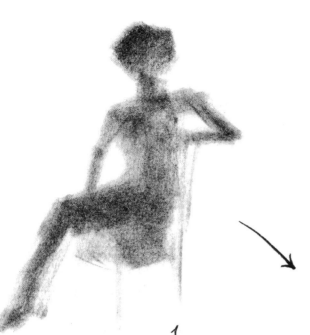

1

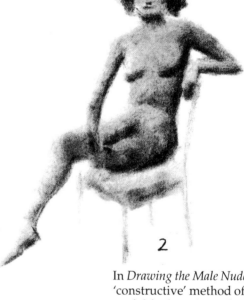

2

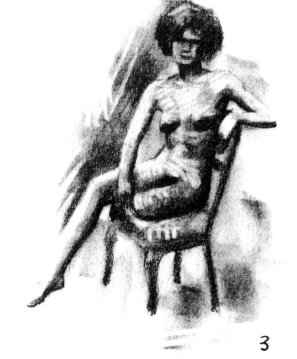

3

In *Drawing the Male Nude* I put forward a 'constructive' method of drawing, which is useful for learning to know the human body in all its anatomical and proportional complexity. In this book, however, I shall take the opportunity to give an equally useful lesson, more 'tonal' and 'gestural', used also in painting, and in which the image emerges gradually and at the same time in all its parts because of the addition or elimination of tone and line. The very existence of different methods, sometimes directly contrasted, demonstrates that in drawing it is not 'rules' but rather 'principles' which foster an effective, intelligent approach.

All artists must experiment and choose the technique most suited to their own temperament and to the subject. They must, however, keep in mind that the human body (the subject of our studies in this series of books) requires, if a realistic portrayal is sought, a preliminary and parallel understanding of the anatomical, scientific aspect of its form.

THE CANONS OF ANATOMICAL PROPORTION

For the photograph on the following page the model is in a very similar pose to the one I have drawn on p. 62. Standing in front of the model, the artist should not try to depict her in purely descriptive, analytical terms (this could be achieved more quickly and realistically using a photograph), but should observe the model carefully, with intelligence and sensitivity, giving due weight to the different formal and expressive elements, that is, stressing those that are truly essential and meaningful for the expression of the character of this particular figure and playing down the superfluous ones. This ability to observe comes from the long and careful study of the live model, and each artist will find his or her personal style of expression. Compare, then, this photograph with the drawings on the following pages and that on p. 62: although the last, for the reasons I set out in the introduction, is executed in a somewhat academic style, emotionally almost detached. You will see how the elements of the figure have been drastically simplified and reduced without the drawing appearing in any way incomplete.

At the beginning of a 'life' session, I suggest to students the following sequence of study:

● Look carefully at the model from various viewpoints (close-up, from a distance, from above, etc.), in order to catch the character of the pose. For example: is the prevailing feeling that of a closed form, folded in on itself, or open, expanding into space? Is the pose static and inert or does it emanate tension and exertion? Is it a geometrically simplified form, whose outlines suggest a triangle, a circle or a square? Which is the greater aspect of the composition: height or width? Is the balance of the model stable or precarious? And so on: answering each question leads to an intelligent observation and a 'volumetric' perception of the body. The experienced artist will see all this with sensitivity and with a spontaneity free from excessive technical consideration.

● Choose the most meaningful viewpoint that circumstances permit, that is, the one that most arouses in the artist an emotion and an interest which stimulates a desire to transfer it to paper.

● Single out the anatomical parts (articulations, the bones beneath the skin, muscular tensions, characteristic fatty deposits, etc.) that will make a convincing drawing (see p. 9).

● As this is an exercise in observation, decide on the purpose of drawing this particular figure from life, and depict it in a style (analytical, synthetic, etc.), with the appropriate technique (pencil, pastel, ink, etc.). (These suggestions have been discussed in my other book in the same series, *Drawing the Male Nude*.)

With the female figure it is usually not so easy to show the skeletal and muscular characteristics; they are softer and less obvious than in the male. Yet, at least at the beginning of your study, it is very helpful to make out the places where the skeleton beneath the skin is apparent and, perhaps, gives a decided individuality to the body. The outline, especially in the photograph (p. 9), shows some of these areas. Besides allowing for a better understanding of the figure in all its complexity, an anatomical investigation (when not limited to a search for knowledge for its own sake) should also suggest to the artist a different treatment of the body's surface.

Indeed, the parts where the bony structure shows beneath the skin (for example, the elbow, the knee, etc.) need to be drawn in a resolute, clear, angular way, highlighting the characteristics of the bones, namely, dense, firm and well defined. The parts in which the fatty tissues or muscles are prevalent should, by contrast, be given a softer, shadowy, rounded treatment. Finally, it is useful to remember that the precise characterization of the subcutaneous bony parts (that is to say, the points of reference) is of special importance. It is necessary to draw correctly the general proportions of the figure and those relevant to the various sections (the trunk, the limbs, etc.), because they are stable and recognizable in whichever position is taken by the model, whereas other reference points (for example, the muscles), are subject to movement and variations, either of individual models or poses and are, therefore, sometimes deceptive.

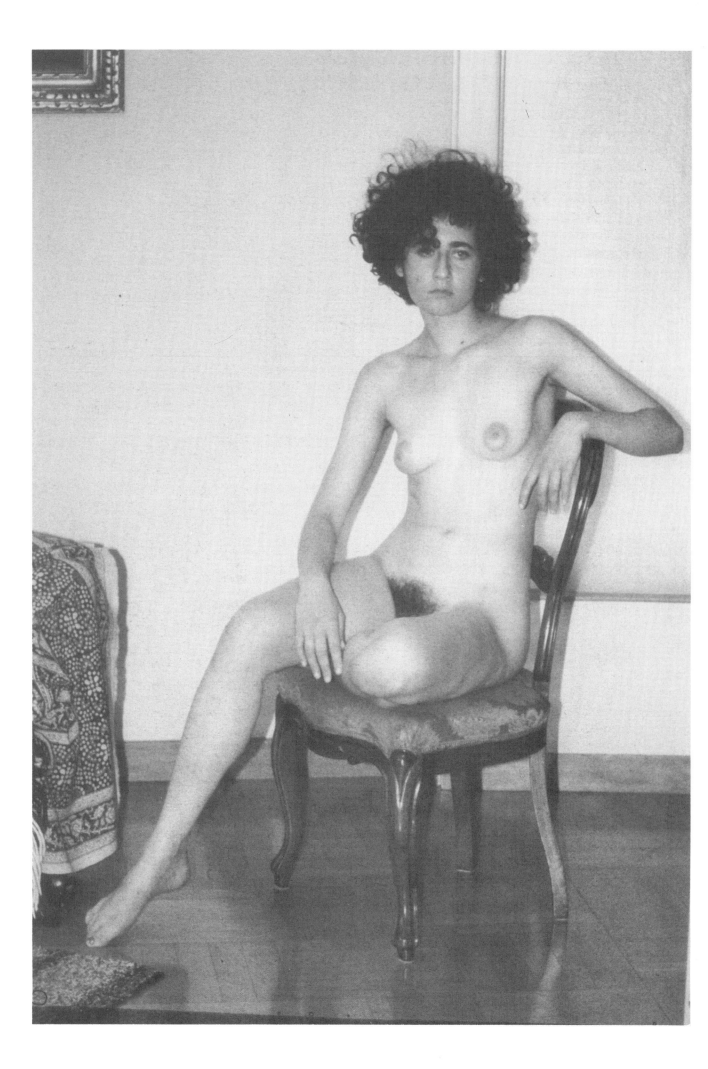

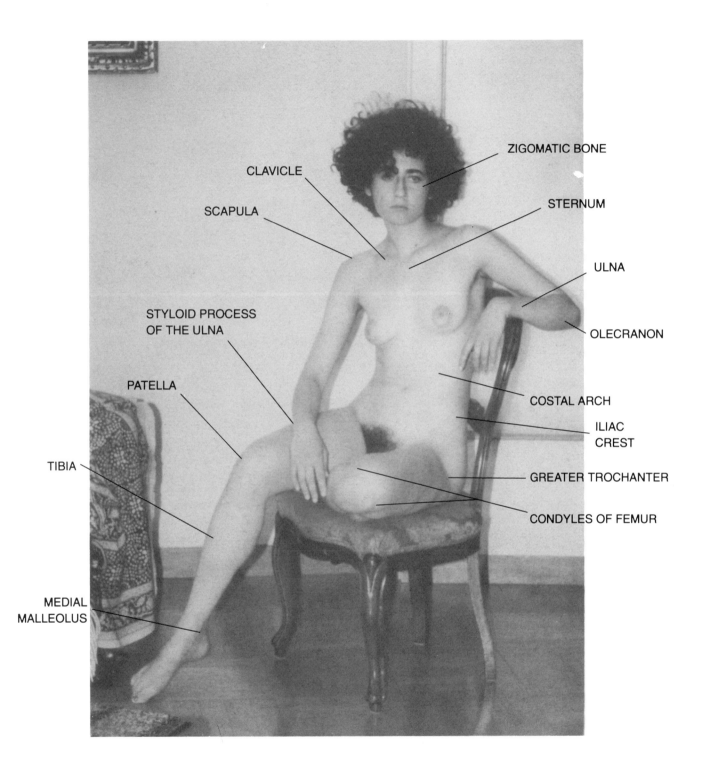

ZIGOMATIC BONE

CLAVICLE

SCAPULA

STERNUM

ULNA

STYLOID PROCESS
OF THE ULNA

OLECRANON

PATELLA

COSTAL ARCH

ILIAC
CREST

TIBIA

GREATER TROCHANTER

CONDYLES OF FEMUR

MEDIAL
MALLEOLUS

9

SOME STYLES OF DEPICTION

The human figure can be portrayed in various ways, differing mainly in the 'conceptual' approach, and according to the intention for which the drawing is made. This has nothing to do with aesthetic, emotive or stylistic questions, even though every artist shows an almost unconscious preference for one particular method or a combination of them.

The following four illustrations show the most widely used techniques in life drawing. The first two (one using shading and the other line) are particularly suited to studies of the nude, based on the modulations of tone and outline suggested by the model; the last two (constructive and structural) are perhaps better suited to a sculptural approach, in which the architectural elements of the figure are emphasized.

Obviously, there is no rigid separation between these techniques, which, in fact, are almost always integrated in varying degrees in a professional drawing. They allow prevailing characteristics to emerge, which may be only sensed here and there in the contingent purposes and objectives of the study, in its psychology and in its most honest and inmost attitude in the artistic pursuit.

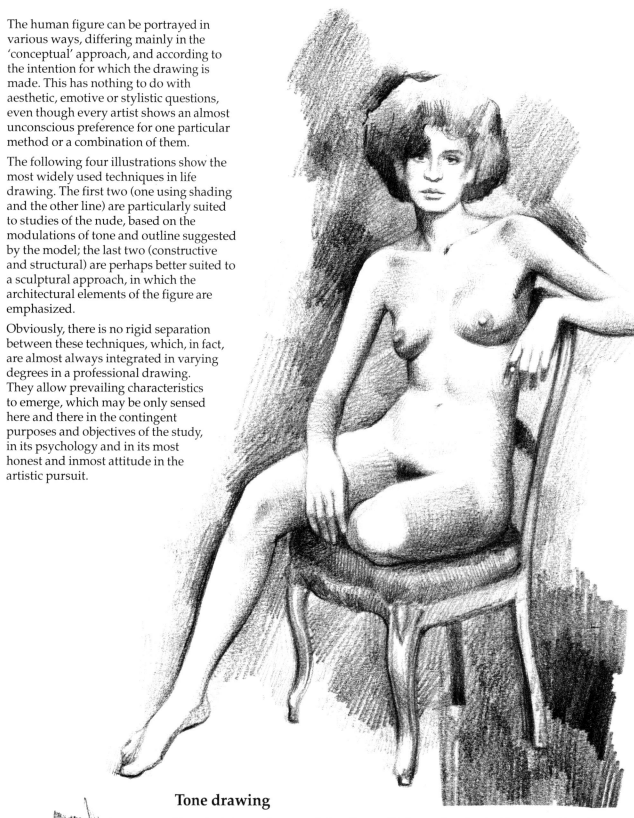

Tone drawing

Tone drawing makes use of the effects of light on the physical form, grading the chiaroscuro, the changes of tone caused by the three-dimensional nature of the body. This can give an impression of almost photographic reality. In drawing as it is generally understood, colour is not used as such; rather it is translated in a series of intermediate tones obtained by the perceptive technical procedures of *sfumatura*, that is, shading from white in the areas of maximum luminosity to black in those of deep shade.

To achieve an effective and interesting tone drawing, not prettified by too many changes of tone, work selectively, reducing the range of greys to no more than two or three shades apart from black and white.

Line drawing

In its most typical form, line drawing eliminates the realism of the body's tones and masses but does not entirely neglect them. In fact, by a selective emphasis on line which can suggest heaviness, fragility, etc., the volumes and masses can be given greater importance. To achieve this result, the artist makes a basic selection of essential images, eliminating all the inexpressive and those which cannot produce a good likeness of the model. Although line should be, above all, a graphic 'code', perhaps related to a 'rational' view, often it expresses great feeling and also sensitivity through its modifiable development, by variations of pressure and manipulation of the pencil, and comes closer to the 'searching' lines of the form.

Constructive drawing

The constructive drawing analyses the human body by separating the parts of the framework, that is, the masses of the head and the upper and lower parts of the torso. A constructive drawing is achieved by sketching in an almost geometric way the various sections of the body. They are perceived, as it were, in transparency, drawing them as they are, rather than as they are seen; reducing the rotundity and, in its place, highlighting the arrangement of masses; looking for the corresponding relationships of connection and of placing in space.

The process is useful when drawing the figure from memory or representing it in particularly complicated poses because this helps to understand the form. This technique is also used in preparatory drawings for sculptures.

HB

Structural drawing

In part, this technique uses the same principles as constructive drawing, but integrates them with the exploration of the masses (the head, chest and pelvis) that form the complex structure of the human body. Here, the lighting of the model is all important because, by its degree of strength, it can give a powerful three-dimensional effect through the contrast it creates between those parts in the light and those in the shade, modelling the form. It is, perhaps, typical of the sculptor's art, which perceives the body as a series of integrated blocks, disregarding the inexpressive lack of substance of shading, concerned instead with volume and, as a whole, suggestive of the model.

If the eyes are half closed it helps one to see more clearly the distribution of light and shade, reducing the tonal gradations. For this type of drawing, materials such as charcoal, soft pencil, chalk and thick brushes that make broad traces are better than the instruments which would be needed for fine detail.

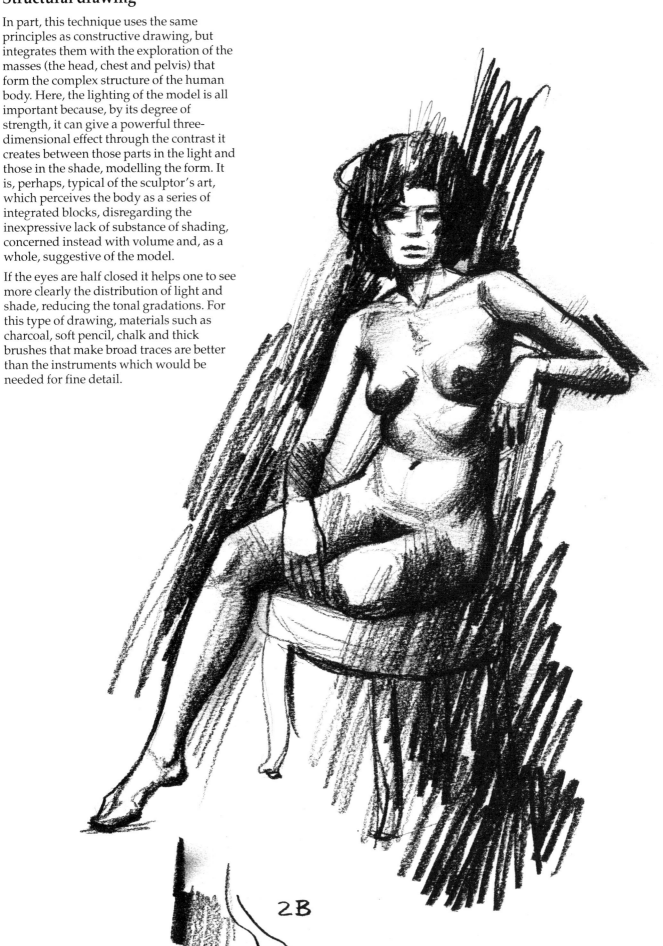

2B

THE STANDING FIGURE

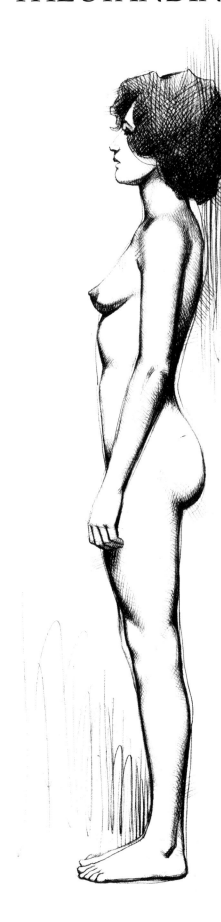

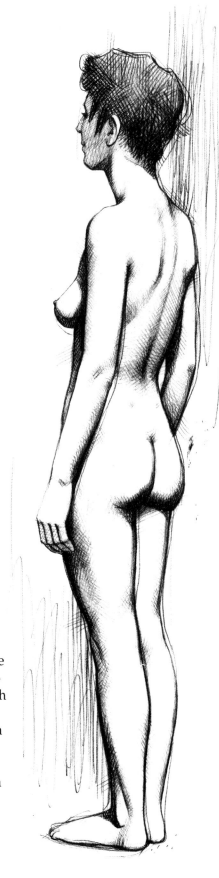

In the next three double-page illustrations (up to p. 19) two models are compared on each page: the one on the left is 27 years of age, height 169cm (5ft 6½in) and the one on the right is 25 years, 162cm (5ft 3¾in). Both are posing in the so-called anatomical position, in which it is easy to note the individual morphological differences.

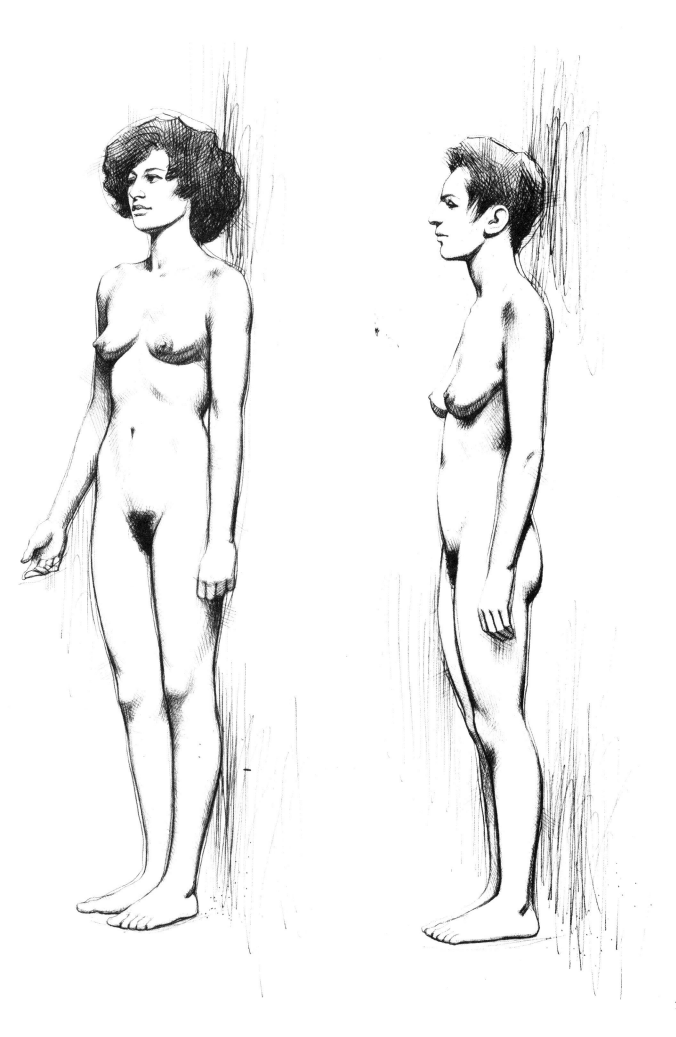

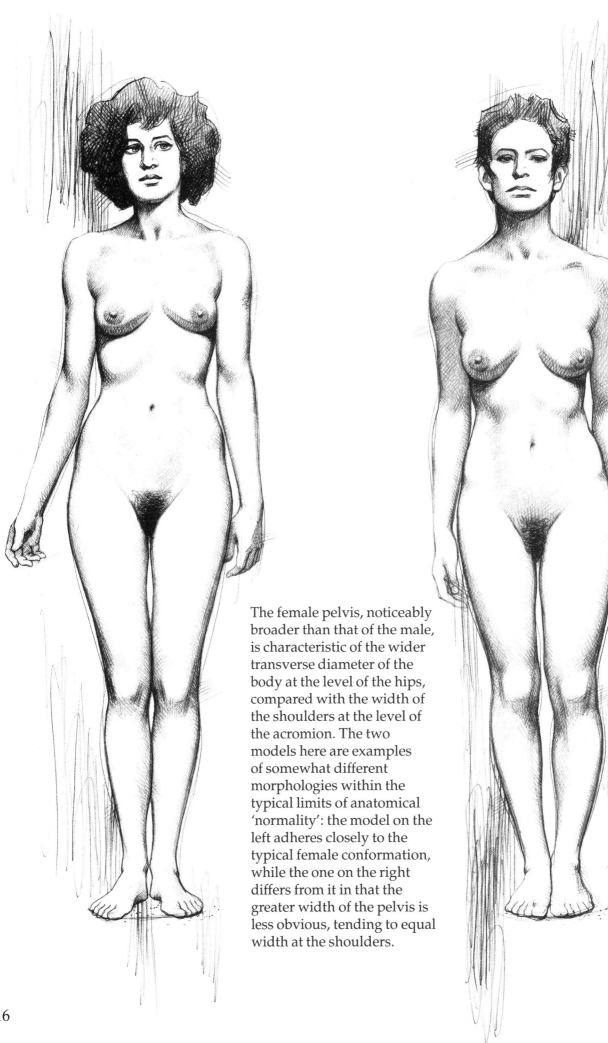

The female pelvis, noticeably broader than that of the male, is characteristic of the wider transverse diameter of the body at the level of the hips, compared with the width of the shoulders at the level of the acromion. The two models here are examples of somewhat different morphologies within the typical limits of anatomical 'normality': the model on the left adheres closely to the typical female conformation, while the one on the right differs from it in that the greater width of the pelvis is less obvious, tending to equal width at the shoulders.

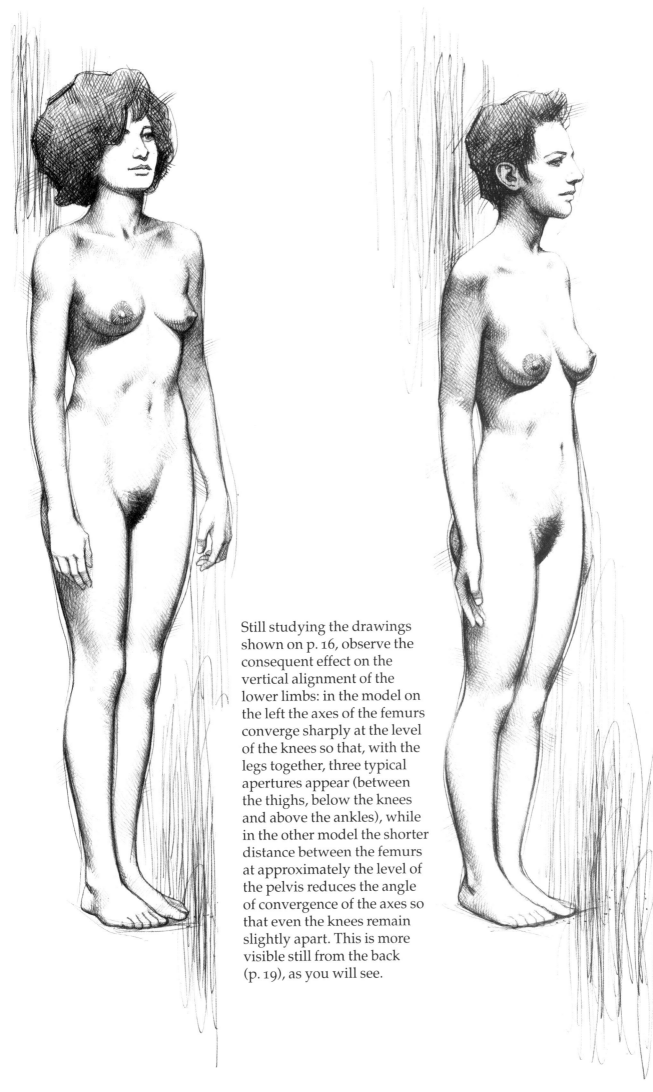

Still studying the drawings shown on p. 16, observe the consequent effect on the vertical alignment of the lower limbs: in the model on the left the axes of the femurs converge sharply at the level of the knees so that, with the legs together, three typical apertures appear (between the thighs, below the knees and above the ankles), while in the other model the shorter distance between the femurs at approximately the level of the pelvis reduces the angle of convergence of the axes so that even the knees remain slightly apart. This is more visible still from the back (p. 19), as you will see.

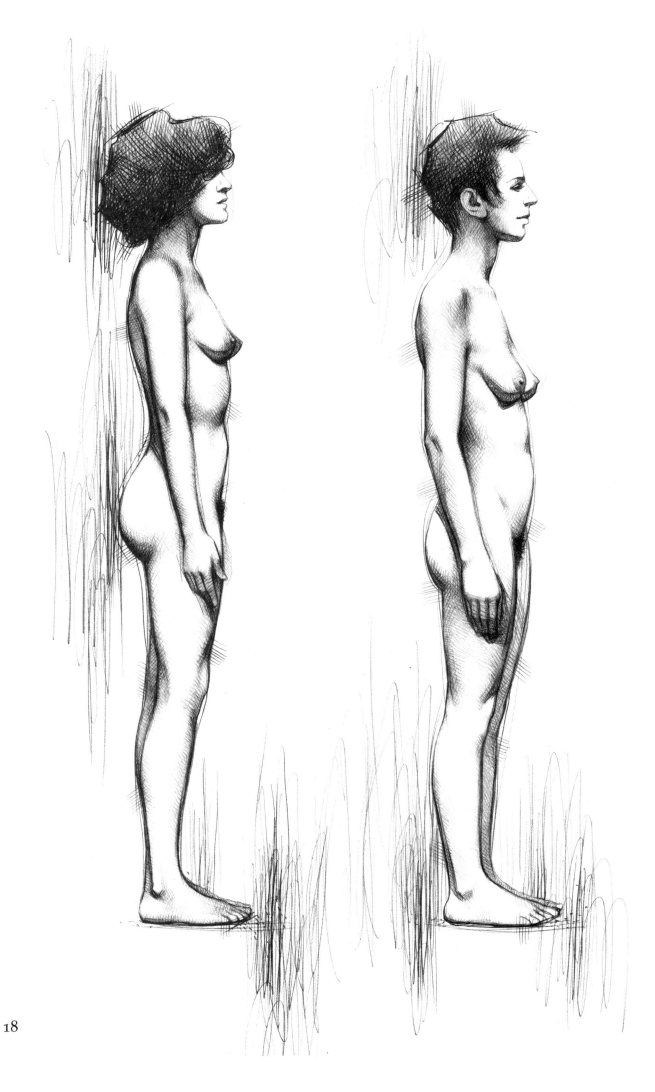

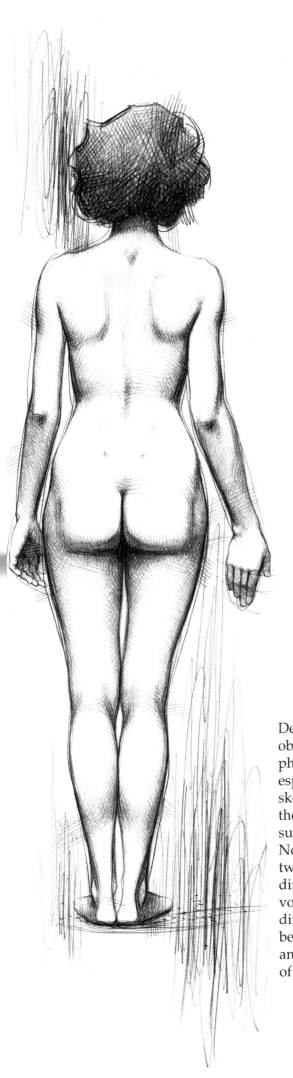

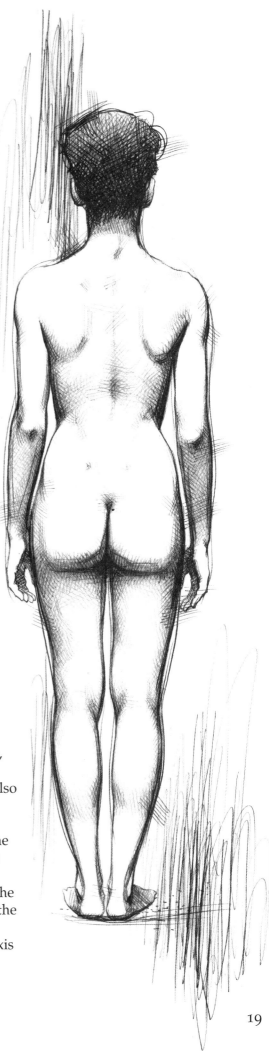

Develop the habit of observing individual physical characteristics, especially those of the skeletal structure, but also those of adipose and subcutaneous muscles. Note, for example, in the two models shown, the difference of form and volume in the breasts, the different protrusion of the belly and the different angles formed by the axis of arm and forearm.

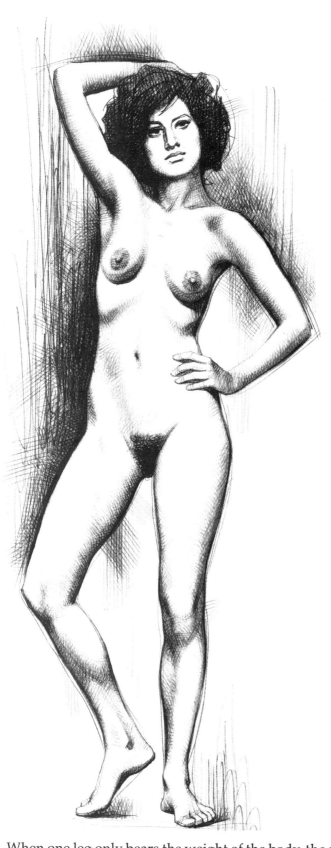

When one leg only bears the weight of the body, the pelvis inclines sideways, dropping down on the opposite side to the taut limb. To compensate for the loss of equilibrium the spine is flexed laterally (especially in the lumbar tract) and, consequently, both the shoulders incline in the opposite direction to the pelvis. This position is called *contrapposto* and occurs in almost all upright positions except those in which the body is perfectly balanced on both legs. In the figure with the arm raised, note how the breast is moved upwards, sliding over the fascia of the pectoral muscle and flattening against the ribs. The figure on the right shows only a hint of *contrapposto* in which the characteristic opposing inclinations, although very slight, are easily recognized.

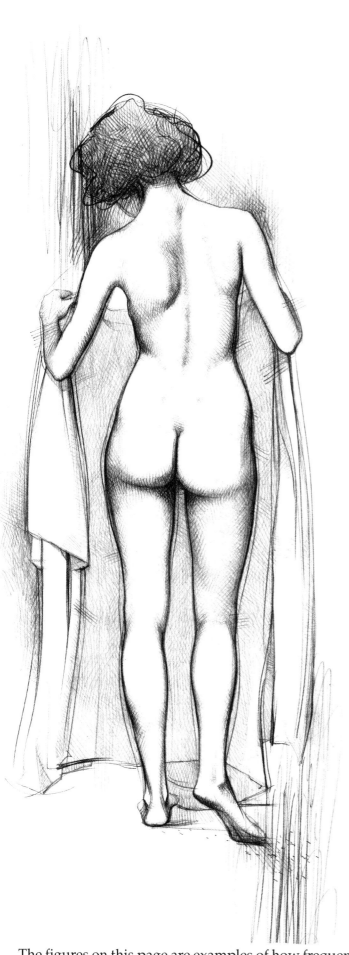

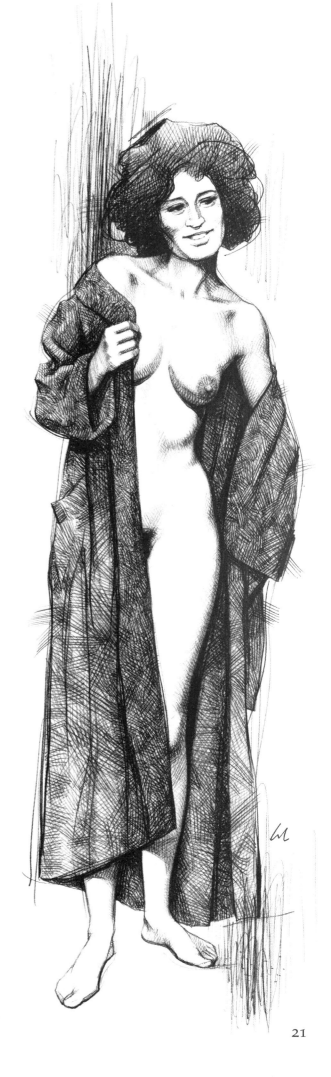

The figures on this page are examples of how frequent and spontaneous *contrapposto* attitudes may be, even in habitual and simple actions: in this case, picking up and putting on a dressing-gown.

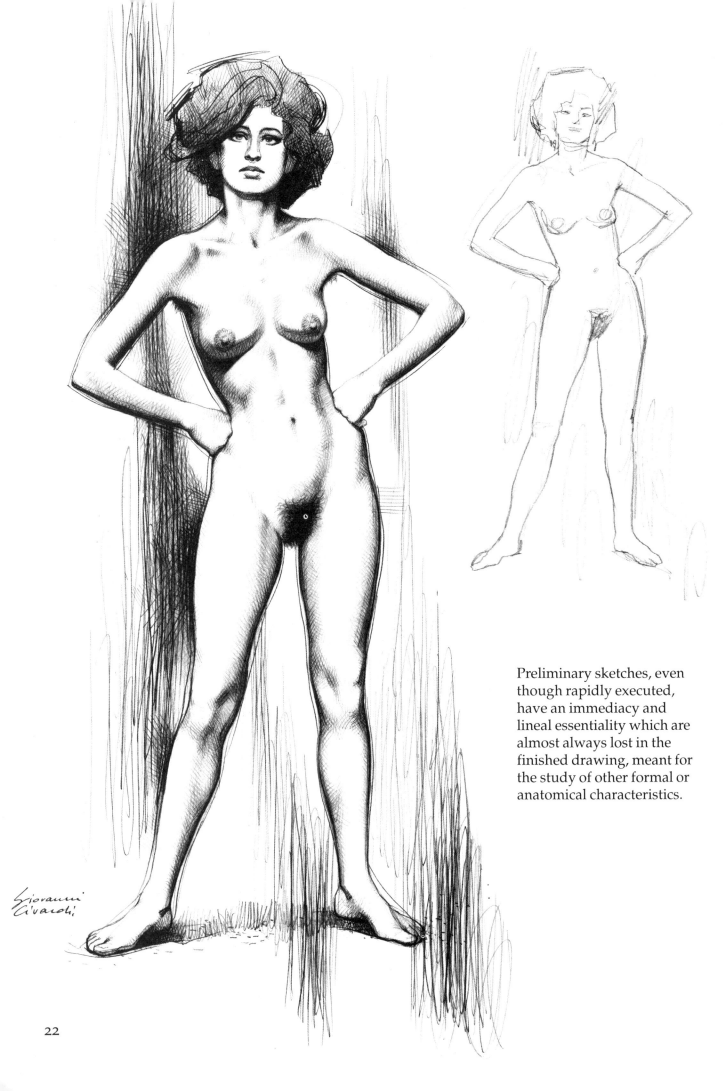

Preliminary sketches, even
though rapidly executed,
have an immediacy and
lineal essentiality which are
almost always lost in the
finished drawing, meant for
the study of other formal or
anatomical characteristics.

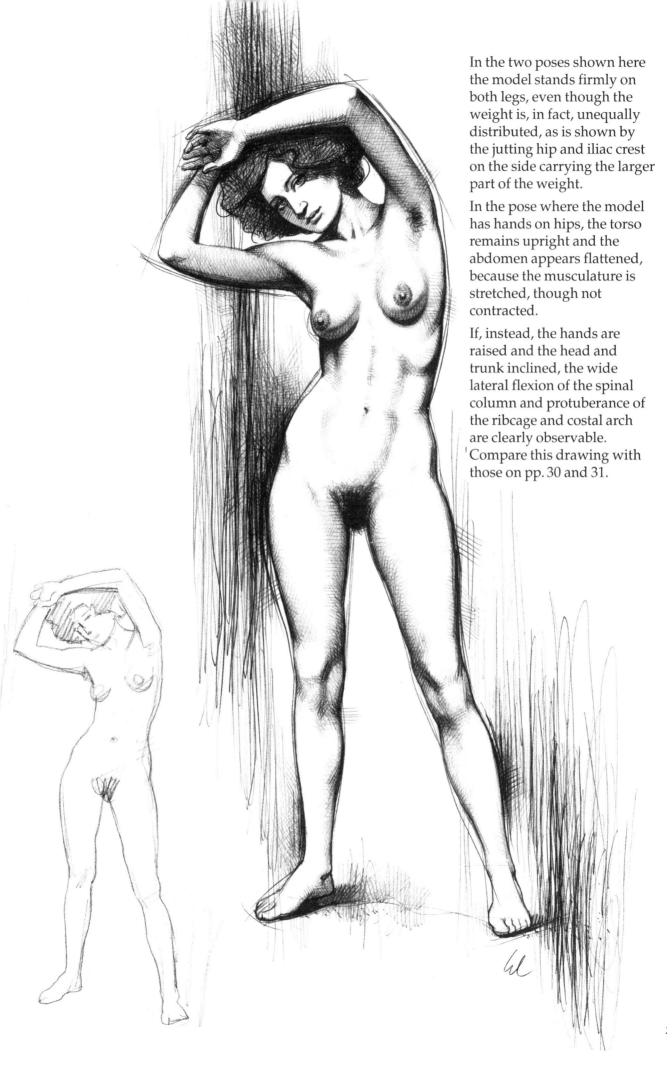

In the two poses shown here the model stands firmly on both legs, even though the weight is, in fact, unequally distributed, as is shown by the jutting hip and iliac crest on the side carrying the larger part of the weight.

In the pose where the model has hands on hips, the torso remains upright and the abdomen appears flattened, because the musculature is stretched, though not contracted.

If, instead, the hands are raised and the head and trunk inclined, the wide lateral flexion of the spinal column and protuberance of the ribcage and costal arch are clearly observable. Compare this drawing with those on pp. 30 and 31.

23

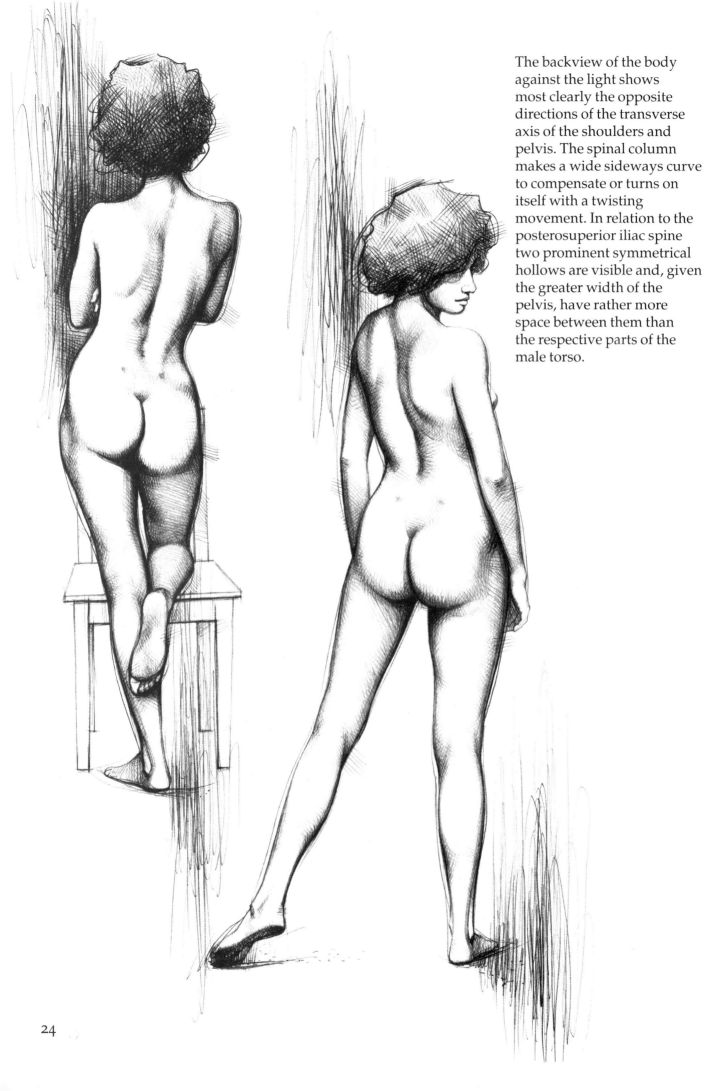

The backview of the body against the light shows most clearly the opposite directions of the transverse axis of the shoulders and pelvis. The spinal column makes a wide sideways curve to compensate or turns on itself with a twisting movement. In relation to the posterosuperior iliac spine two prominent symmetrical hollows are visible and, given the greater width of the pelvis, have rather more space between them than the respective parts of the male torso.

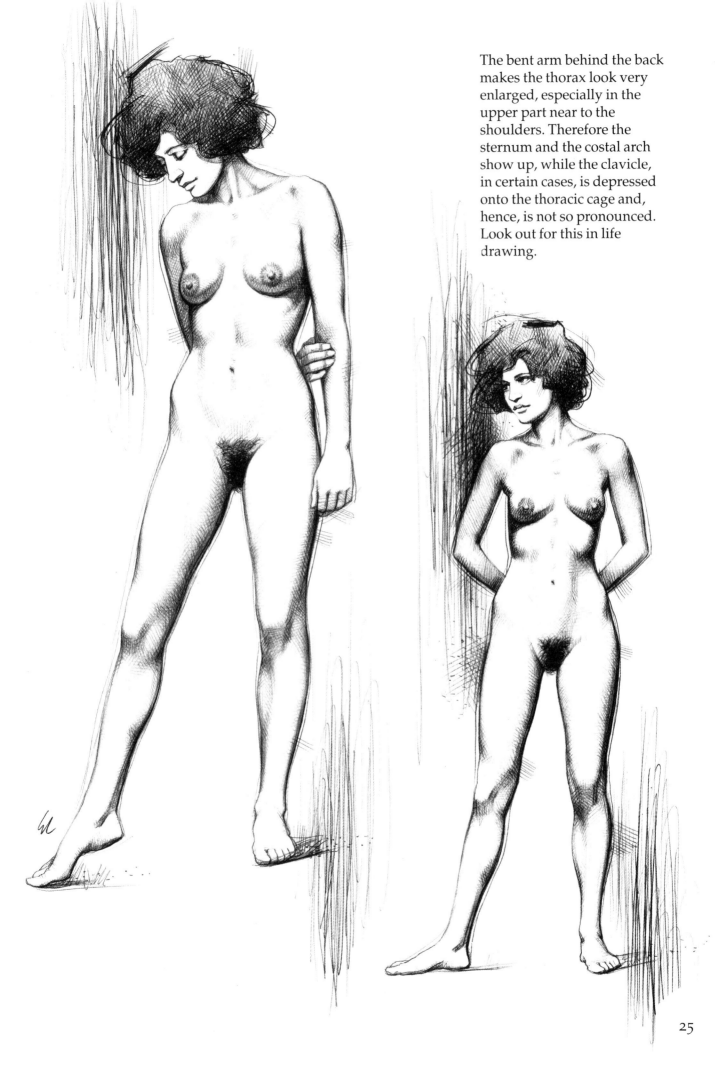

The bent arm behind the back makes the thorax look very enlarged, especially in the upper part near to the shoulders. Therefore the sternum and the costal arch show up, while the clavicle, in certain cases, is depressed onto the thoracic cage and, hence, is not so pronounced. Look out for this in life drawing.

25

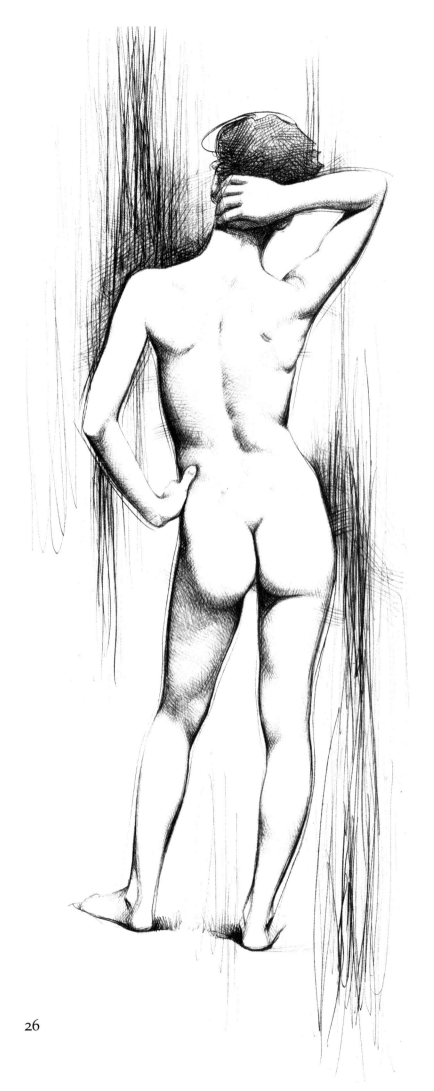

The scapula slides over the thoracic cage when the various shoulder and arm muscles (scapular muscles, infraspinatus, supraspinatus, teres major, deltoid, etc.), contract and can be seen under the broad muscles of the back (trapezius and latissimus dorsi). They follow, therefore, the movements of the shoulder and upper limb, moving outwards (as when the arm is thrust forward) and inwards towards the median line of the body (vertebral column) when the arm is drawn backwards. If instead, as shown here, the arm is moved upwards or to any extent abducted, the medial margin of the scapula (which, usually, is parallel to the spine) assumes a diagonal position, clearly visible under the muscles and the skin.

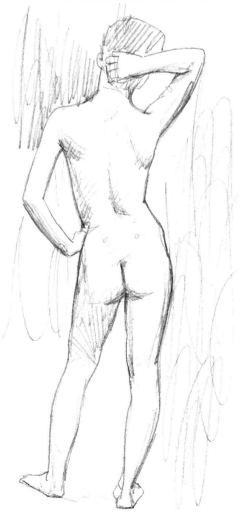

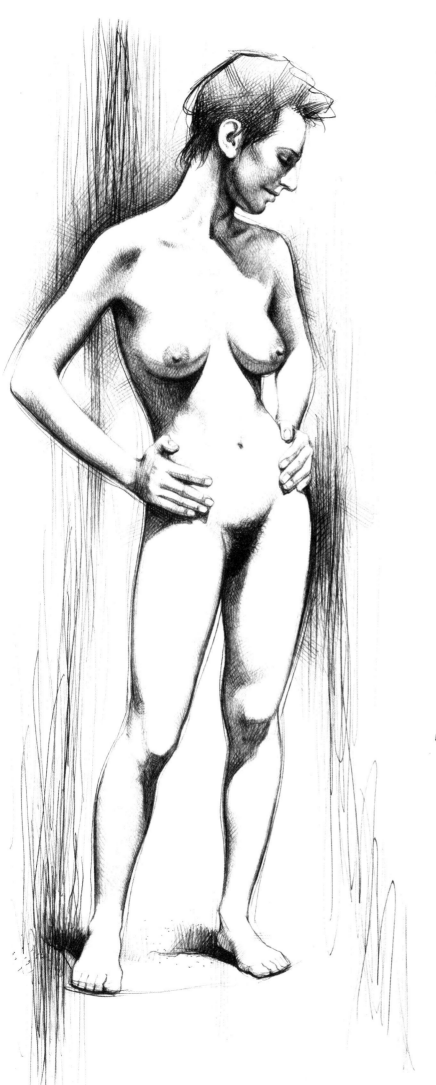

While studying the upright position in which the model leans without any support, look closely at the body's line of gravity, which must fall into the area of support bounded by the feet: the various sections of the body (head, trunk and limbs) in fact spontaneously position themselves so as to maintain or restore the state of equilibrium. The hands resting on the hips push the arms away from the body and the slightly stretched pectoralis major is seen like cords from the thorax to the shoulder, helping to outline the armpit. The breasts rest on the anterior part of the thorax, above pectoralis major and at the level of the 4th, 5th and 6th ribs. The force of gravity gives them a quasi-conical or hemispherical aspect, but more rounded below than above. Pay close attention to individual morphological characteristics and to the modifications induced by the different positions.

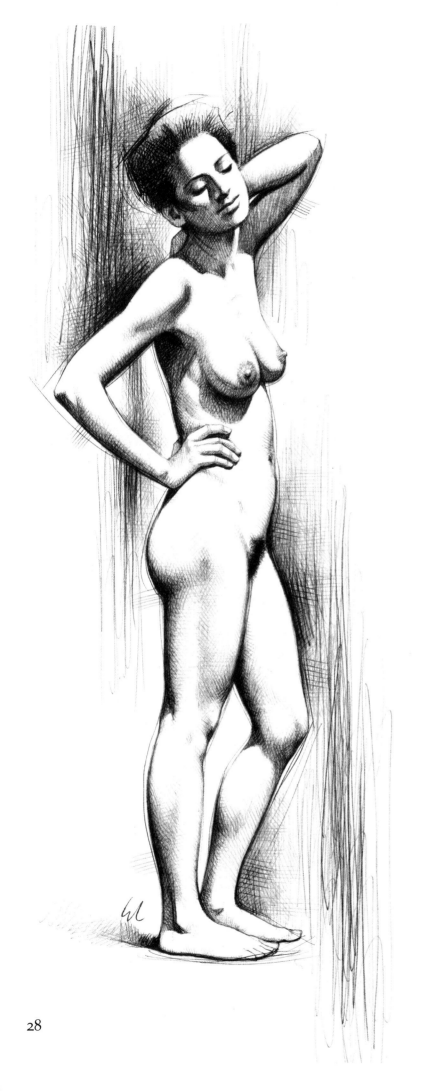

Here, the model is drawn from two viewpoints: the side and the back. The aim is to show the complex working of the skeleton. Remember that the pelvis and the vertebral column show the different fundamental characteristics of the positions taken up by the body and are the parts of the skeleton which must be observed most closely; with solid masses it is the thoracic cage, the head and the limbs that are linked.

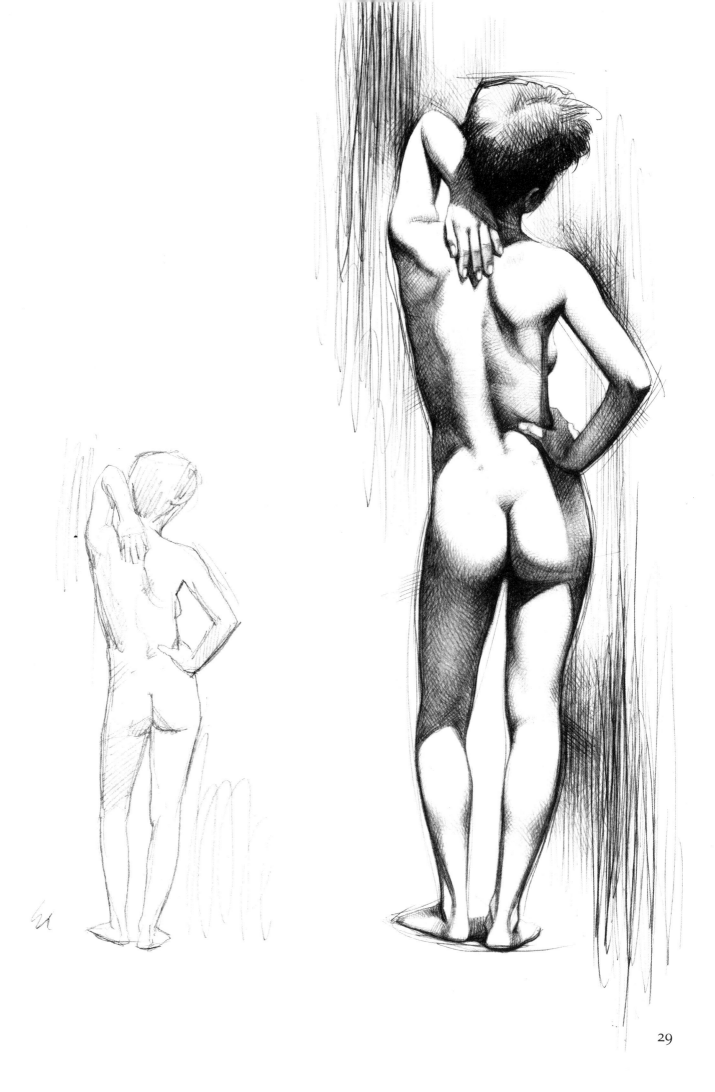

In this backview drawing the *contrapposto* pose (see p. 23) is strongly accented: the weight of the trunk falls on the right lower limb, while the pelvis inclines, dropping on the left side because the left limb is slightly flexed and serves only as subsidiary support.

The inclination of the pelvis is followed by that of the spinal cord (lumbar tract). Maintenance of equilibrium now requires a counteracting lateral shift of body weight achieved by the positioning of the arms, turning of the head and lateral flexion of the thorax. The trapezius and latissimus dorsi muscles help to hold the trunk upright and arched slightly backwards.

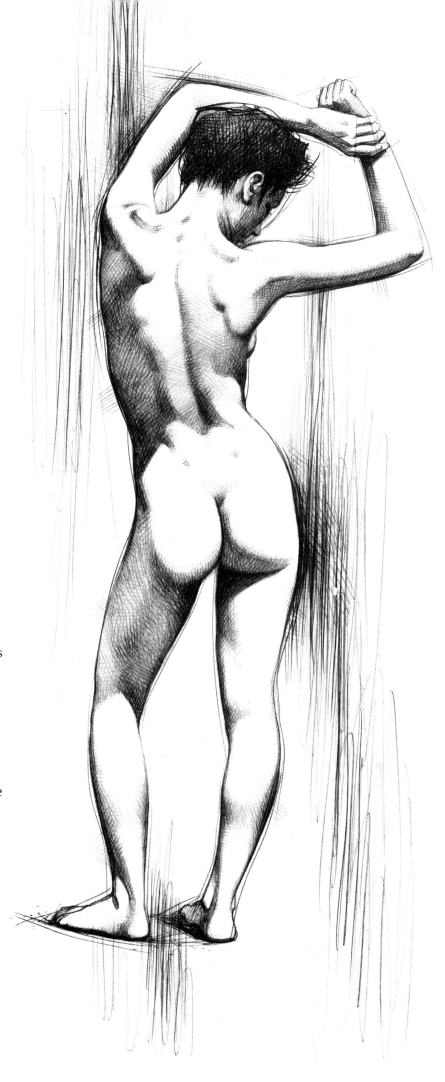

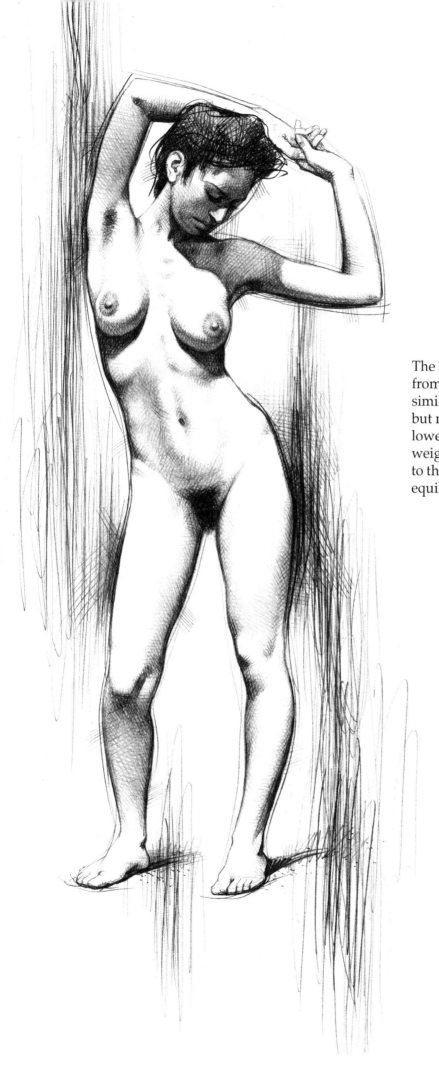

The same model is seen here from the front in a pose similar to the preceding one, but note that now it is the left lower limb that carries the weight, and the trunk inclines to the left to preserve the equilibrium.

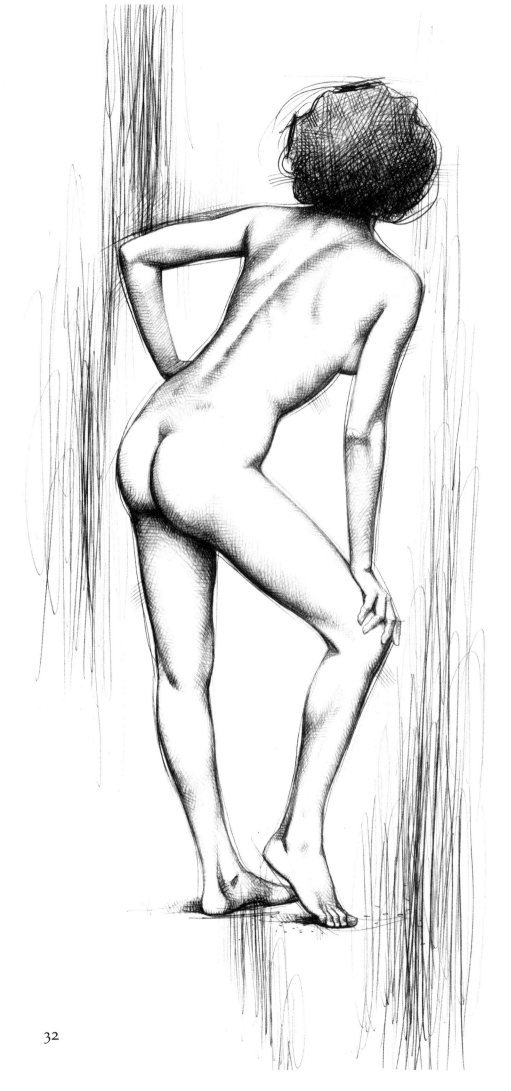

I suggested this pose to the model (seen from both front and back) because I wanted to remind you of the need for close study of the entire skeletal structure. It is in fact this, rather than the muscular system, that determines the postural attributes of the body: the pelvis, in particular, is always the 'functional centre' of the skeleton. It is interesting to note in this position the alternate orientation of the limbs (the upper left and lower right flexed, the upper right and lower left extended).

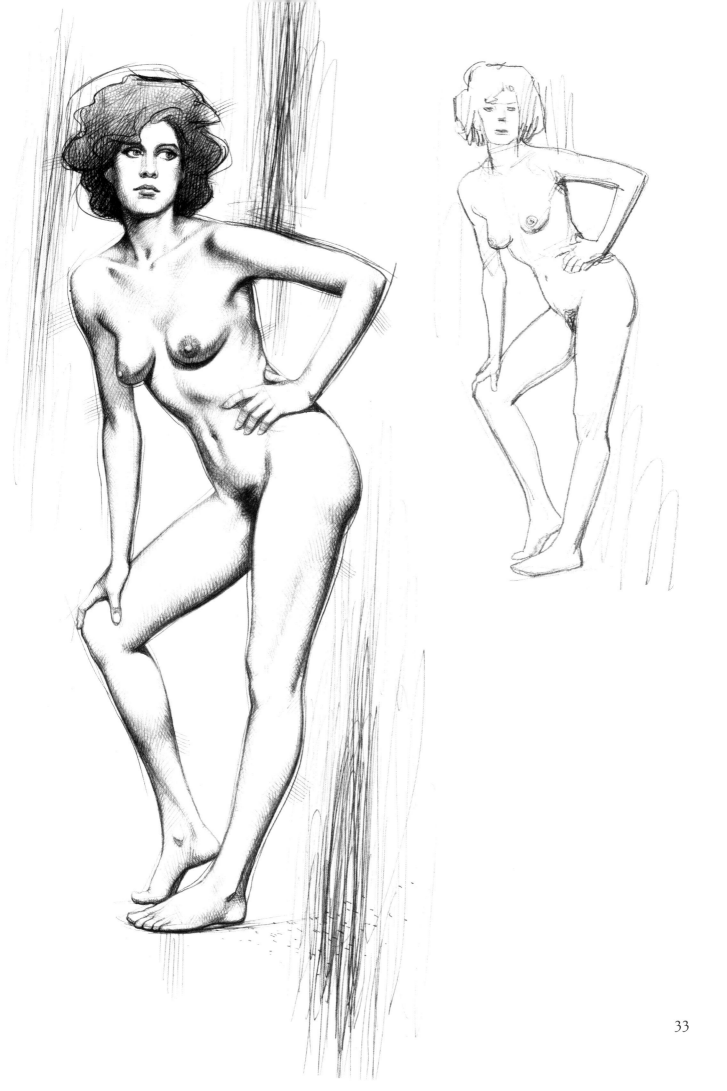

The model holding this pose presents some interesting observations.

From three-quarters back view
The deltoid and trapezius muscles, controlling the raising of the arms, are contracted and prominent, delineating the shoulders. In this position a transverse furrow forms, corresponding to the acromion and outlining the deltoid muscle. Latissimus dorsi covers the back of the thoracic cage and, because it is a quite thin sheath, allows serratus magnus (which it covers only in part) and some ribs to be seen.

Gluteus maximus forms the muscular structure of the buttocks, the volume of which is determined by the amount of adipose tissue. Note how the furrow (gluteal sulcus) above each buttock disappears towards the outer side. The right hip appears flattened because of the fascia lata which, in this position, is very taut. The sharp, projecting greater trochanter is also prominent. Finally, when seeing the model from behind instead of from the front or side, note how the levels of some parts of the body (breasts, hips, iliac crest, pubis, etc.) relate.

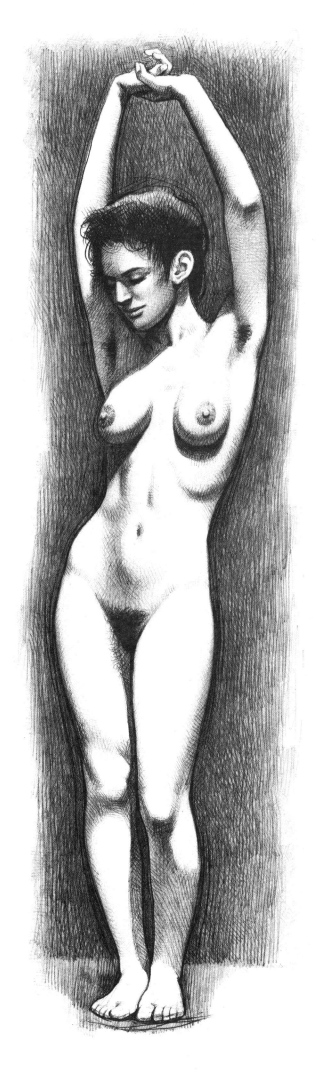

From the front
Observe the hollows of the armpits and their anterior and posterior walls formed by the muscles coming from the trunk and inserted near the head of the humerus (pectoralis major, latissimus dorsi, rotatores muscles); the slant is accentuated by the shoulders and even more so by the pelvis; the arms raised above the head reduce the lateral flexion of the trunk which preserves the balance. The tilt of the pelvis then allows a correspondingly different dislocation at the knees. The patella is held *in situ* by its tendons and the enlargement of the quadriceps; because of the only slightly contracted muscles of the hip, the right knee hardly juts out at all, sunken between the condyles of the femur, while the left knee, being flexed and therefore affected by the traction of the tendons, looks more prominent.

35

THE MOVING FIGURE

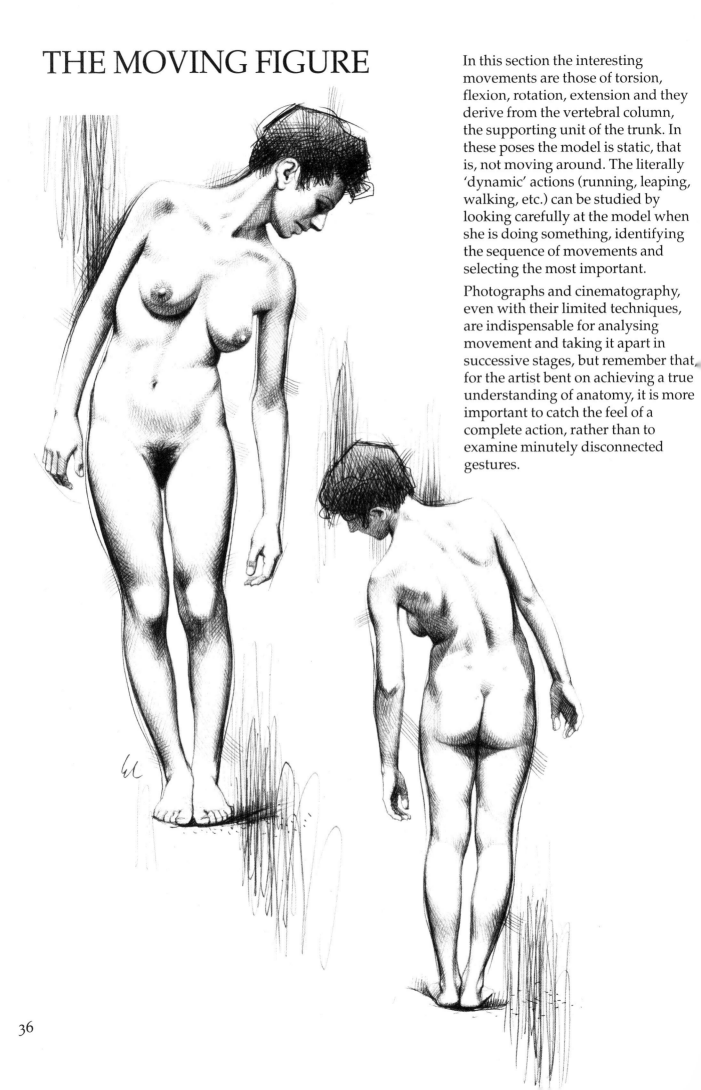

In this section the interesting movements are those of torsion, flexion, rotation, extension and they derive from the vertebral column, the supporting unit of the trunk. In these poses the model is static, that is, not moving around. The literally 'dynamic' actions (running, leaping, walking, etc.) can be studied by looking carefully at the model when she is doing something, identifying the sequence of movements and selecting the most important.

Photographs and cinematography, even with their limited techniques, are indispensable for analysing movement and taking it apart in successive stages, but remember that, for the artist bent on achieving a true understanding of anatomy, it is more important to catch the feel of a complete action, rather than to examine minutely disconnected gestures.

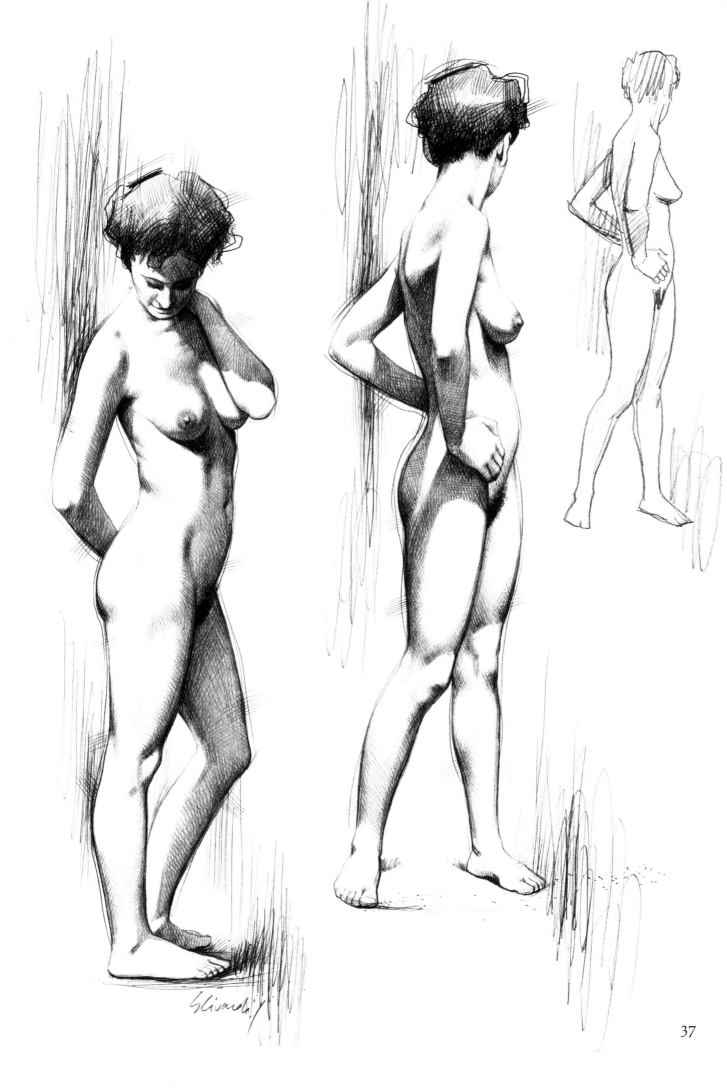

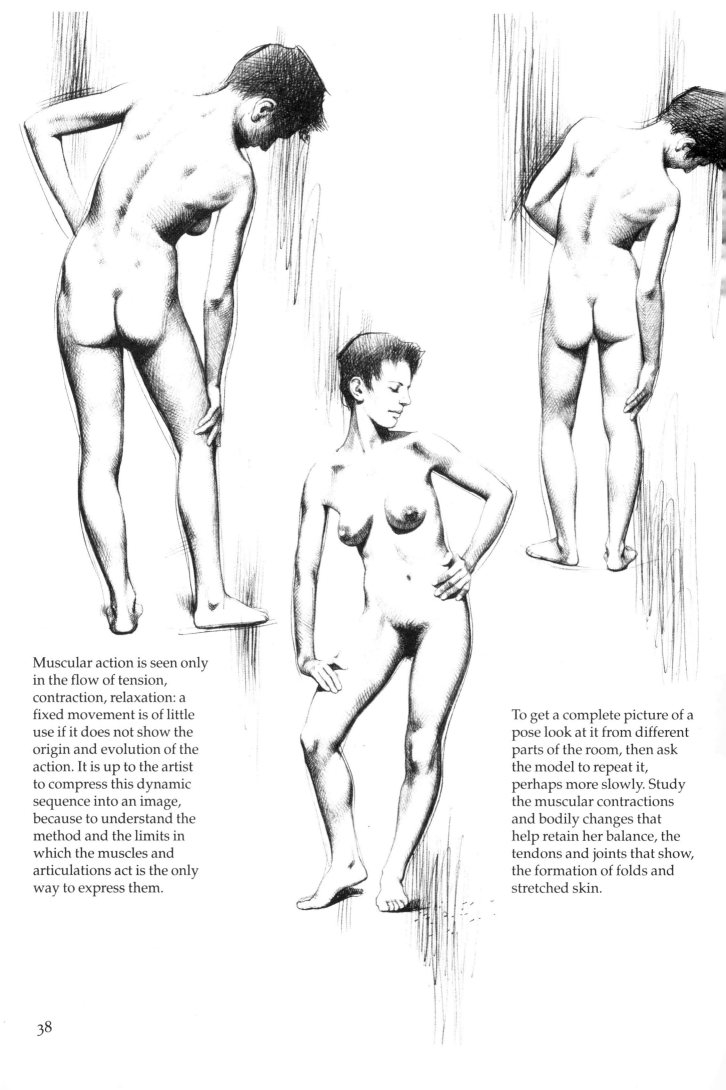

Muscular action is seen only in the flow of tension, contraction, relaxation: a fixed movement is of little use if it does not show the origin and evolution of the action. It is up to the artist to compress this dynamic sequence into an image, because to understand the method and the limits in which the muscles and articulations act is the only way to express them.

To get a complete picture of a pose look at it from different parts of the room, then ask the model to repeat it, perhaps more slowly. Study the muscular contractions and bodily changes that help retain her balance, the tendons and joints that show, the formation of folds and stretched skin.

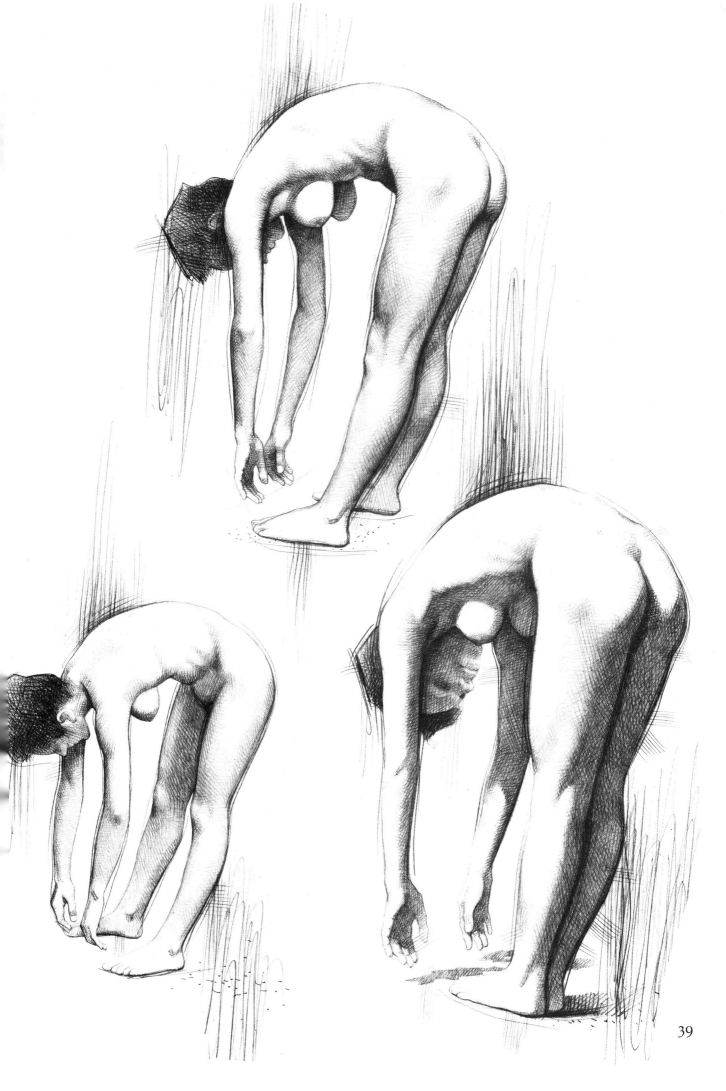

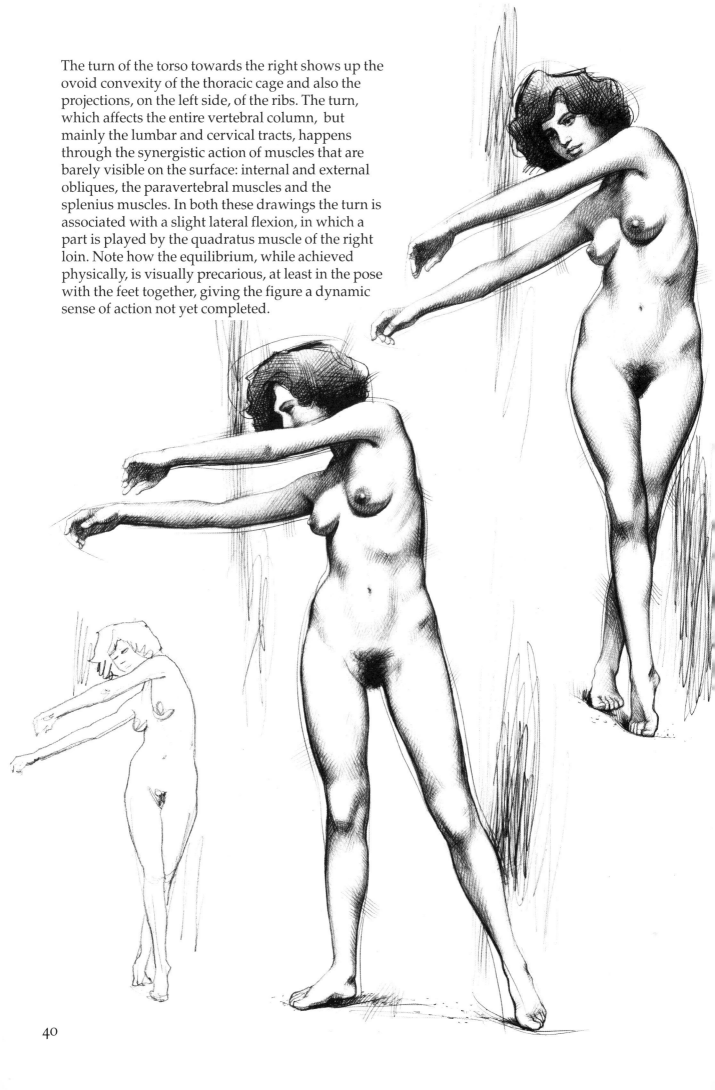

The turn of the torso towards the right shows up the ovoid convexity of the thoracic cage and also the projections, on the left side, of the ribs. The turn, which affects the entire vertebral column, but mainly the lumbar and cervical tracts, happens through the synergistic action of muscles that are barely visible on the surface: internal and external obliques, the paravertebral muscles and the splenius muscles. In both these drawings the turn is associated with a slight lateral flexion, in which a part is played by the quadratus muscle of the right loin. Note how the equilibrium, while achieved physically, is visually precarious, at least in the pose with the feet together, giving the figure a dynamic sense of action not yet completed.

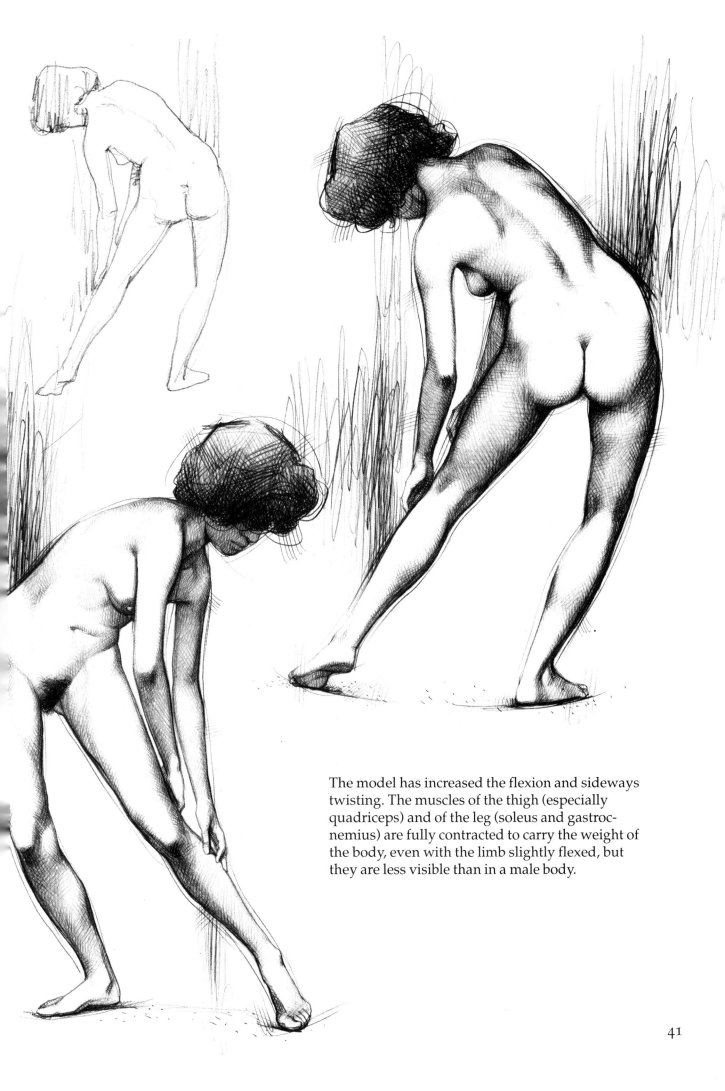

The model has increased the flexion and sideways twisting. The muscles of the thigh (especially quadriceps) and of the leg (soleus and gastrocnemius) are fully contracted to carry the weight of the body, even with the limb slightly flexed, but they are less visible than in a male body.

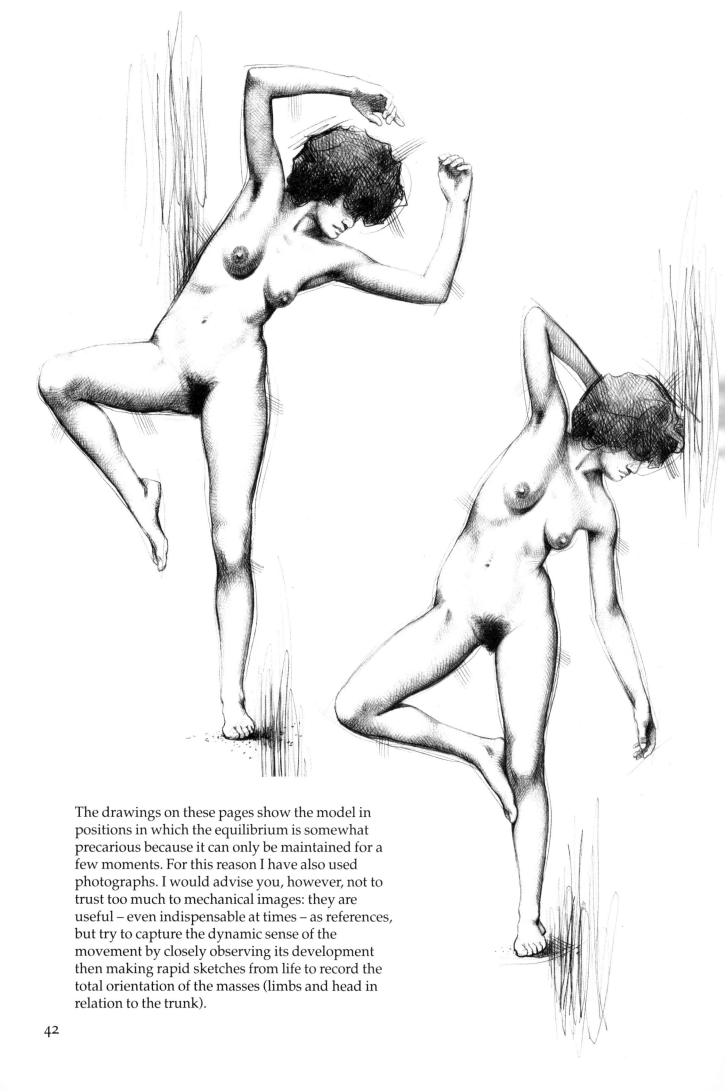

The drawings on these pages show the model in positions in which the equilibrium is somewhat precarious because it can only be maintained for a few moments. For this reason I have also used photographs. I would advise you, however, not to trust too much to mechanical images: they are useful – even indispensable at times – as references, but try to capture the dynamic sense of the movement by closely observing its development then making rapid sketches from life to record the total orientation of the masses (limbs and head in relation to the trunk).

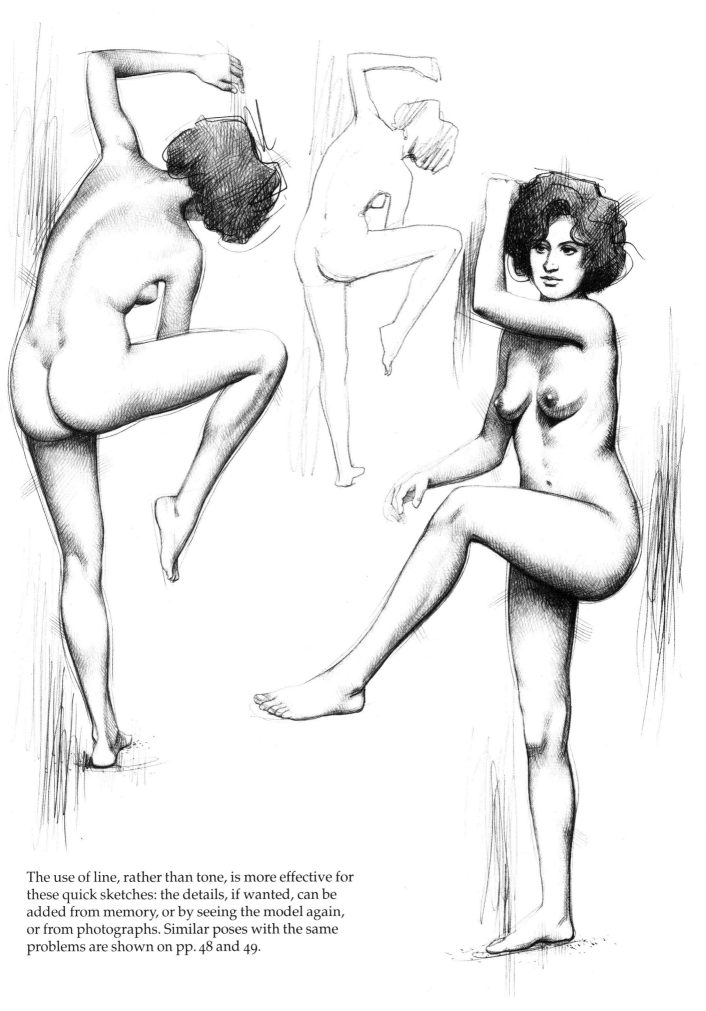

The use of line, rather than tone, is more effective for these quick sketches: the details, if wanted, can be added from memory, or by seeing the model again, or from photographs. Similar poses with the same problems are shown on pp. 48 and 49.

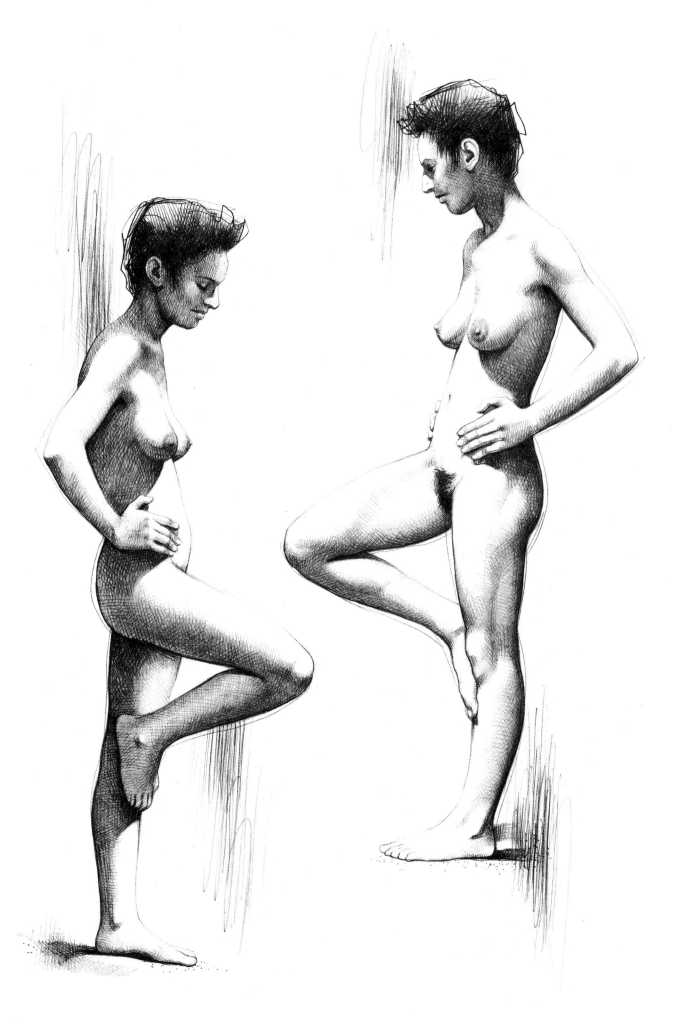

44

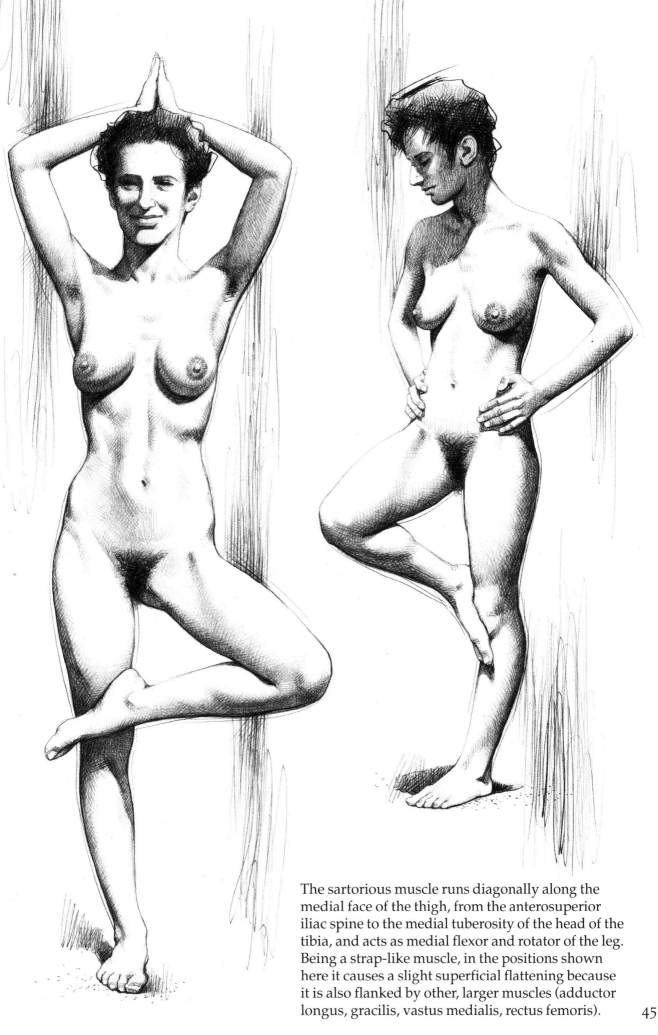

The sartorious muscle runs diagonally along the medial face of the thigh, from the anterosuperior iliac spine to the medial tuberosity of the head of the tibia, and acts as medial flexor and rotator of the leg. Being a strap-like muscle, in the positions shown here it causes a slight superficial flattening because it is also flanked by other, larger muscles (adductor longus, gracilis, vastus medialis, rectus femoris).

45

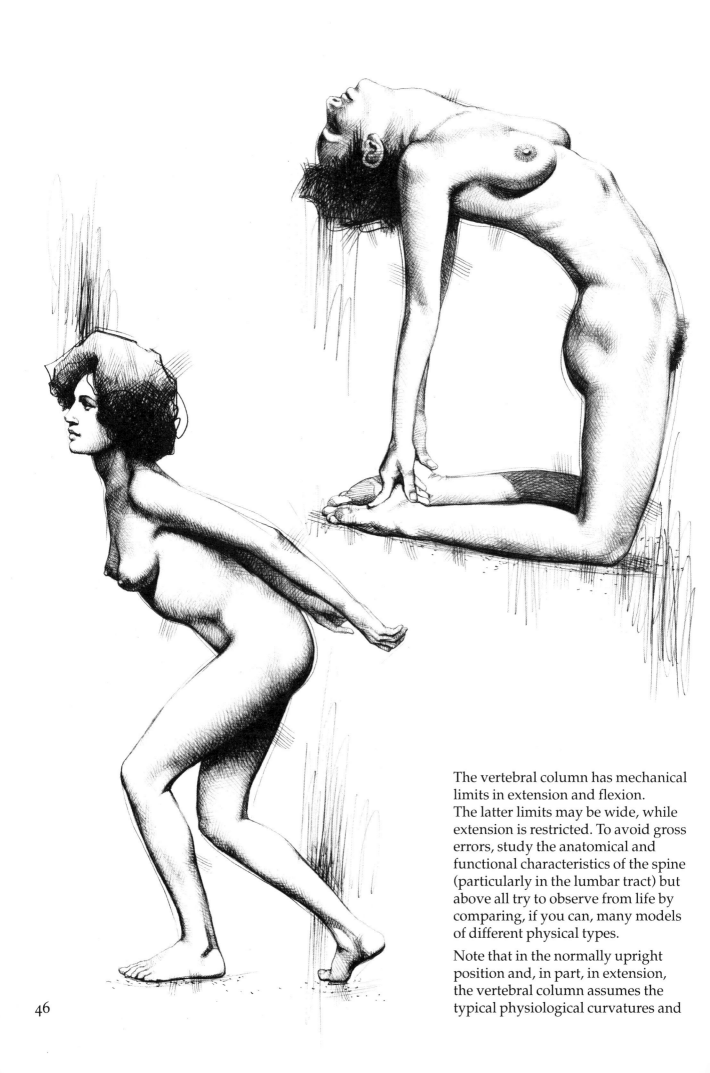

The vertebral column has mechanical limits in extension and flexion. The latter limits may be wide, while extension is restricted. To avoid gross errors, study the anatomical and functional characteristics of the spine (particularly in the lumbar tract) but above all try to observe from life by comparing, if you can, many models of different physical types.

Note that in the normally upright position and, in part, in extension, the vertebral column assumes the typical physiological curvatures and

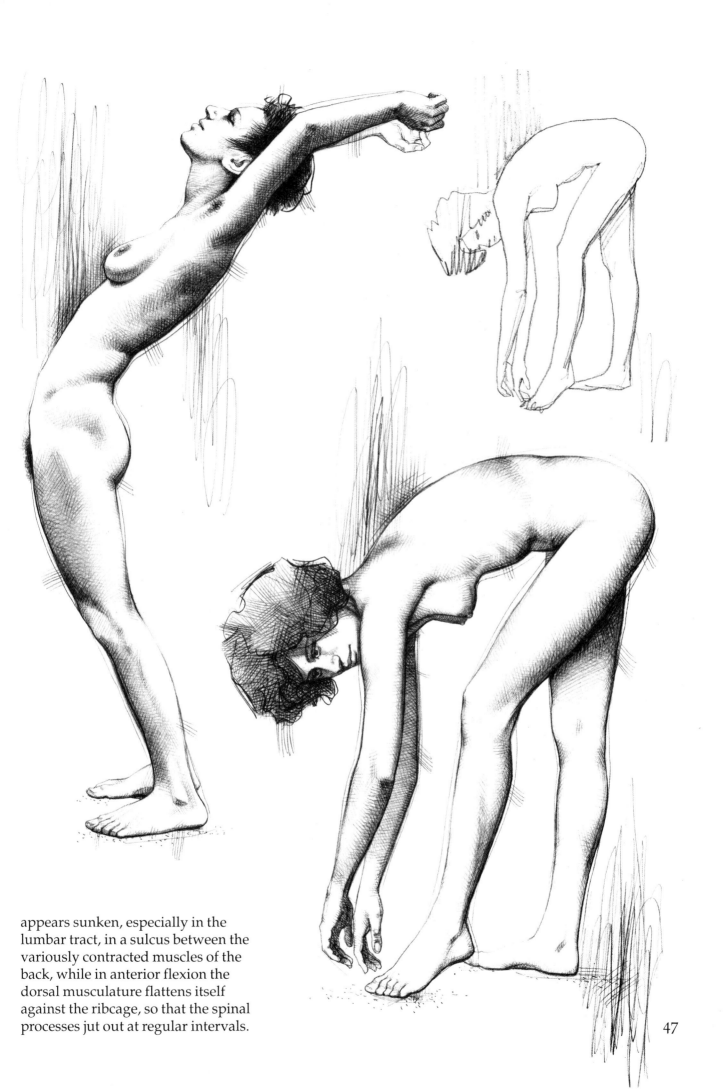

appears sunken, especially in the lumbar tract, in a sulcus between the variously contracted muscles of the back, while in anterior flexion the dorsal musculature flattens itself against the ribcage, so that the spinal processes jut out at regular intervals.

47

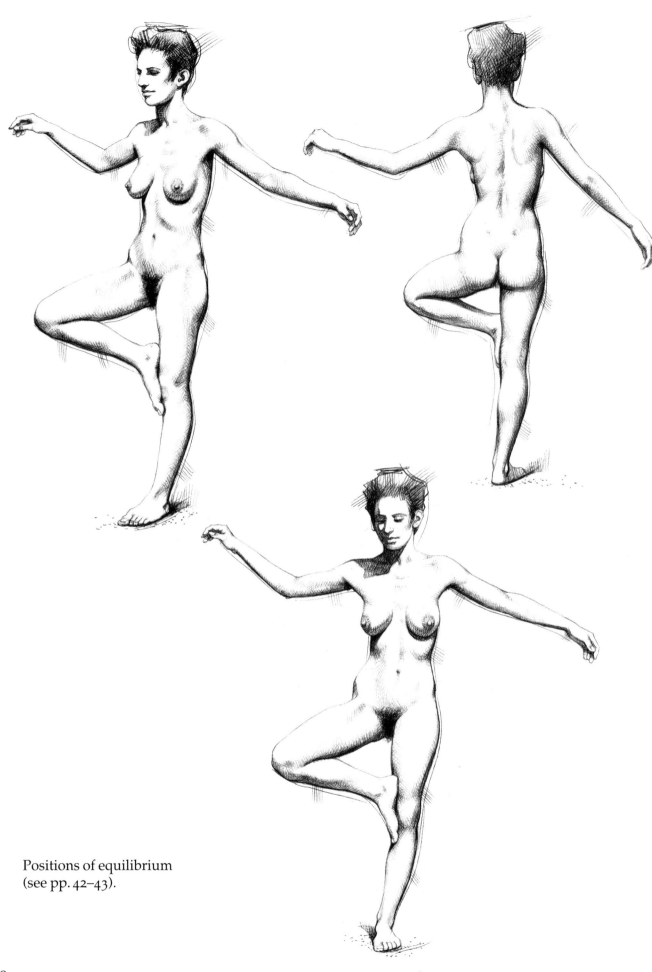

Positions of equilibrium
(see pp. 42–43).

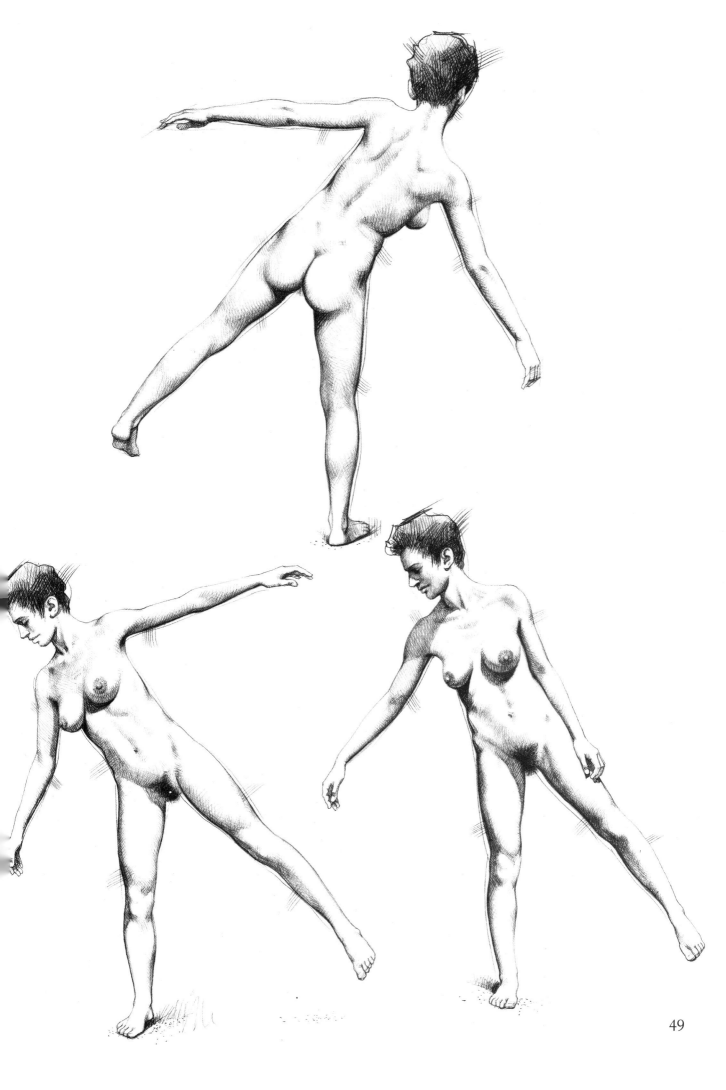

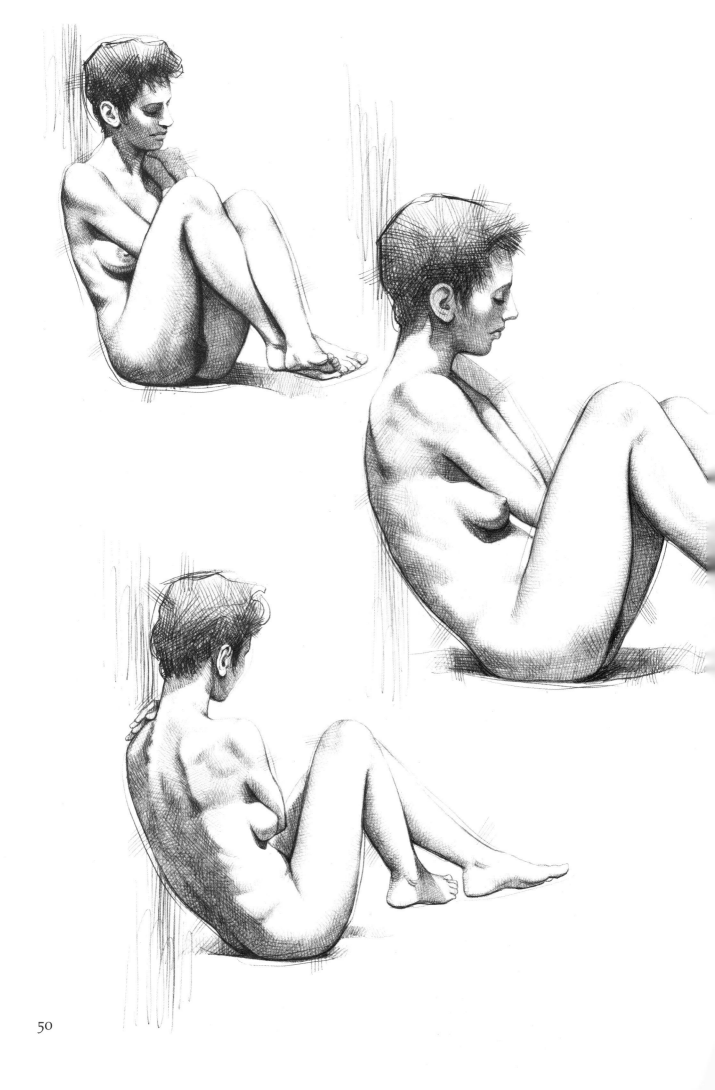

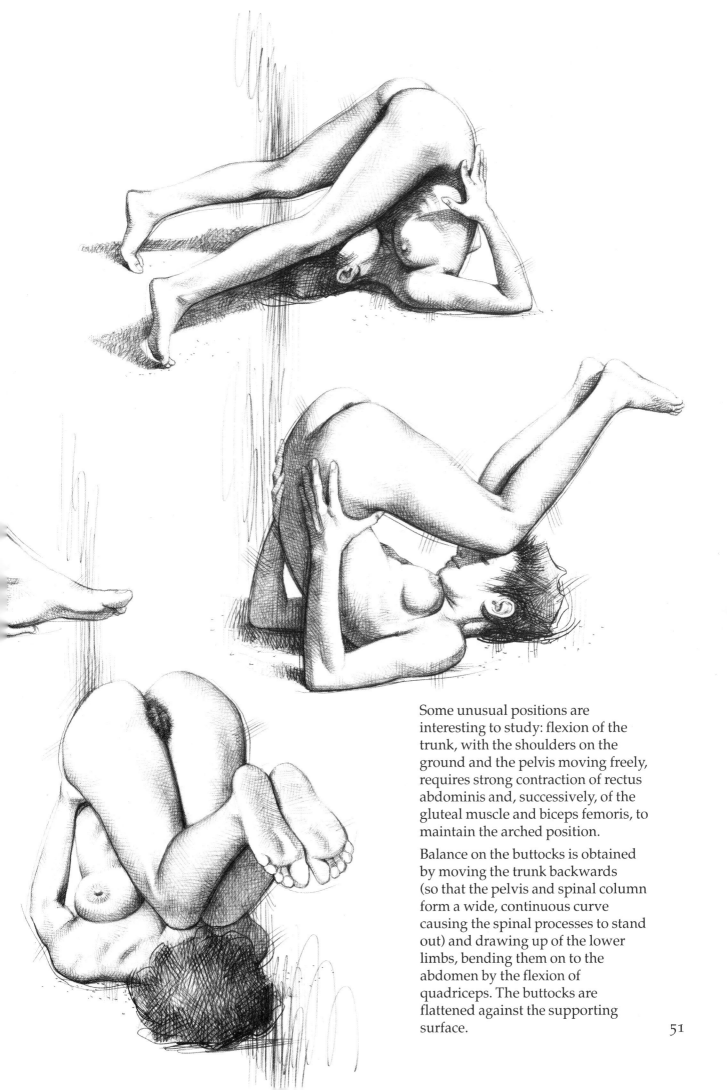

Some unusual positions are interesting to study: flexion of the trunk, with the shoulders on the ground and the pelvis moving freely, requires strong contraction of rectus abdominis and, successively, of the gluteal muscle and biceps femoris, to maintain the arched position.

Balance on the buttocks is obtained by moving the trunk backwards (so that the pelvis and spinal column form a wide, continuous curve causing the spinal processes to stand out) and drawing up of the lower limbs, bending them on to the abdomen by the flexion of quadriceps. The buttocks are flattened against the supporting surface.

51

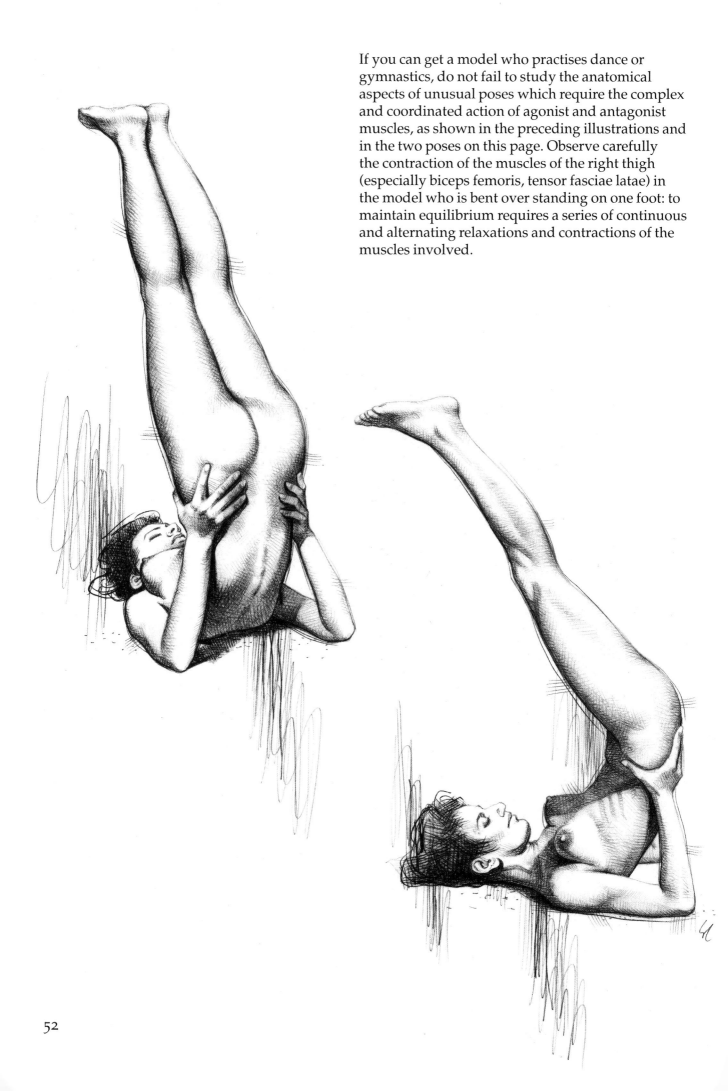

If you can get a model who practises dance or gymnastics, do not fail to study the anatomical aspects of unusual poses which require the complex and coordinated action of agonist and antagonist muscles, as shown in the preceding illustrations and in the two poses on this page. Observe carefully the contraction of the muscles of the right thigh (especially biceps femoris, tensor fasciae latae) in the model who is bent over standing on one foot: to maintain equilibrium requires a series of continuous and alternating relaxations and contractions of the muscles involved.

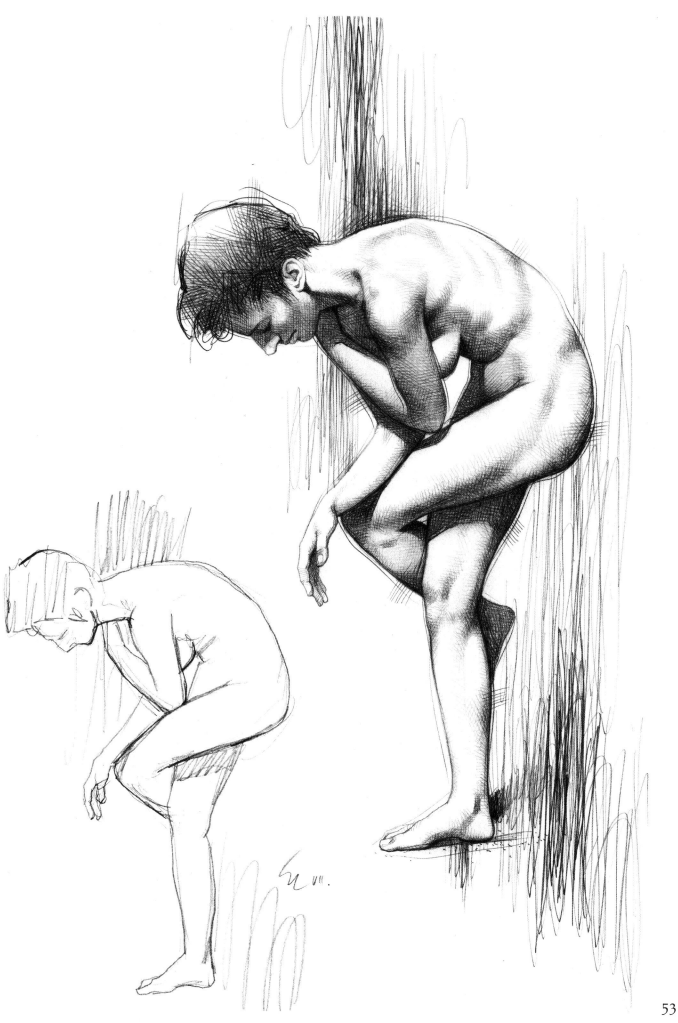

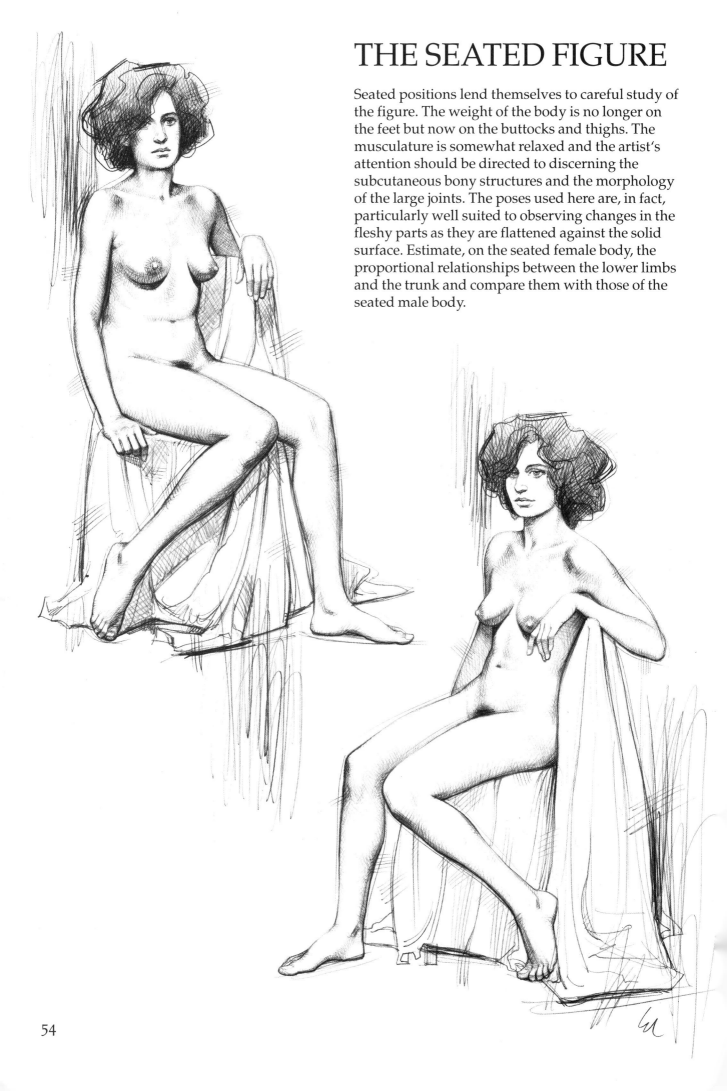

THE SEATED FIGURE

Seated positions lend themselves to careful study of the figure. The weight of the body is no longer on the feet but now on the buttocks and thighs. The musculature is somewhat relaxed and the artist's attention should be directed to discerning the subcutaneous bony structures and the morphology of the large joints. The poses used here are, in fact, particularly well suited to observing changes in the fleshy parts as they are flattened against the solid surface. Estimate, on the seated female body, the proportional relationships between the lower limbs and the trunk and compare them with those of the seated male body.

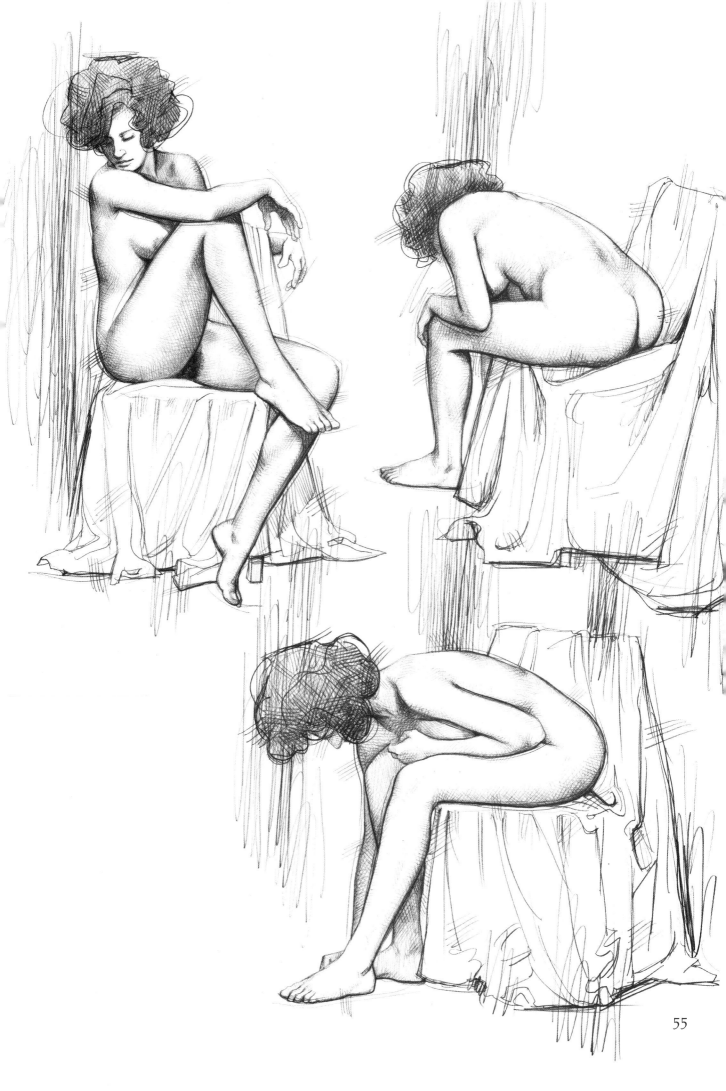

Observe, in these two poses, the bony characteristics of the upper limb: at the level of the shoulder the head of the humerus is covered by the deltoid muscle but, above this, the bone of the acromial process of the scapula is always very prominent. The forearm is made up of two flattened bones, the ulna and the radius, covered by the flexor and extensor muscles of the fingers and hand, but in several places close to the surface of the skin as, for example, at the elbow (olecranon of the ulna) and at the wrist (styloid processes of the ulna and radius). Note that in the woman's upper arm and forearm, with the limb strongly extended, the axes are not aligned, but form an obtuse angle towards the rear, and can attain a more accentuated hypertension than occurs in the male.

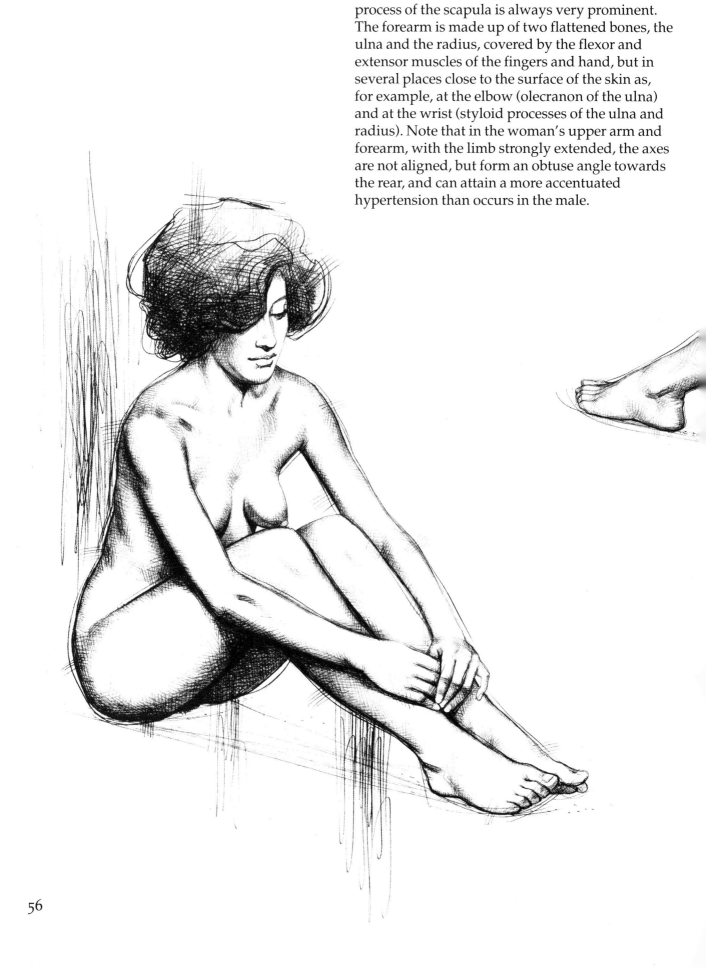

56

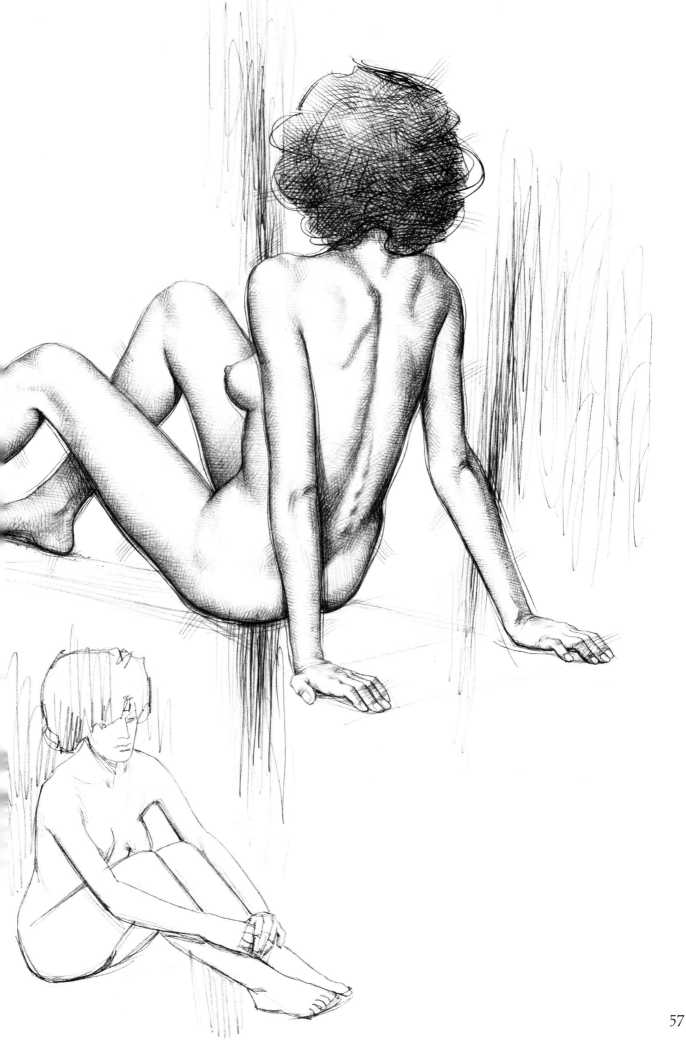

The poses on these pages show further
examples of the particular anatomical
characteristics of the female upper
limbs to which some reference has been
made in the preceding pages. Now look
at the figure below on the opposite
page (see also p. 69) and at the tilt of the
pelvis caused by the raising of the right
haunch and consequent lateral flexion
of the vertebral column; the left
scapula, given the position of the limb,
is more prominent and its medial
border shows more distinctly by
comparison with the right scapula,
which is held against the thoracic cage.

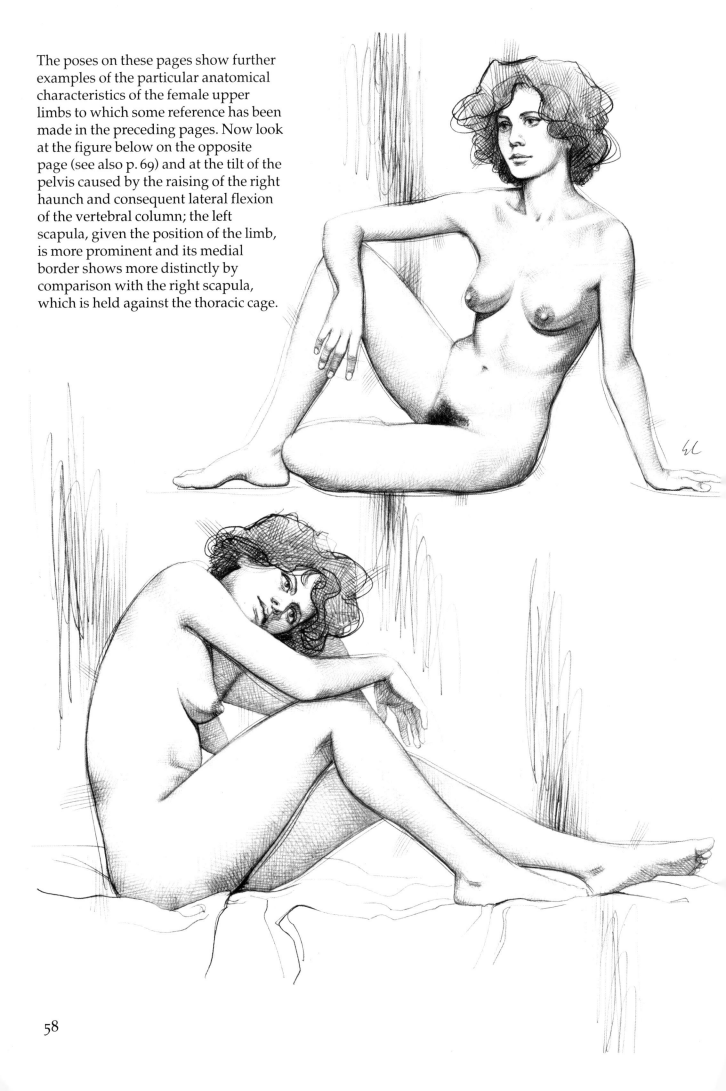

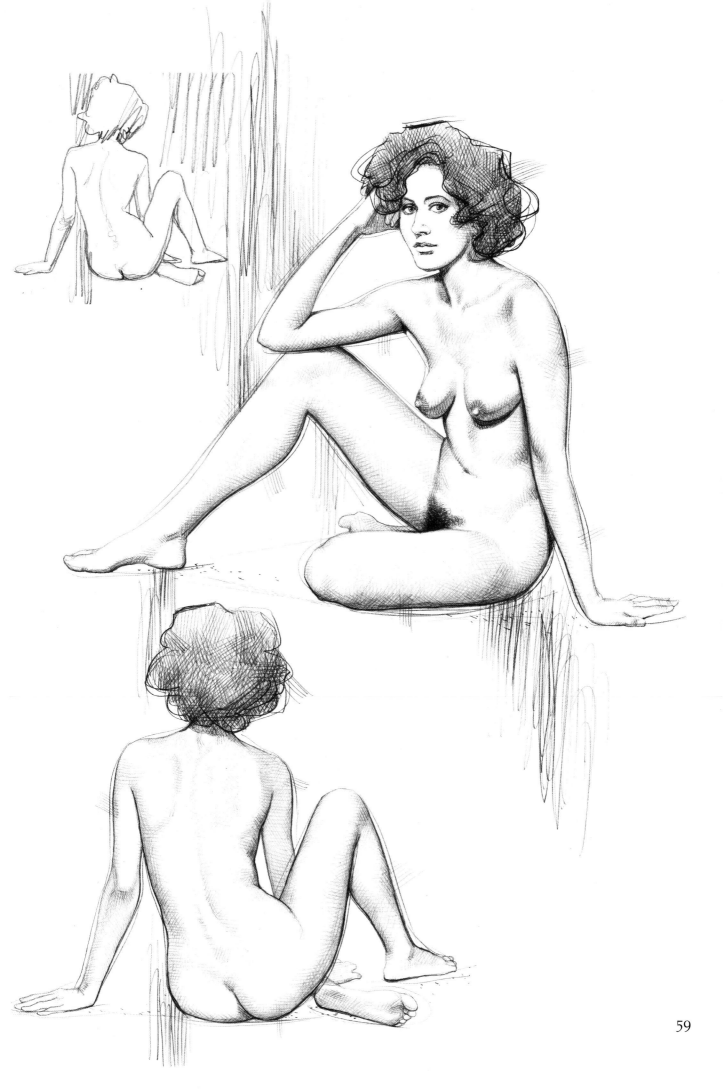

These two poses, shown here consecutively, demonstrate the changes in the trunk. By assuming these poses in sequence the model shows the changes that occur in the trunk. With the body flexed forwards (below), note the prominence of the clavicle, with the long curve of the vertebral column and the relaxation of the abdominal muscles (where the skin forms transverse folds). In the position (above) which shows the trunk extended and the arms raised, the backbone is bent in the lumbar tract, the spinous process is not much in evidence except in the cervical section; the deltoid muscles and trapezius are more marked.

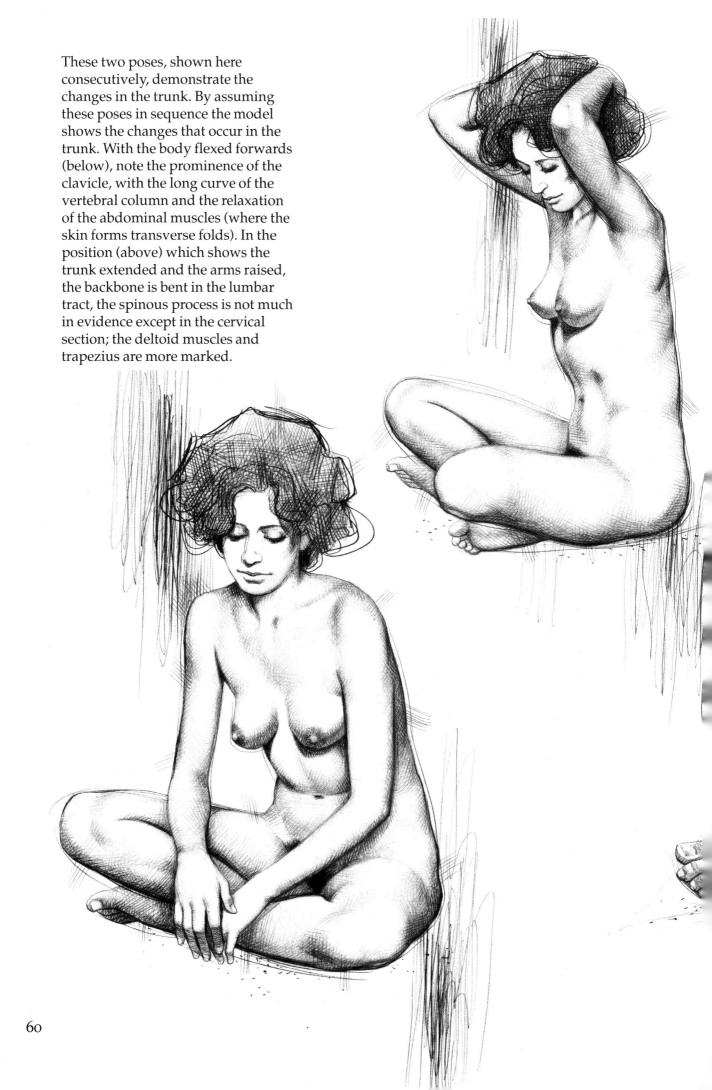

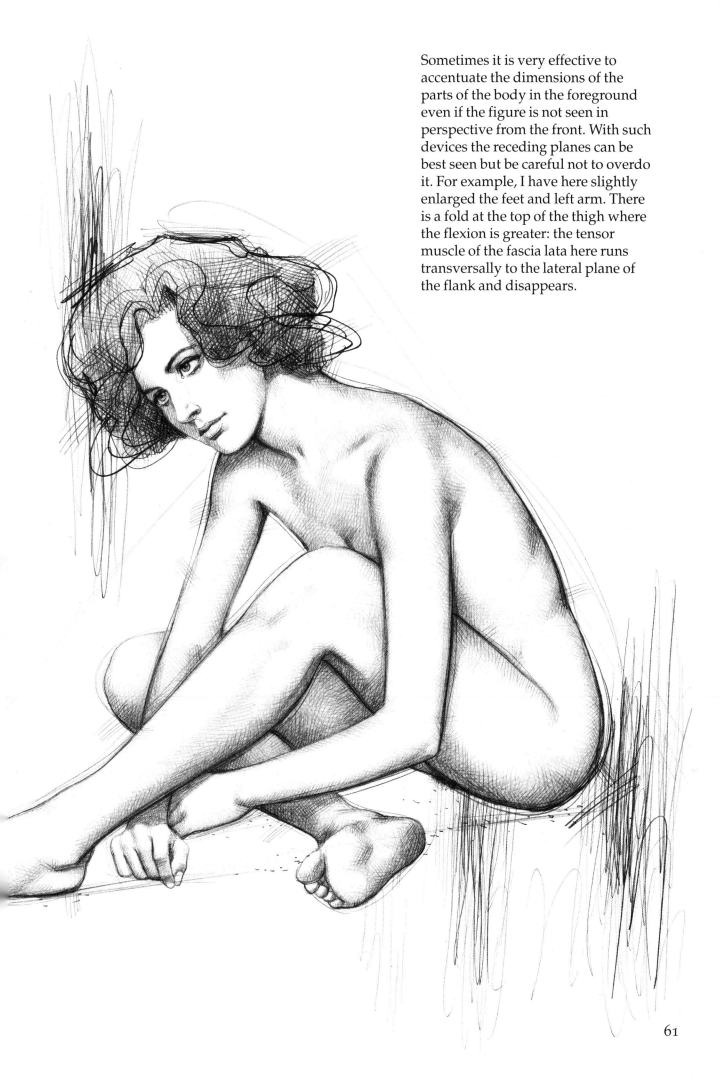

Sometimes it is very effective to accentuate the dimensions of the parts of the body in the foreground even if the figure is not seen in perspective from the front. With such devices the receding planes can be best seen but be careful not to overdo it. For example, I have here slightly enlarged the feet and left arm. There is a fold at the top of the thigh where the flexion is greater: the tensor muscle of the fascia lata here runs transversally to the lateral plane of the flank and disappears.

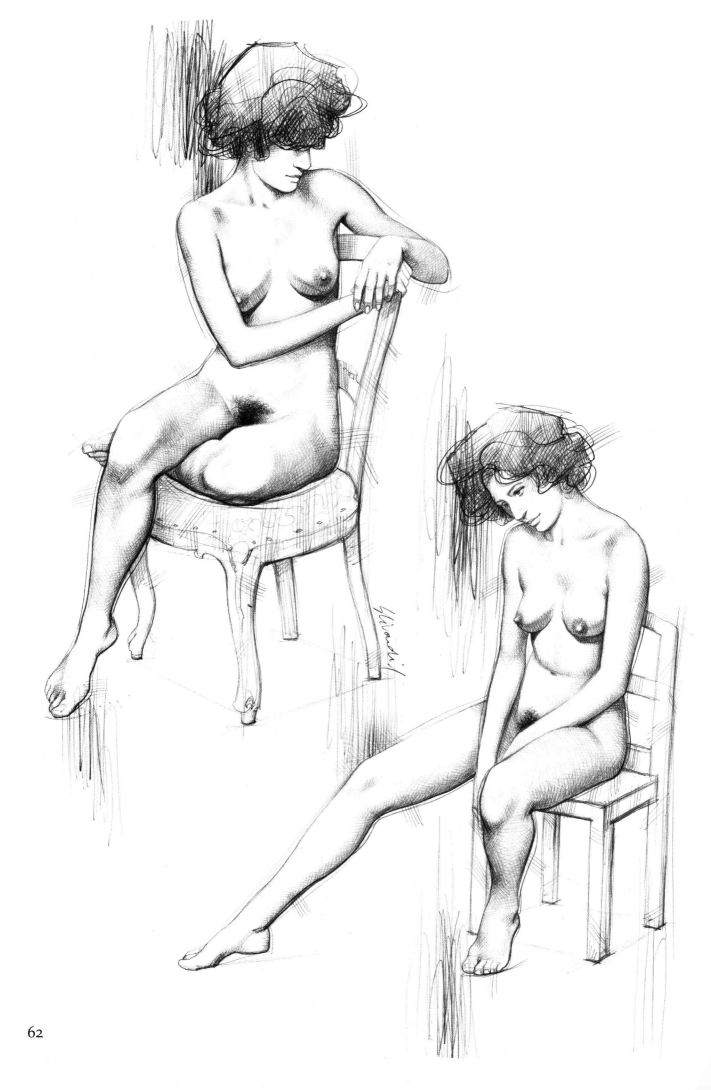

62

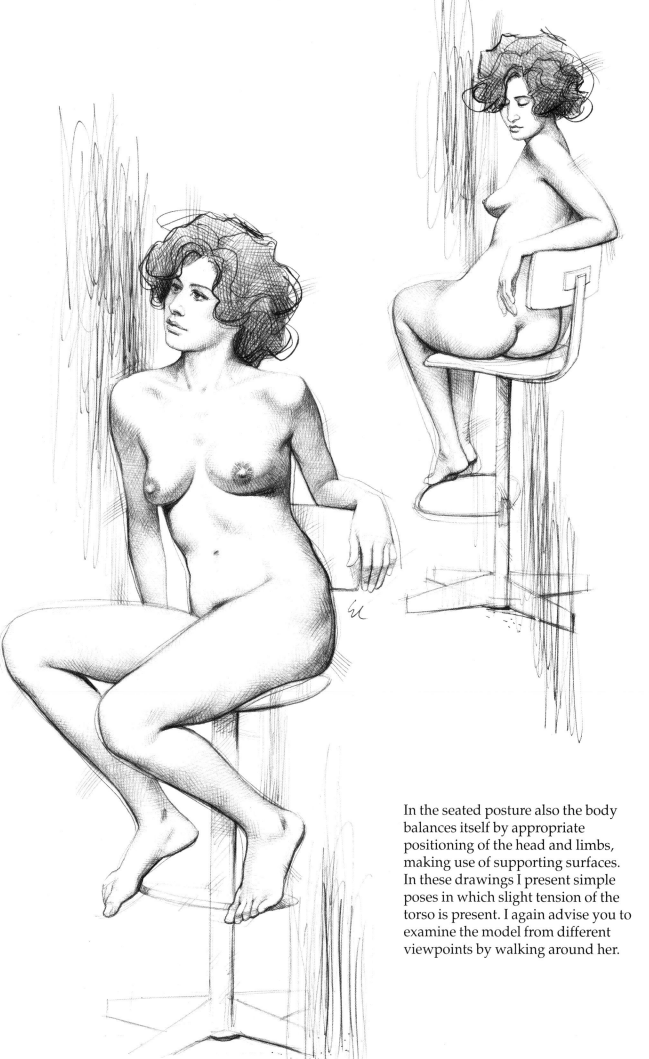

In the seated posture also the body balances itself by appropriate positioning of the head and limbs, making use of supporting surfaces. In these drawings I present simple poses in which slight tension of the torso is present. I again advise you to examine the model from different viewpoints by walking around her.

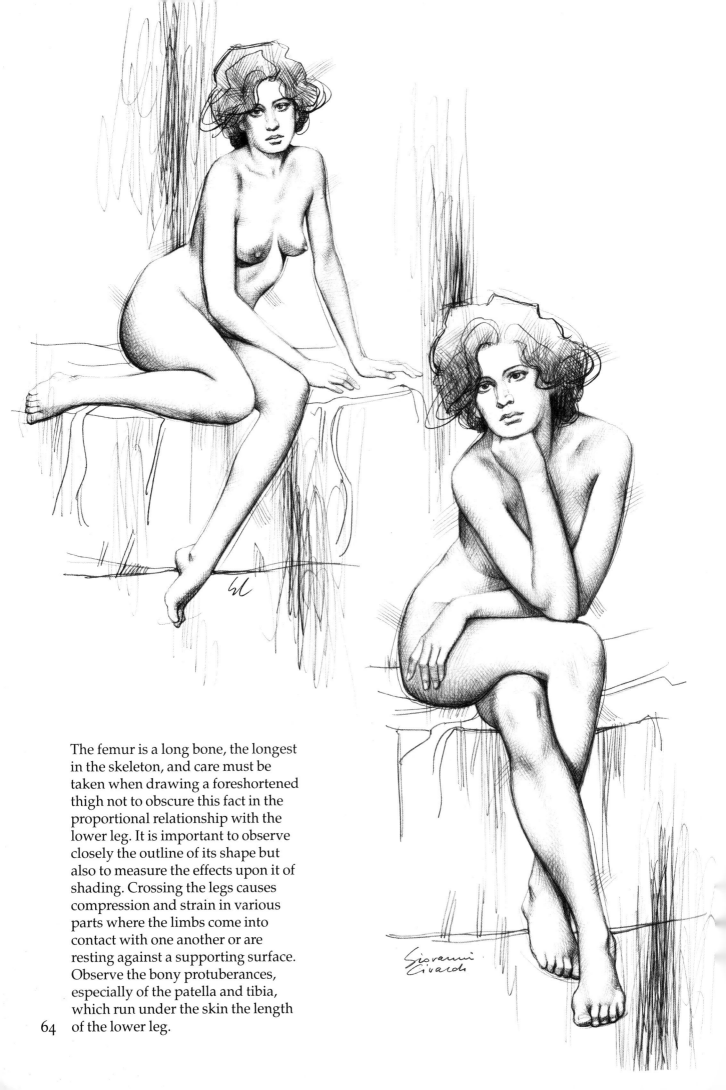

The femur is a long bone, the longest
in the skeleton, and care must be
taken when drawing a foreshortened
thigh not to obscure this fact in the
proportional relationship with the
lower leg. It is important to observe
closely the outline of its shape but
also to measure the effects upon it of
shading. Crossing the legs causes
compression and strain in various
parts where the limbs come into
contact with one another or are
resting against a supporting surface.
Observe the bony protuberances,
especially of the patella and tibia,
which run under the skin the length

64 of the lower leg.

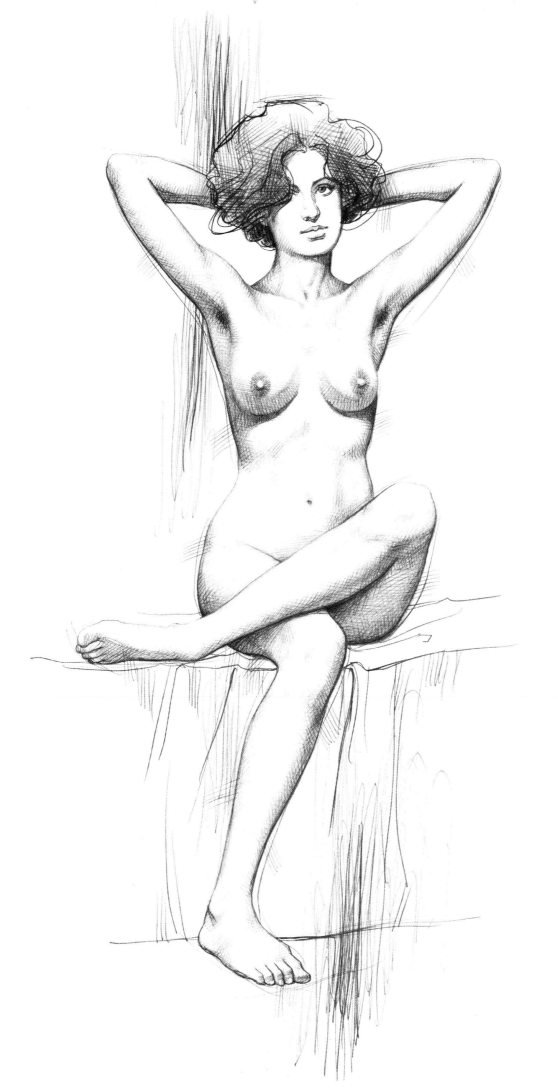

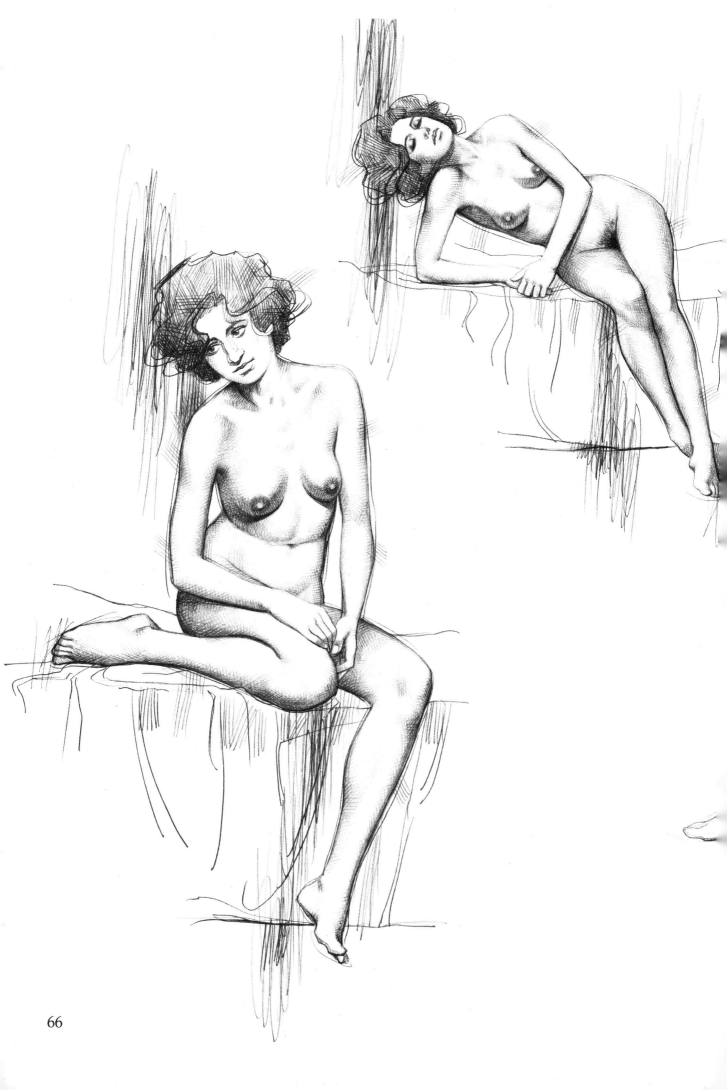

Here I suggest a few of the positions that are helpful to the study of the relationships of proportion and positioning of the upper and lower limbs. The model's pose is such that the limbs are arranged frontally, almost on the same plane, to avoid distortions arising from depth and perspective.

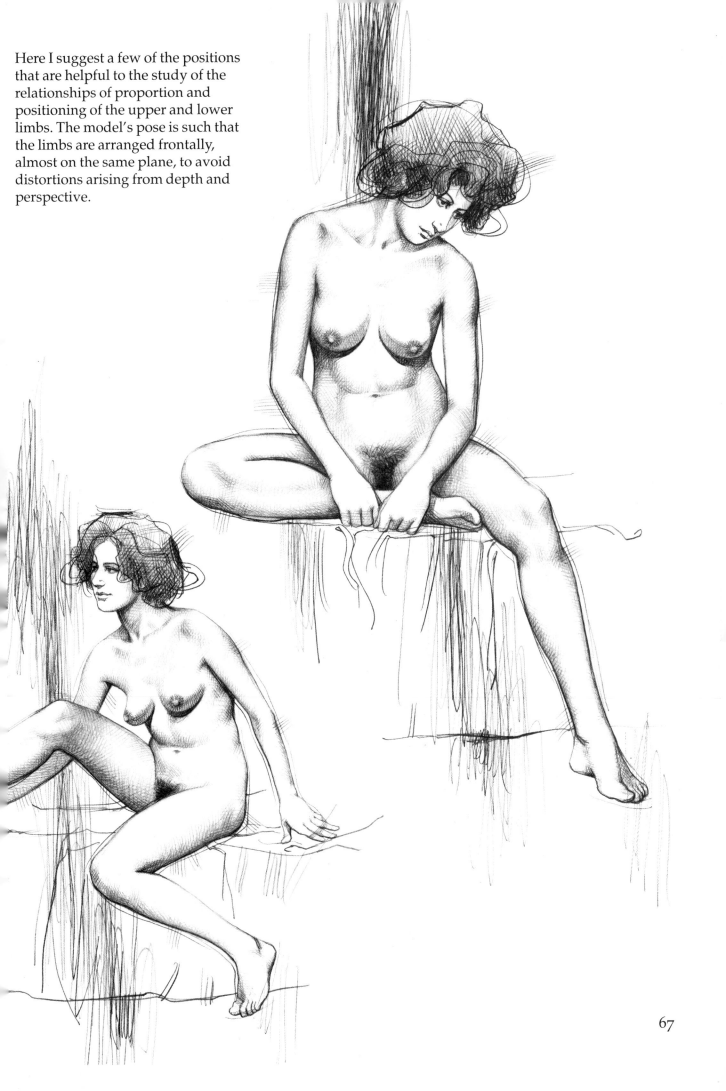

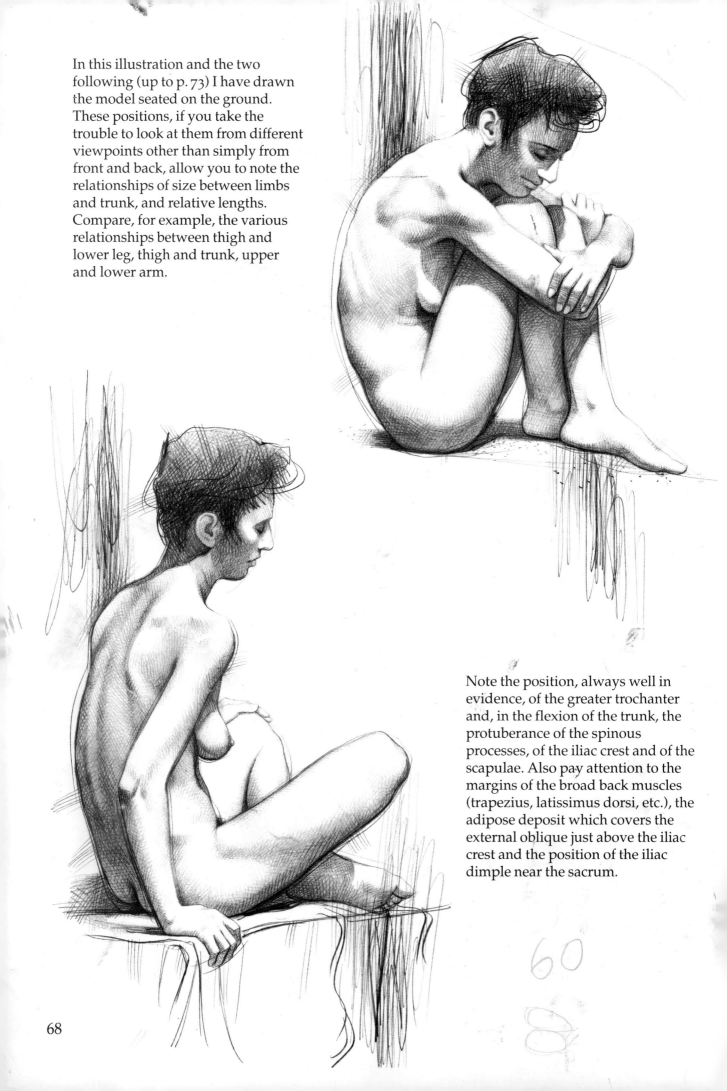

In this illustration and the two following (up to p. 73) I have drawn the model seated on the ground. These positions, if you take the trouble to look at them from different viewpoints other than simply from front and back, allow you to note the relationships of size between limbs and trunk, and relative lengths. Compare, for example, the various relationships between thigh and lower leg, thigh and trunk, upper and lower arm.

Note the position, always well in evidence, of the greater trochanter and, in the flexion of the trunk, the protuberance of the spinous processes, of the iliac crest and of the scapulae. Also pay attention to the margins of the broad back muscles (trapezius, latissimus dorsi, etc.), the adipose deposit which covers the external oblique just above the iliac crest and the position of the iliac dimple near the sacrum.

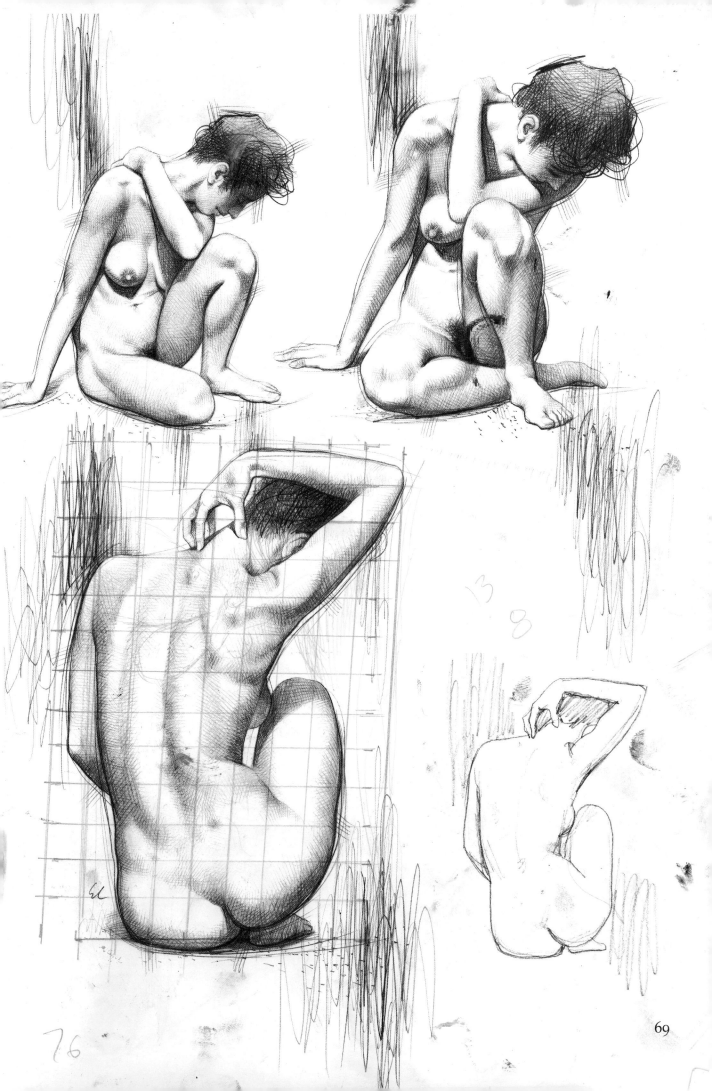

76

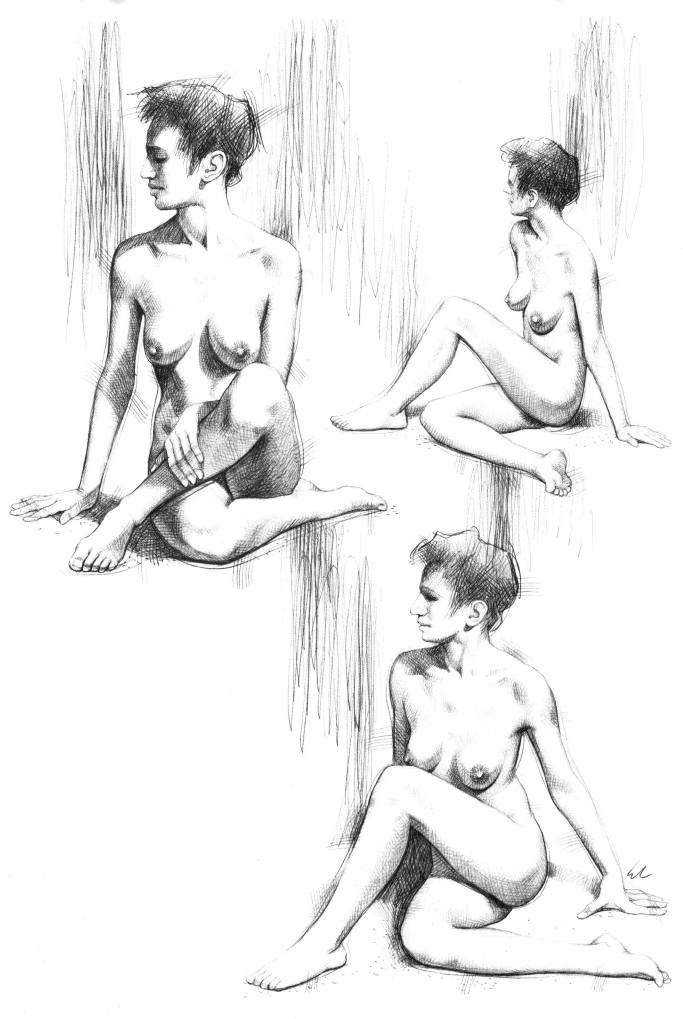

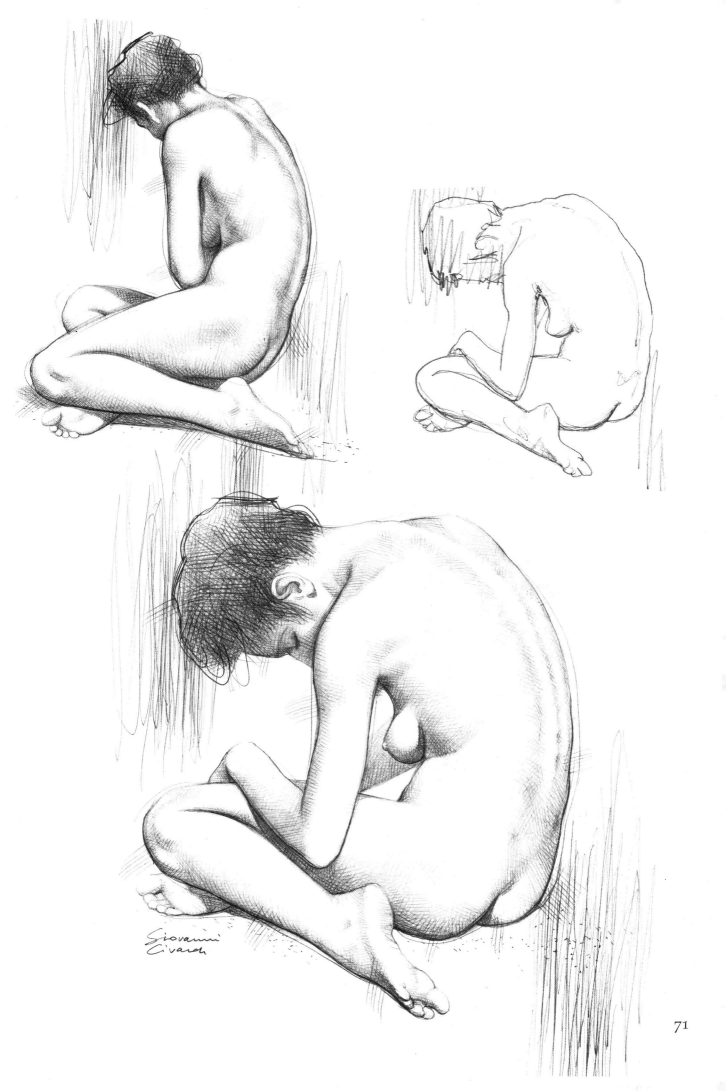

Giovanni
Civardi

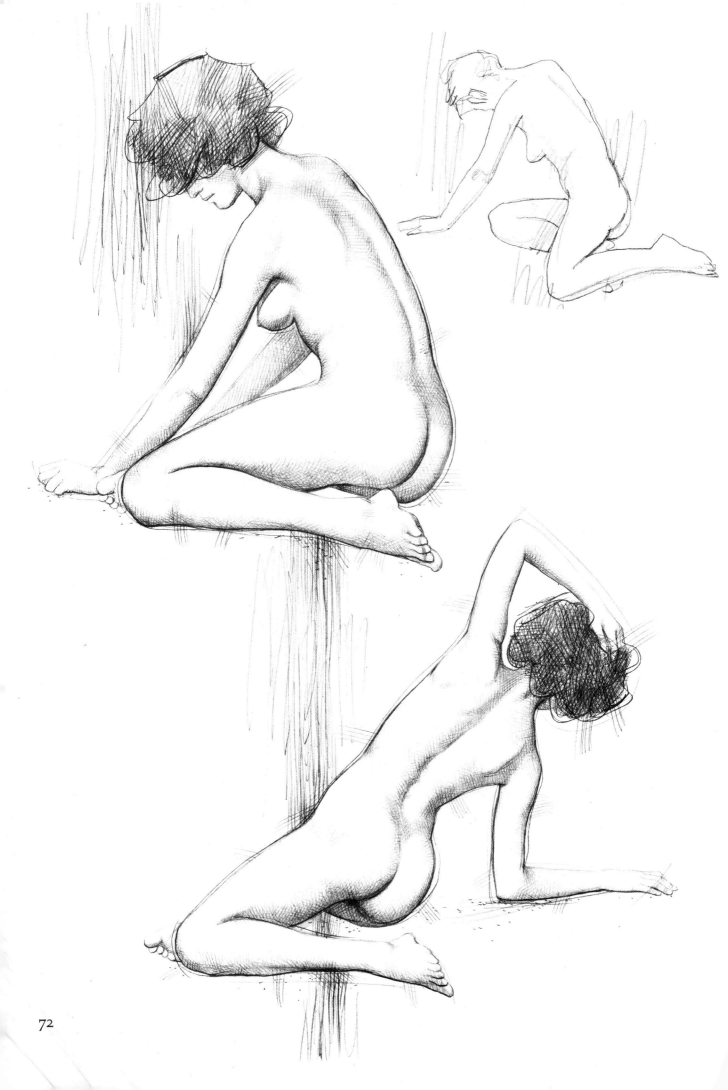

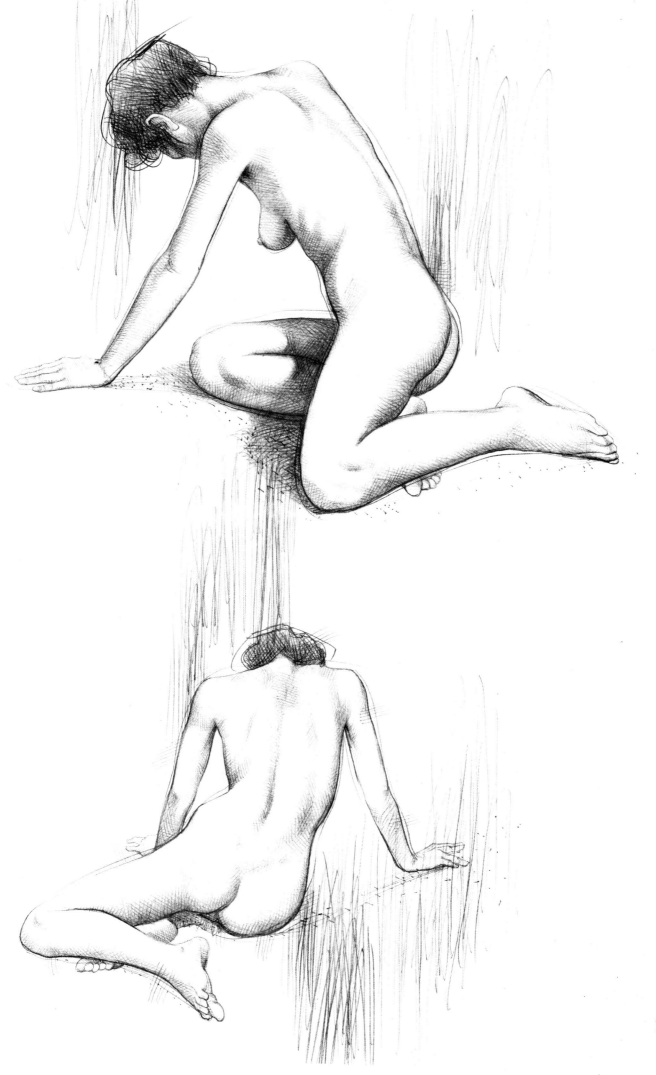

THE KNEELING FIGURE

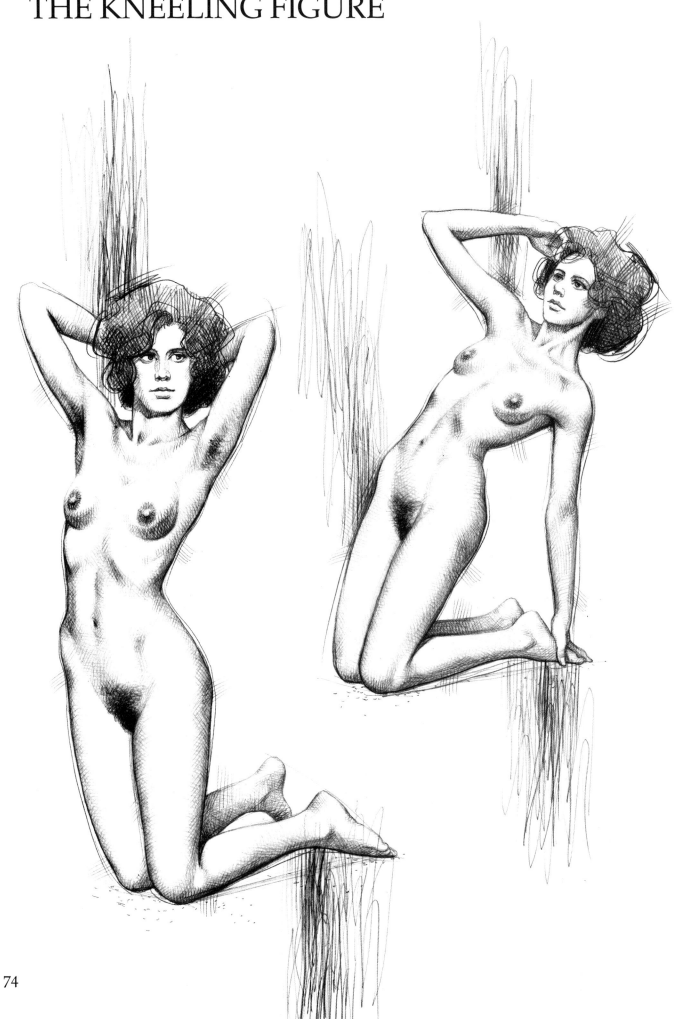

The body can assume various positions when kneeling: for example, the weight may fall on one or both knees; the model's trunk may be flexed, extended or rotated; the arms may balance the body or act as supports. In the drawings on these pages, note the contraction of the straight muscles of the abdomen (between which appears a slight longitudinal sulcus) and also of quadriceps femoris, notwithstanding the supporting action of the left arm. The navel appears slightly dilated, because the abdominal wall is stretched and is pressing against the internal fasciae and organs.

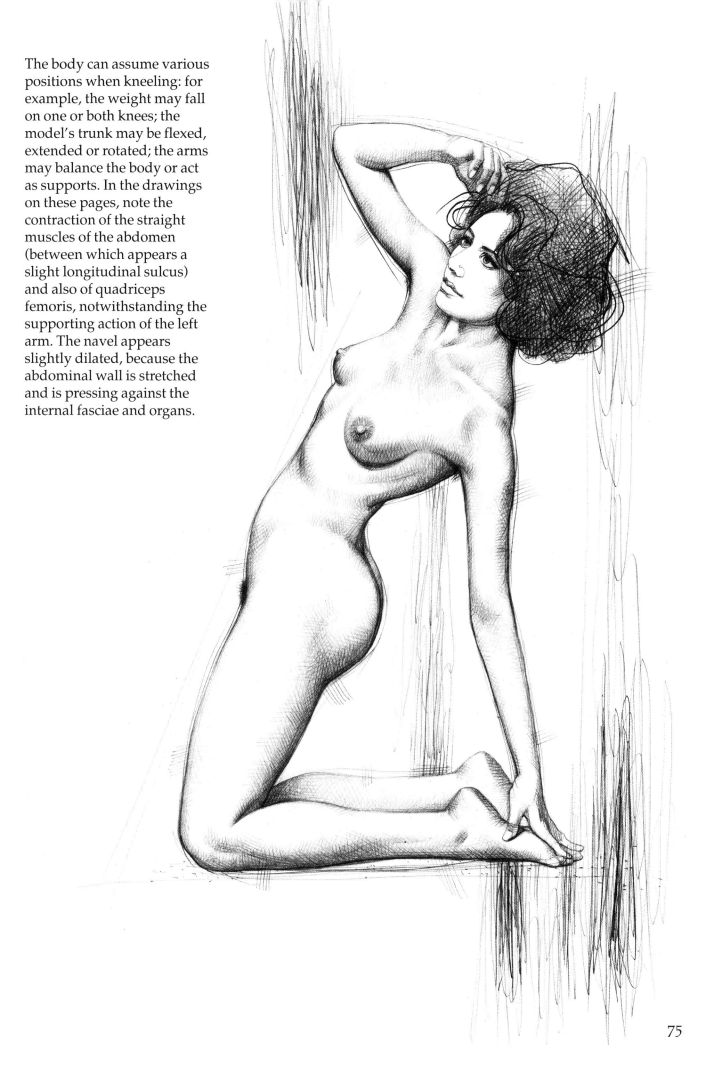

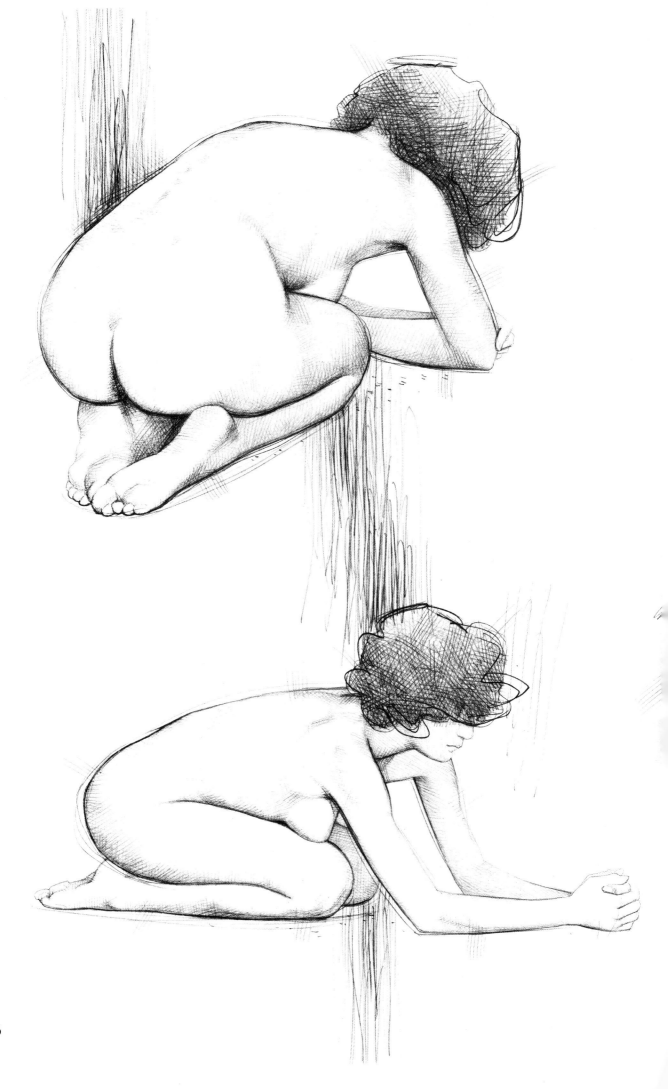

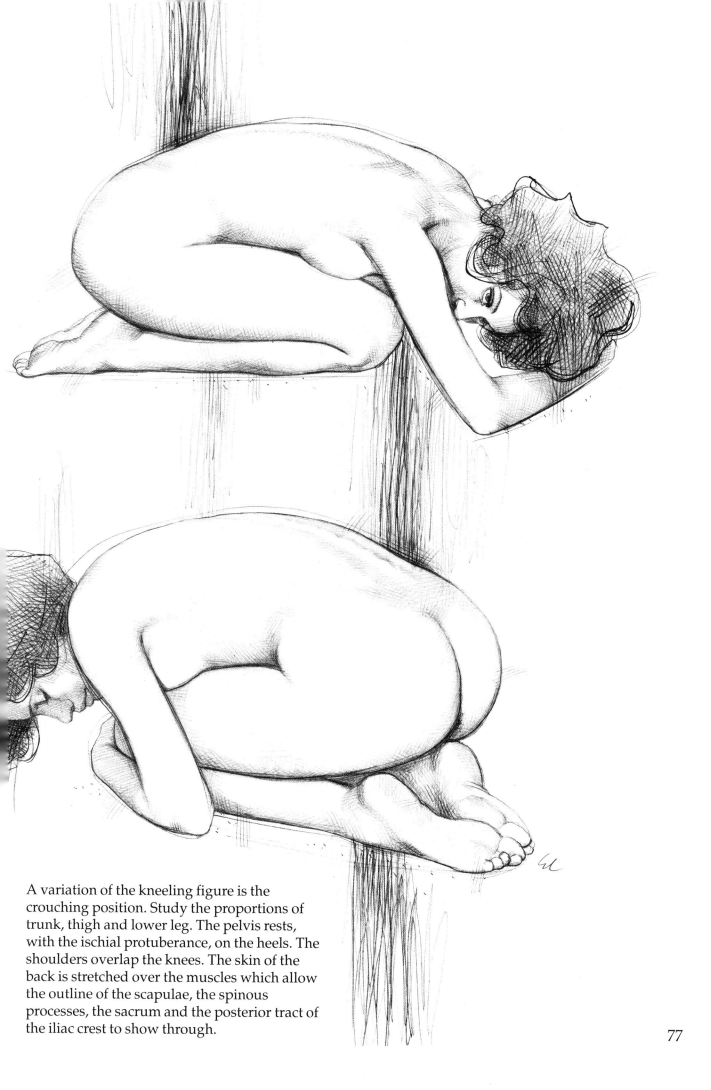

A variation of the kneeling figure is the
crouching position. Study the proportions of
trunk, thigh and lower leg. The pelvis rests,
with the ischial protuberance, on the heels. The
shoulders overlap the knees. The skin of the
back is stretched over the muscles which allow
the outline of the scapulae, the spinous
processes, the sacrum and the posterior tract of
the iliac crest to show through.

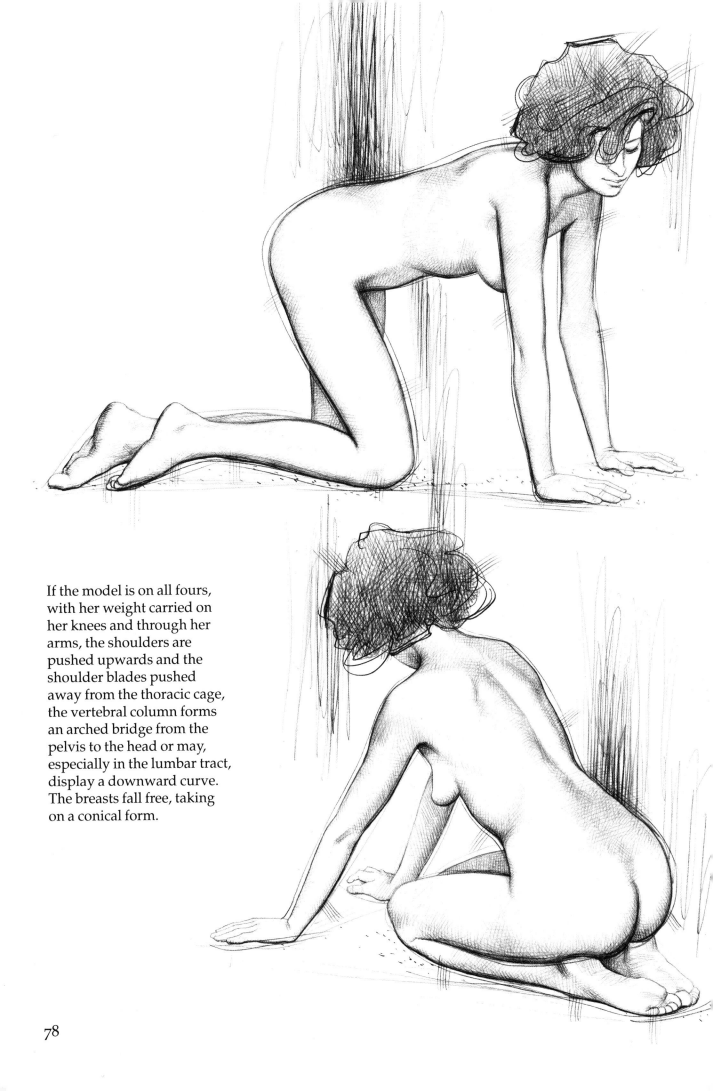

If the model is on all fours, with her weight carried on her knees and through her arms, the shoulders are pushed upwards and the shoulder blades pushed away from the thoracic cage, the vertebral column forms an arched bridge from the pelvis to the head or may, especially in the lumbar tract, display a downward curve. The breasts fall free, taking on a conical form.

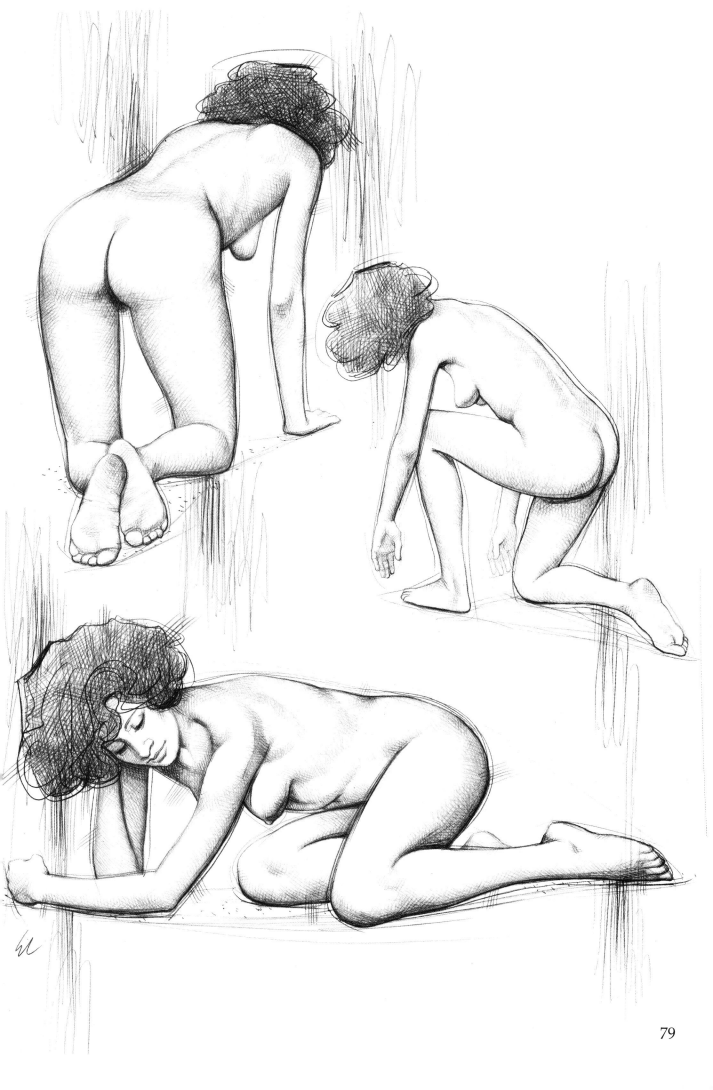

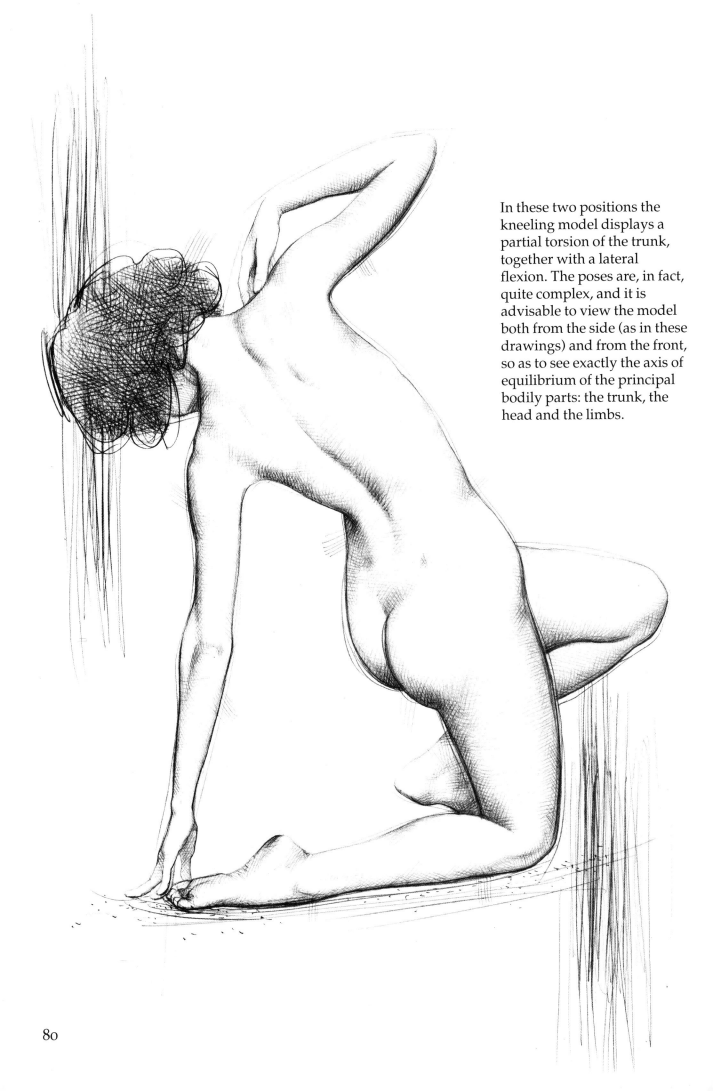

In these two positions the kneeling model displays a partial torsion of the trunk, together with a lateral flexion. The poses are, in fact, quite complex, and it is advisable to view the model both from the side (as in these drawings) and from the front, so as to see exactly the axis of equilibrium of the principal bodily parts: the trunk, the head and the limbs.

80

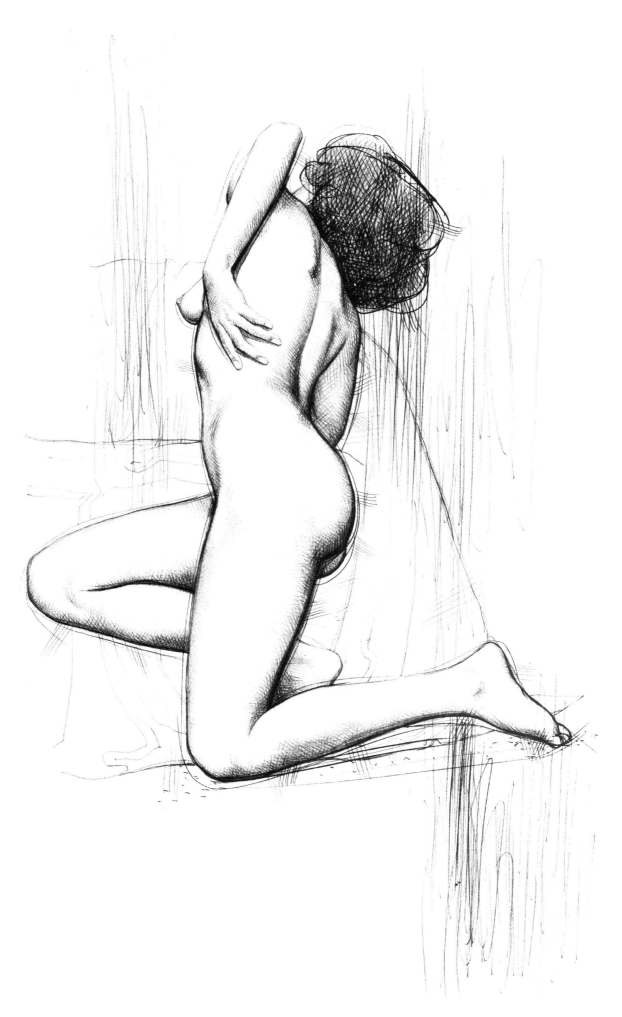

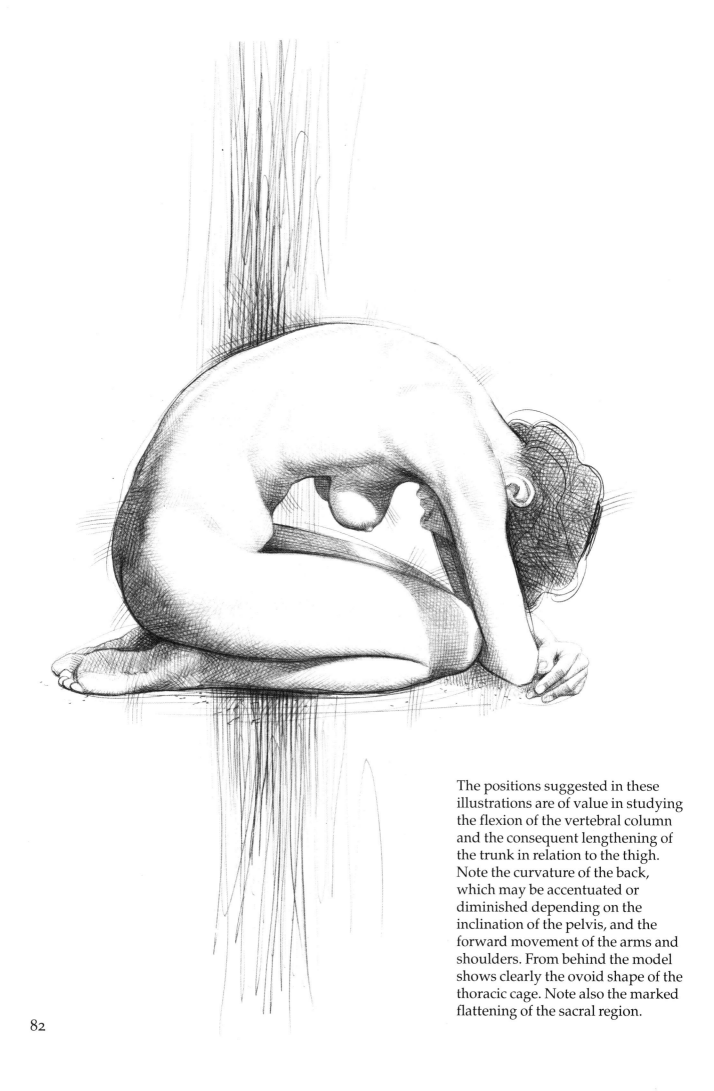

The positions suggested in these illustrations are of value in studying the flexion of the vertebral column and the consequent lengthening of the trunk in relation to the thigh. Note the curvature of the back, which may be accentuated or diminished depending on the inclination of the pelvis, and the forward movement of the arms and shoulders. From behind the model shows clearly the ovoid shape of the thoracic cage. Note also the marked flattening of the sacral region.

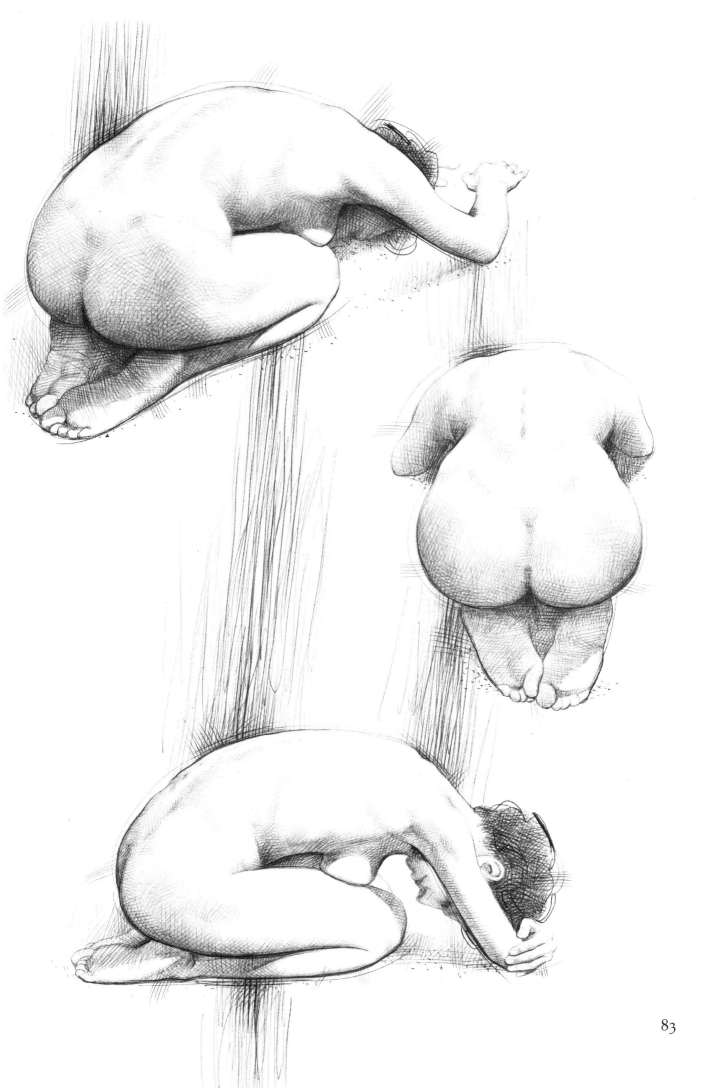

83

The left thigh is placed vertically and, the better to carry the weight, is held slightly towards the centre, accentuating the normal inclination of the axis of the femur. The hands and right foot, resting on the ground, support the chest and head. The breasts, when the trunk is leaning well forwards (in this case, almost horizontally), submit to the force of gravity and assume either a decidedly regular hemispherical or a conical form, according to the individual morphology. In the figure on the right, it is interesting to note the differing prominence of the shoulder blades, in relation to the position of the arms: the right is carrying the weight, and therefore the humerus, pressing on the glenoid cavity of the scapula, is pushing it away from the ribcage (against which, however, it is held by the latisissimus dorsi, rhomboid and subscapularis muscles); the left arm is doing nothing but maintaining the equilibrium and therefore the shoulder blade, not being called upon, remains close to the ribs following their curvature.

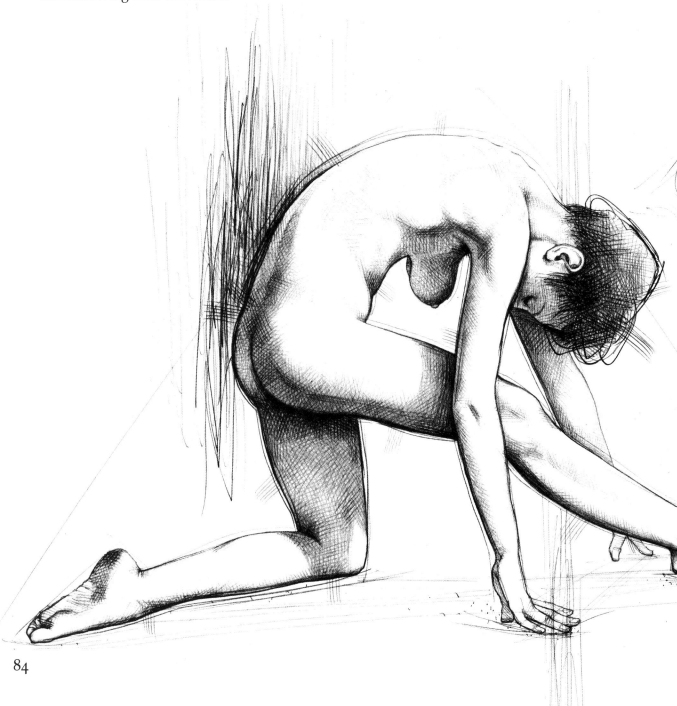

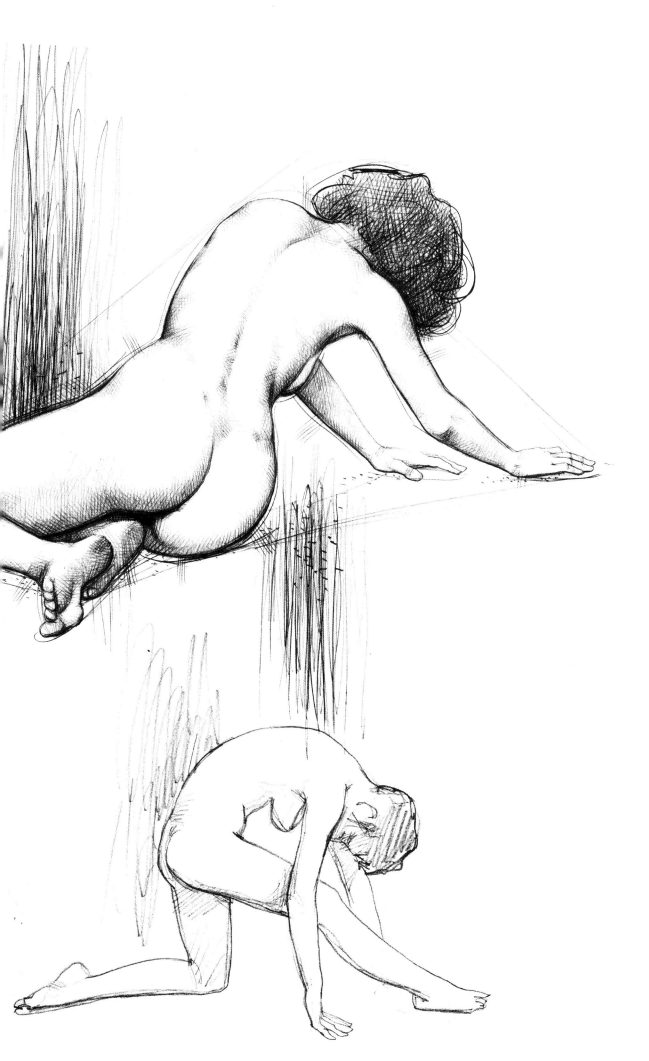

85

THE RECLINING AND OUTSTRETCHED FIGURE

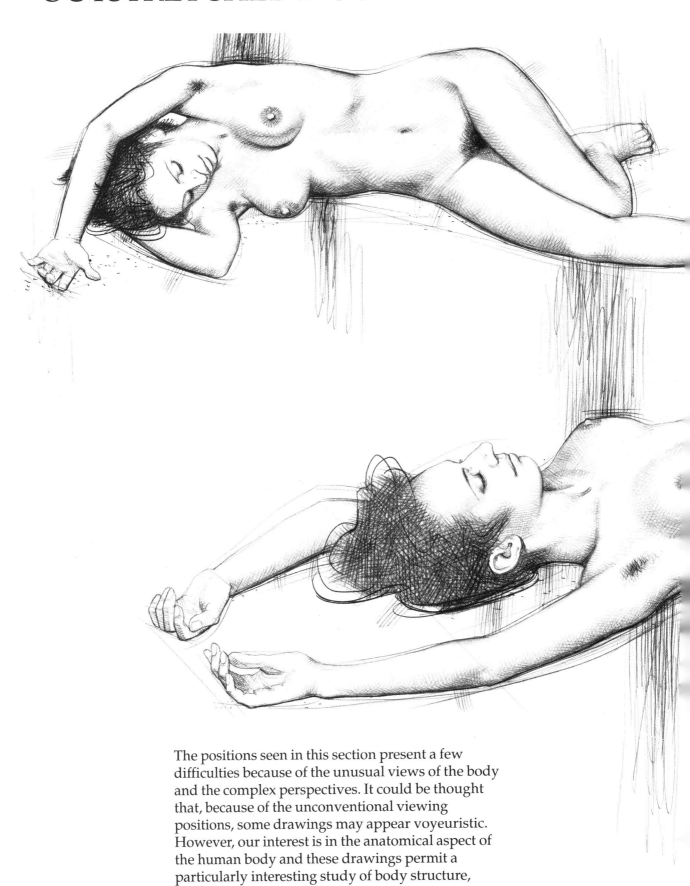

The positions seen in this section present a few difficulties because of the unusual views of the body and the complex perspectives. It could be thought that, because of the unconventional viewing positions, some drawings may appear voyeuristic. However, our interest is in the anatomical aspect of the human body and these drawings permit a particularly interesting study of body structure, especially of the skeletal system and also the morphology of the soft parts (muscle and adipose tissue) under the influence of gravity.

When the model lies on her back, the belly becomes hollow and flattens; the costal arch, the anterior iliac spine and the anterior portion of the iliac crest visibly stand out; the breasts widen and spread over the ribcage, in moderate hemispherical relief, tapering off towards the walls of the thorax. The model lying on one side shows the width of the pelvis and, on the free side, the iliac crest is prominent, as is the greater trochanter; the breasts, through the effects of gravity, become rounder towards the ground.

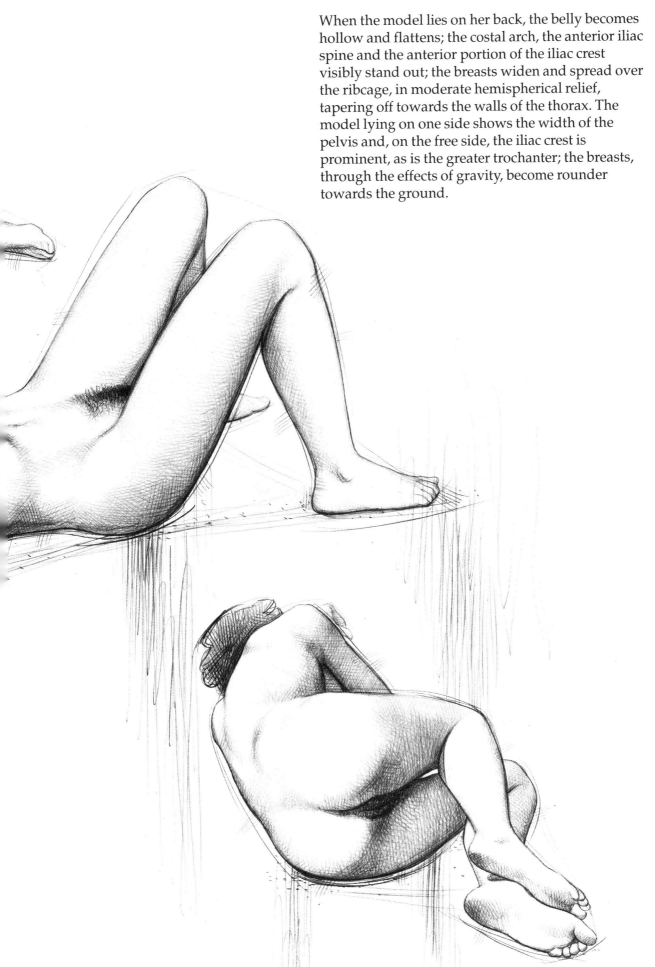

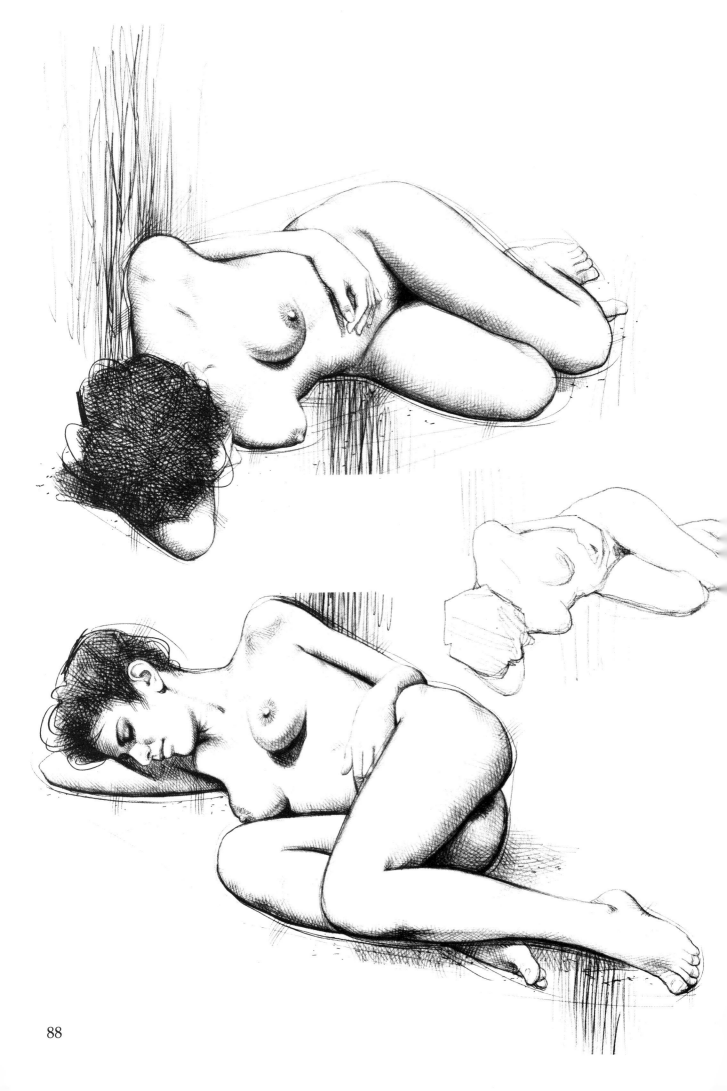

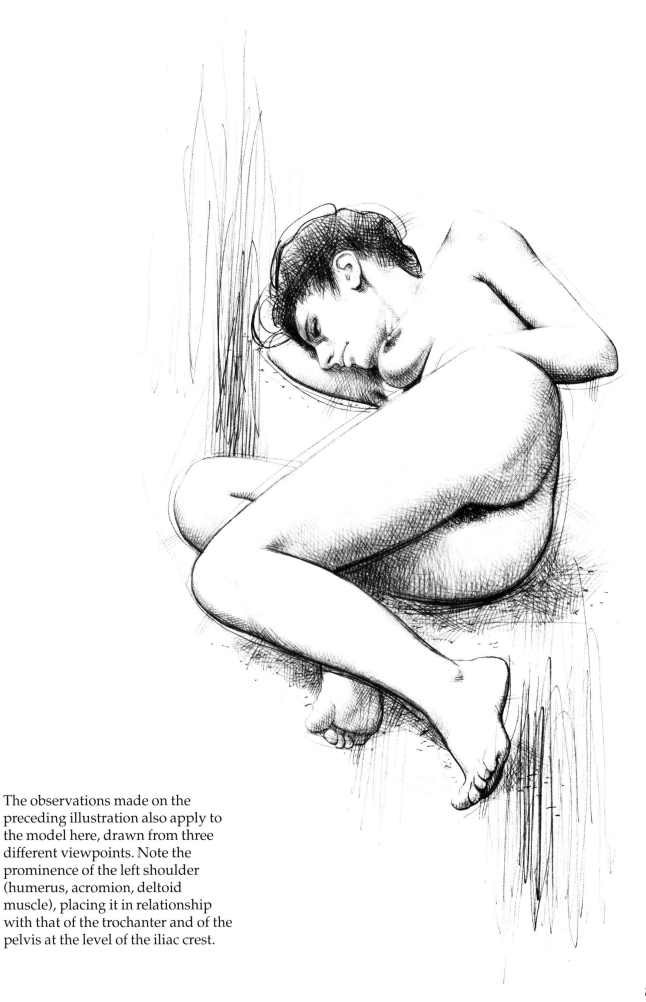

The observations made on the
preceding illustration also apply to
the model here, drawn from three
different viewpoints. Note the
prominence of the left shoulder
(humerus, acromion, deltoid
muscle), placing it in relationship
with that of the trochanter and of the
pelvis at the level of the iliac crest.

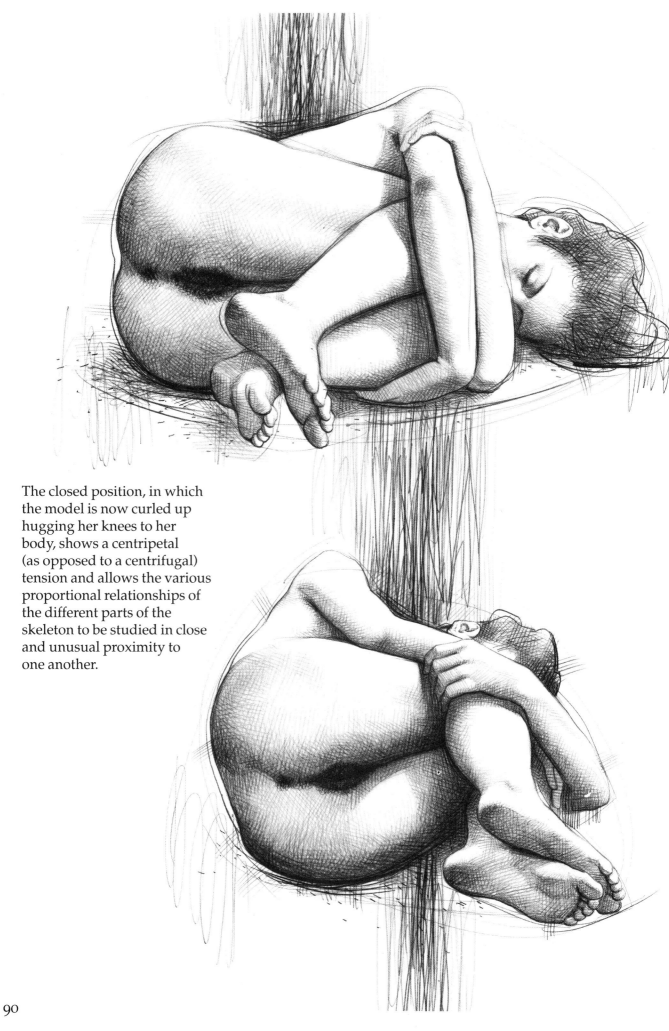

The closed position, in which the model is now curled up hugging her knees to her body, shows a centripetal (as opposed to a centrifugal) tension and allows the various proportional relationships of the different parts of the skeleton to be studied in close and unusual proximity to one another.

Note how the parts of the body in contact with the floor flatten and adjust themselves to it.

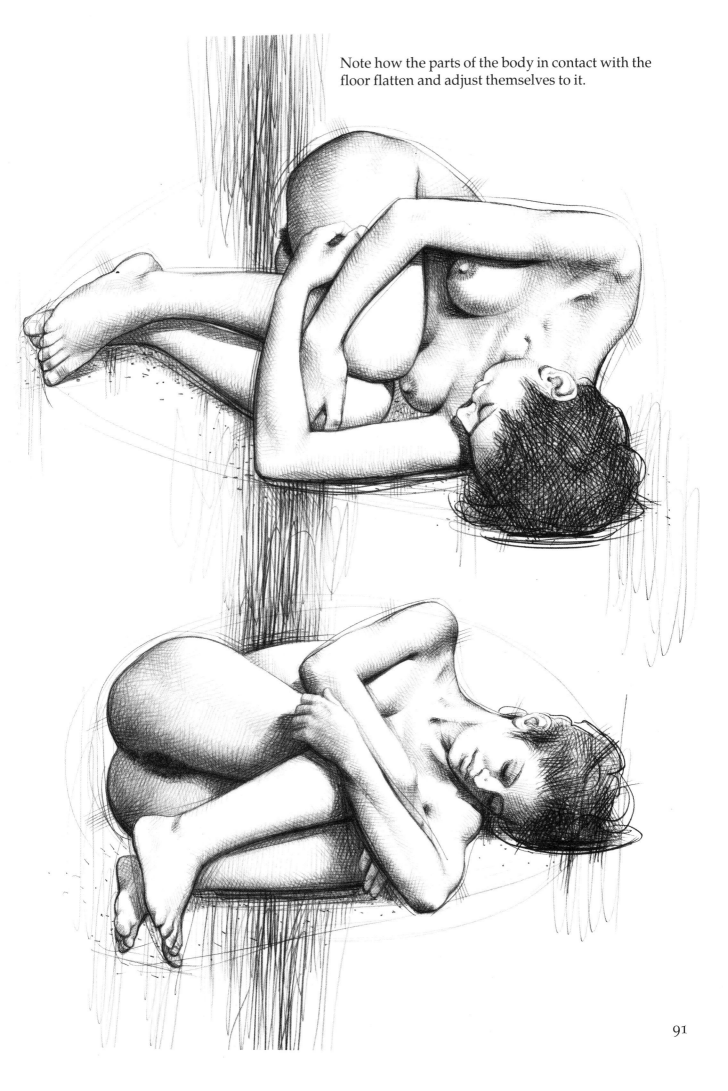

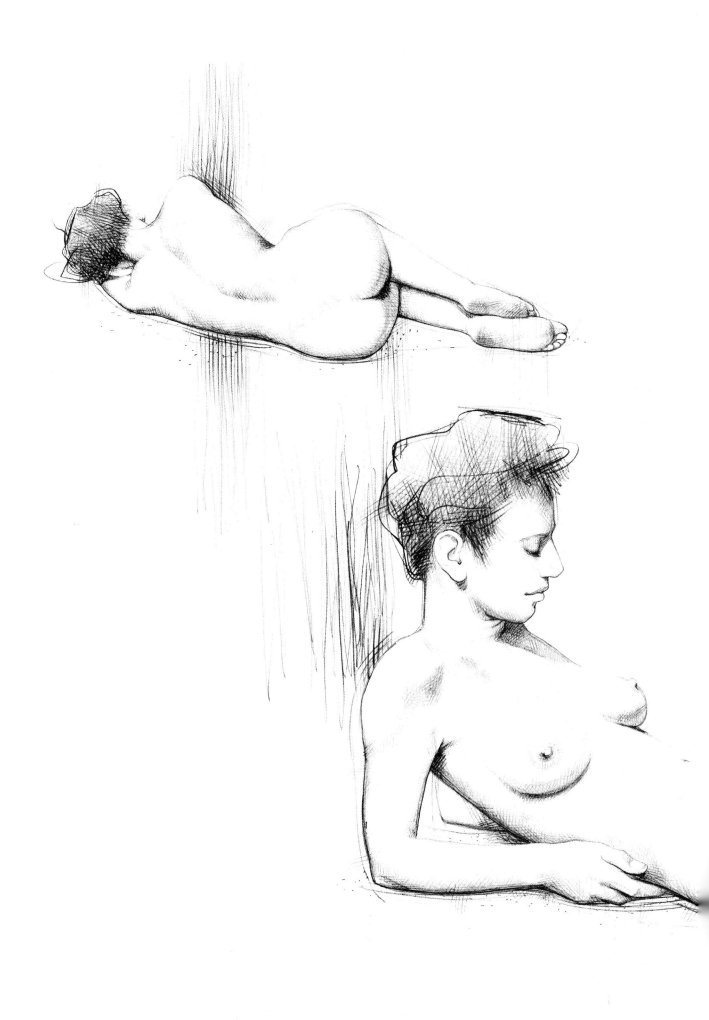

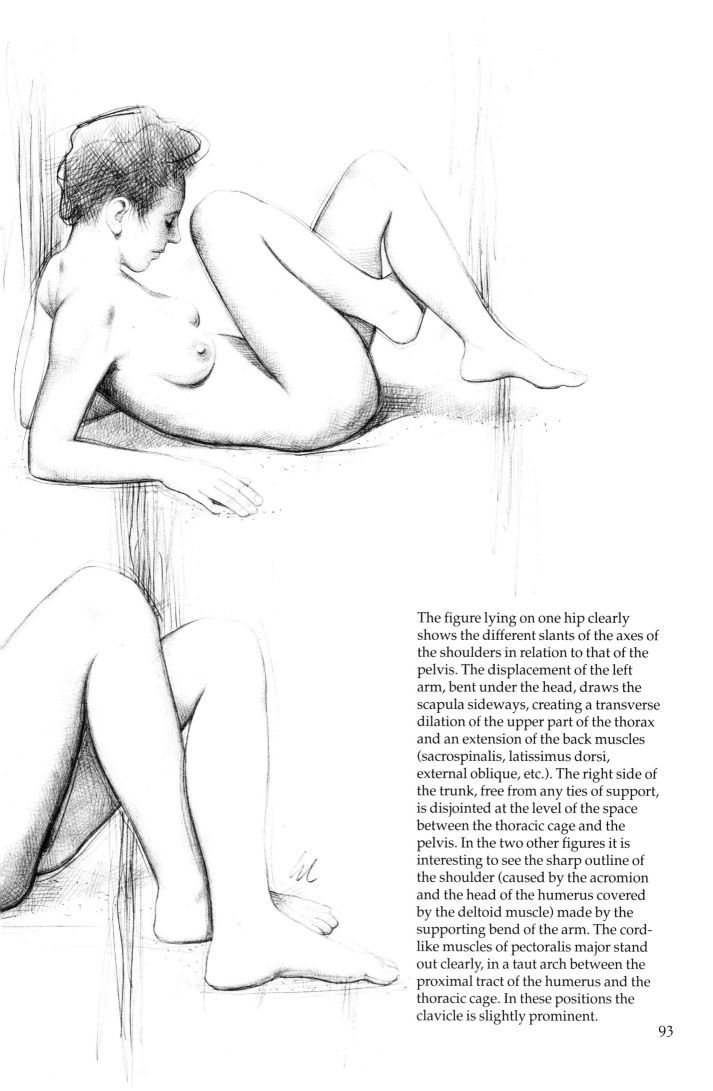

The figure lying on one hip clearly shows the different slants of the axes of the shoulders in relation to that of the pelvis. The displacement of the left arm, bent under the head, draws the scapula sideways, creating a transverse dilation of the upper part of the thorax and an extension of the back muscles (sacrospinalis, latissimus dorsi, external oblique, etc.). The right side of the trunk, free from any ties of support, is disjointed at the level of the space between the thoracic cage and the pelvis. In the two other figures it is interesting to see the sharp outline of the shoulder (caused by the acromion and the head of the humerus covered by the deltoid muscle) made by the supporting bend of the arm. The cord-like muscles of pectoralis major stand out clearly, in a taut arch between the proximal tract of the humerus and the thoracic cage. In these positions the clavicle is slightly prominent.

93

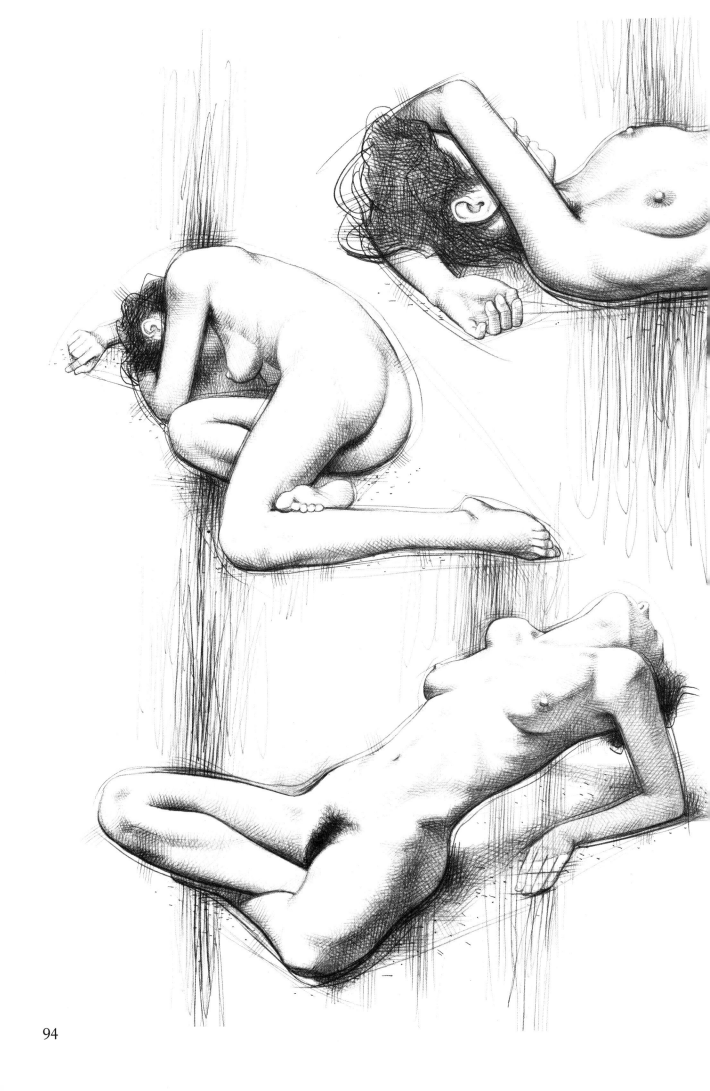

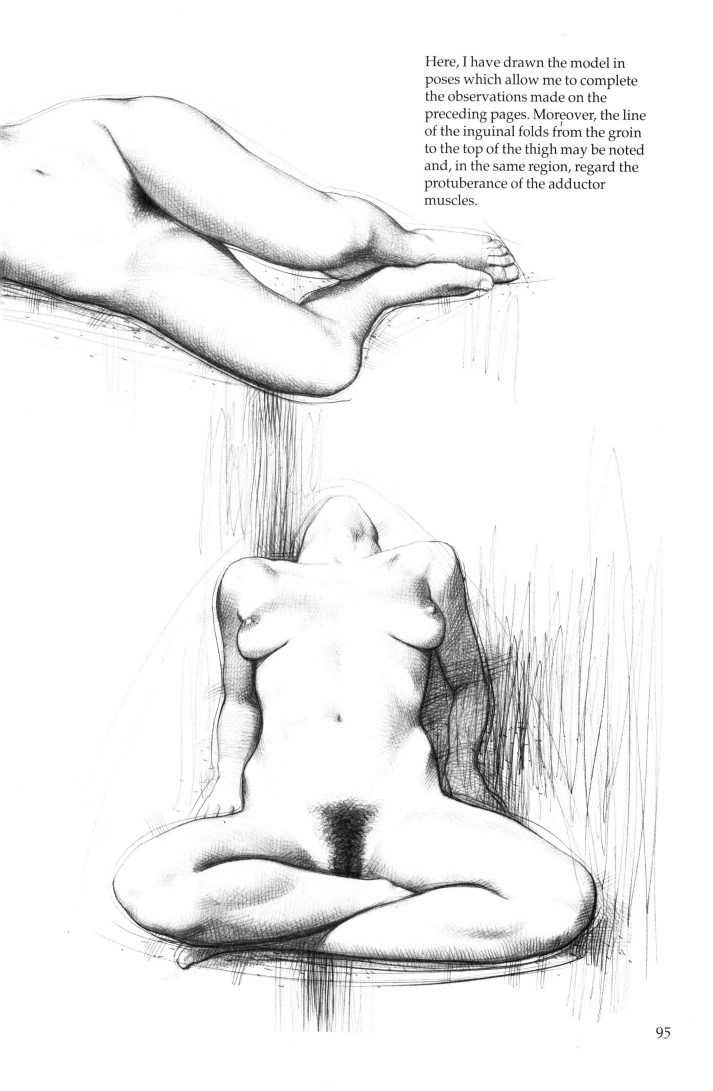

Here, I have drawn the model in poses which allow me to complete the observations made on the preceding pages. Moreover, the line of the inguinal folds from the groin to the top of the thigh may be noted and, in the same region, regard the protuberance of the adductor muscles.

When the body is outstretched it can
naturally take up spontaneous
positions in which the torsion of the
trunk is very accentuated, sometimes
to the limit of the articular process.
Observe, at the sides of the knee
when the limb is partially flexed, the
cord-like protrusion of the tendons
of insertion of biceps femoris
(stretched laterally between the
hip joint and the fibula) and the
semitendinosus muscle (stretched
medially between the hip joint
and the tibia).

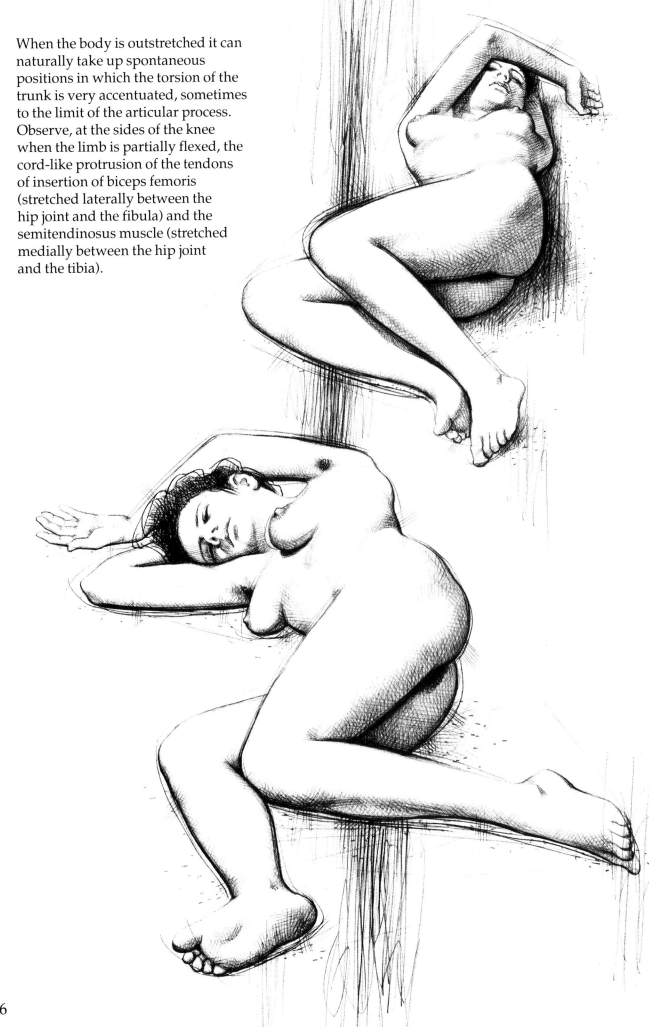

If the thighs are spread apart the adductor muscles (a group of muscles originating in the hip and inserted in the femur), which draw the thigh towards the medial plane, are much in evidence. If the thigh is sharply flexed against the body, one can sometimes see, if the model is thin enough, the hip bone showing, lightly covered by the muscles of gluteus maximus (buttock).

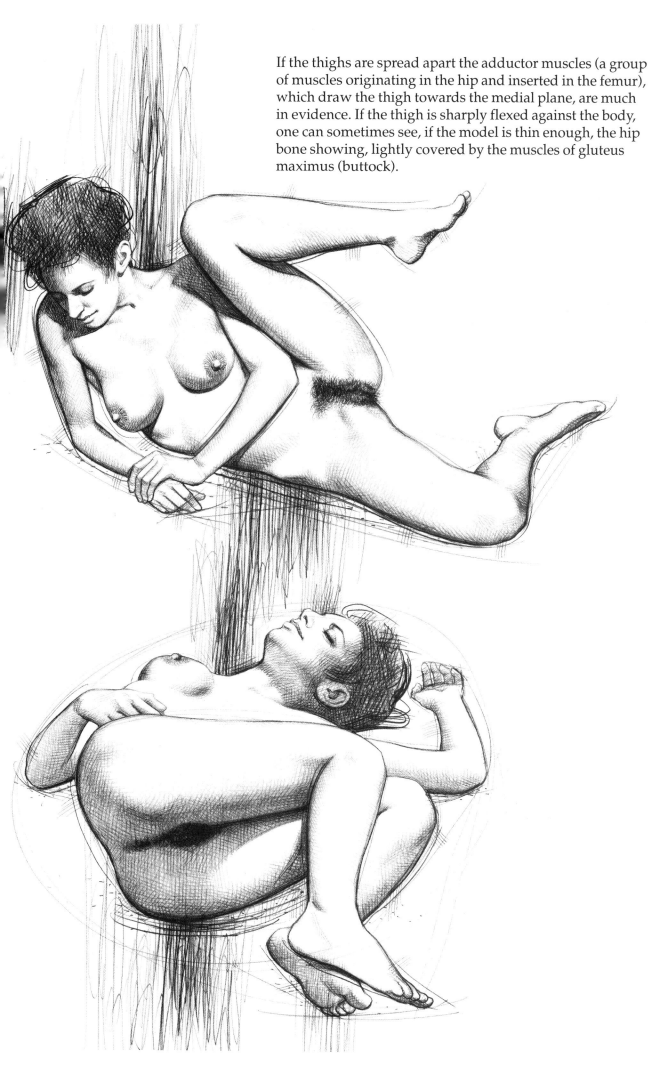

97

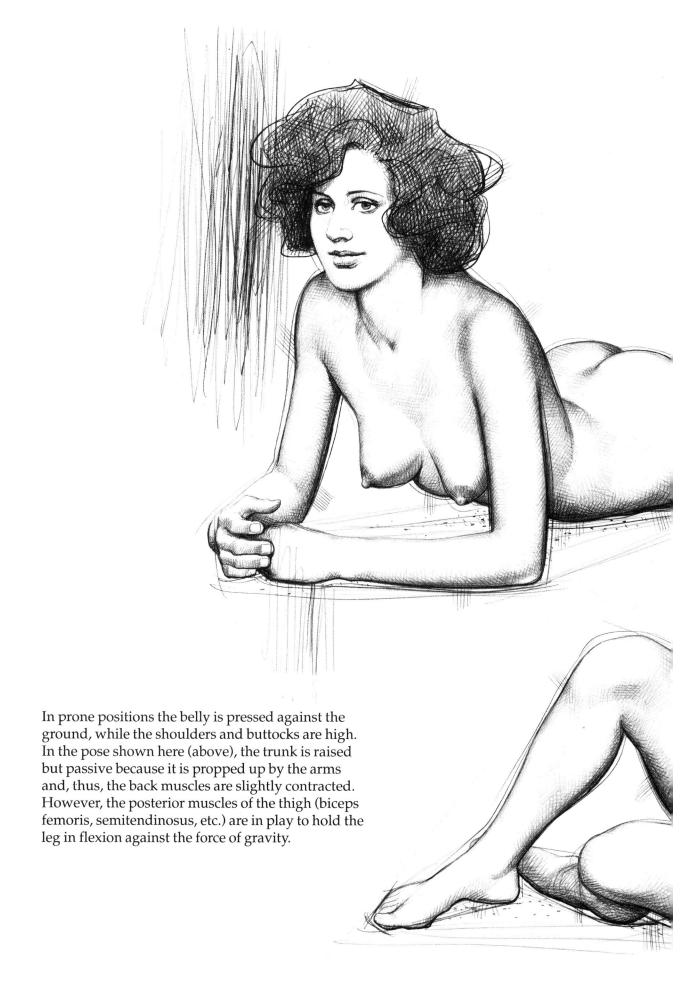

In prone positions the belly is pressed against the ground, while the shoulders and buttocks are high. In the pose shown here (above), the trunk is raised but passive because it is propped up by the arms and, thus, the back muscles are slightly contracted. However, the posterior muscles of the thigh (biceps femoris, semitendinosus, etc.) are in play to hold the leg in flexion against the force of gravity.

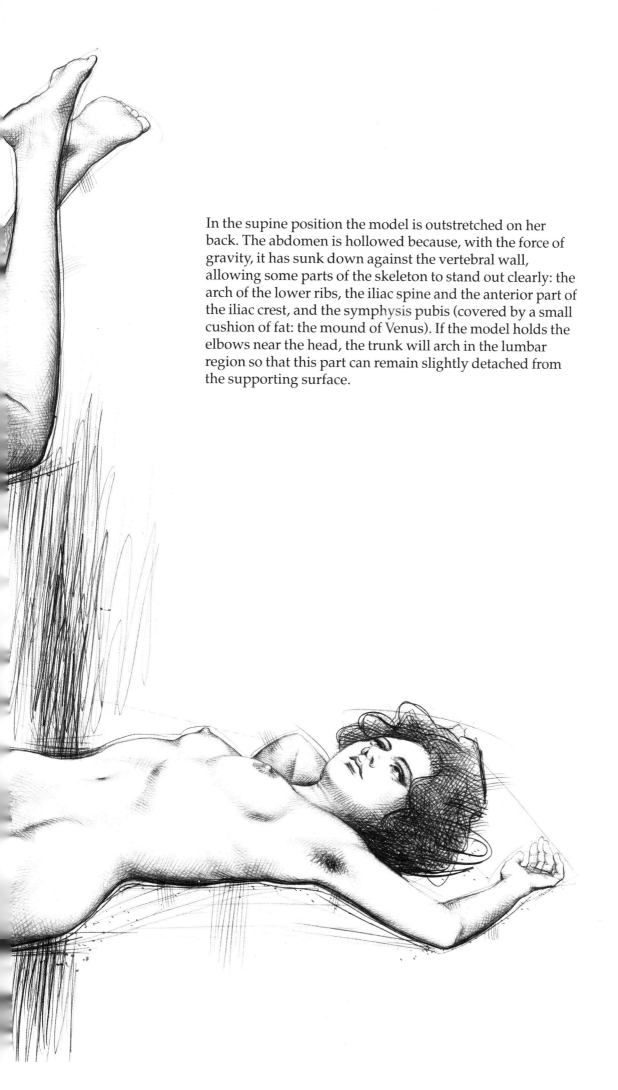

In the supine position the model is outstretched on her back. The abdomen is hollowed because, with the force of gravity, it has sunk down against the vertebral wall, allowing some parts of the skeleton to stand out clearly: the arch of the lower ribs, the iliac spine and the anterior part of the iliac crest, and the symphysis pubis (covered by a small cushion of fat: the mound of Venus). If the model holds the elbows near the head, the trunk will arch in the lumbar region so that this part can remain slightly detached from the supporting surface.

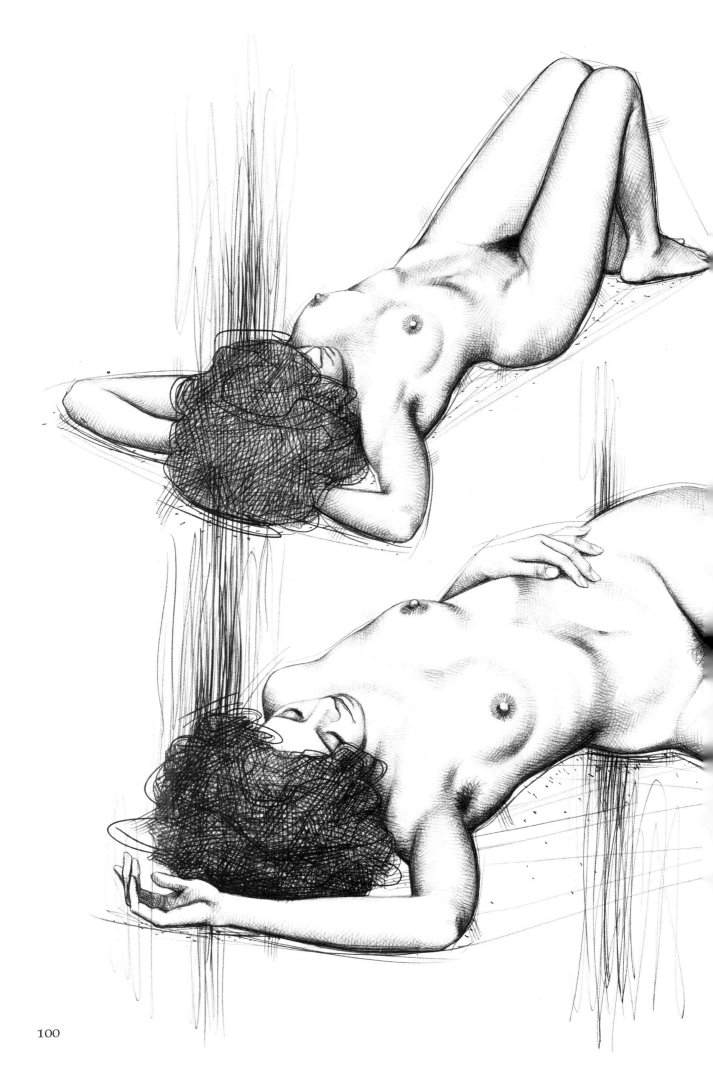

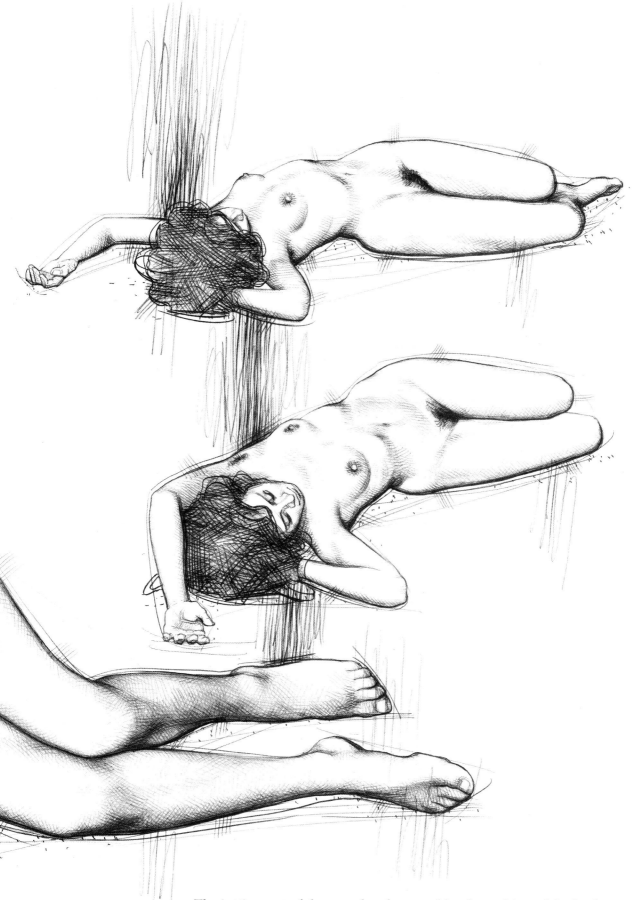

The jutting out of the costal arch caused by the arching of the back, to which some allusion was made in the preceding illustration, is seen clearly in the sketches on these pages. Observe the relationships between the ovoidal mass of the thoracic cage (the greater longitudinal diameter) and the ovoidal mass of the pelvis (the greater transverse diameter), skeletally connected only by the lumbar section of the vertebral column and turning in various degrees.

With the model holding the poses shown here, you can see the effects of torsion on the trunk. In these cases also it is the bony protuberances that above all merit attention, because the muscles, in the female body, are not much in evidence and in these positions not active. Rather, it is important to distinguish conformation due to muscle tissue from that attributable to fatty tissue. These fatty deposits, although slight, are found in certain areas in women: the breasts, the outer side and back of the arm, the buttocks, the top of the thighs, the back of the neck (dowager's hump), etc. If the figure is arranged in depth and perhaps, to be drawn, requires a gradation of perspective, it may be effective to accentuate the dimensions and definition of the parts in the foreground, for example, in the two studies below, the feet, the legs and the left knee.

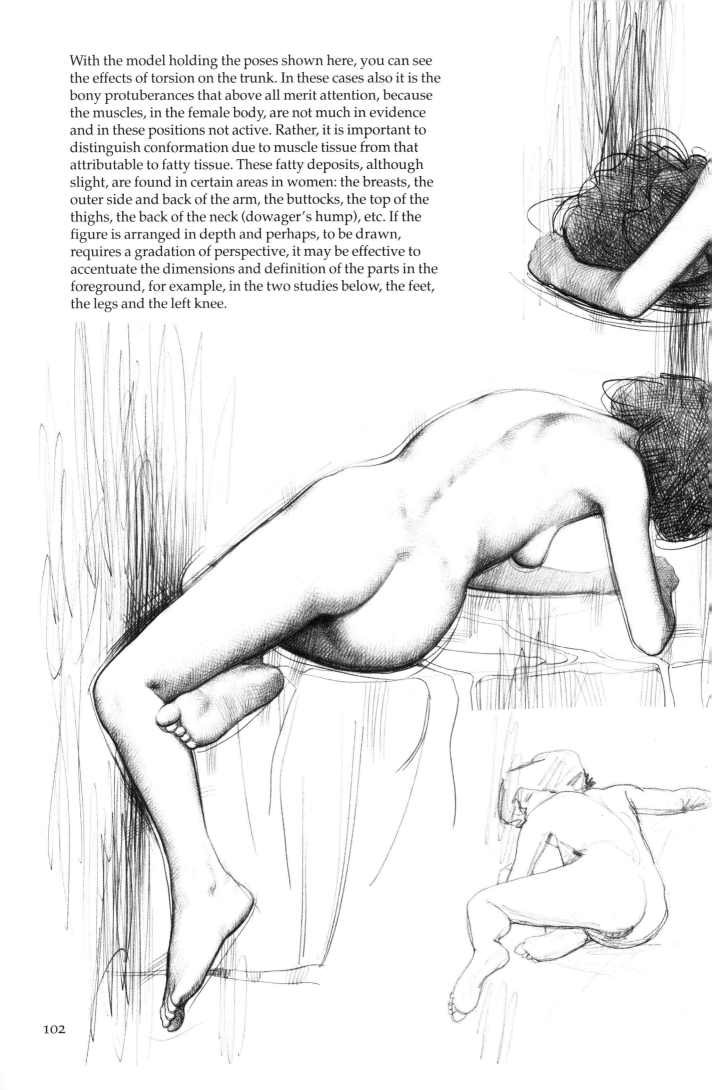

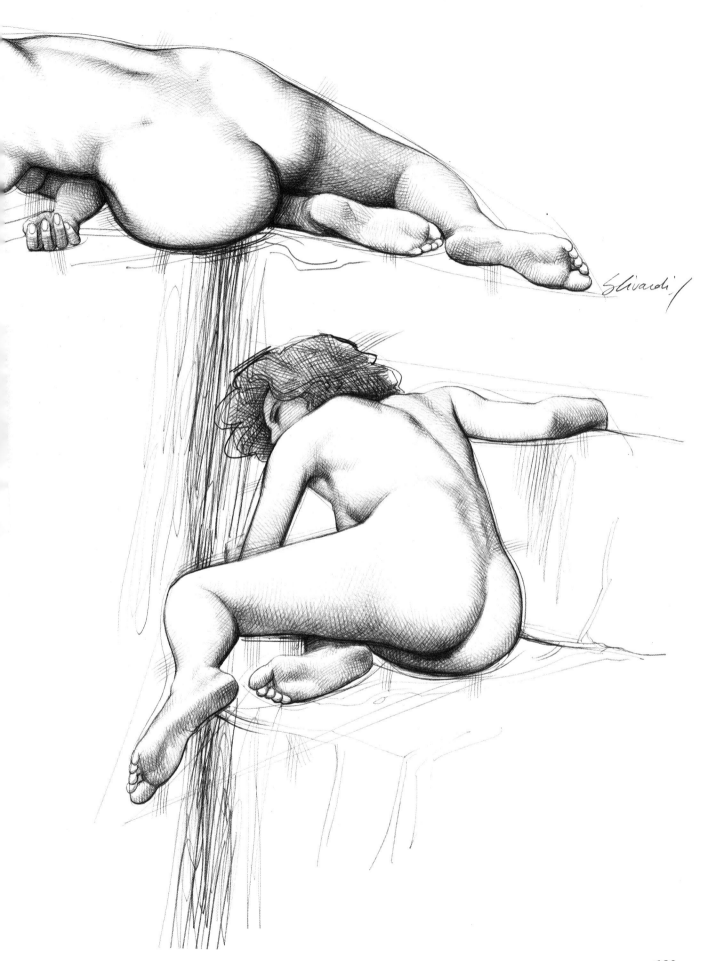

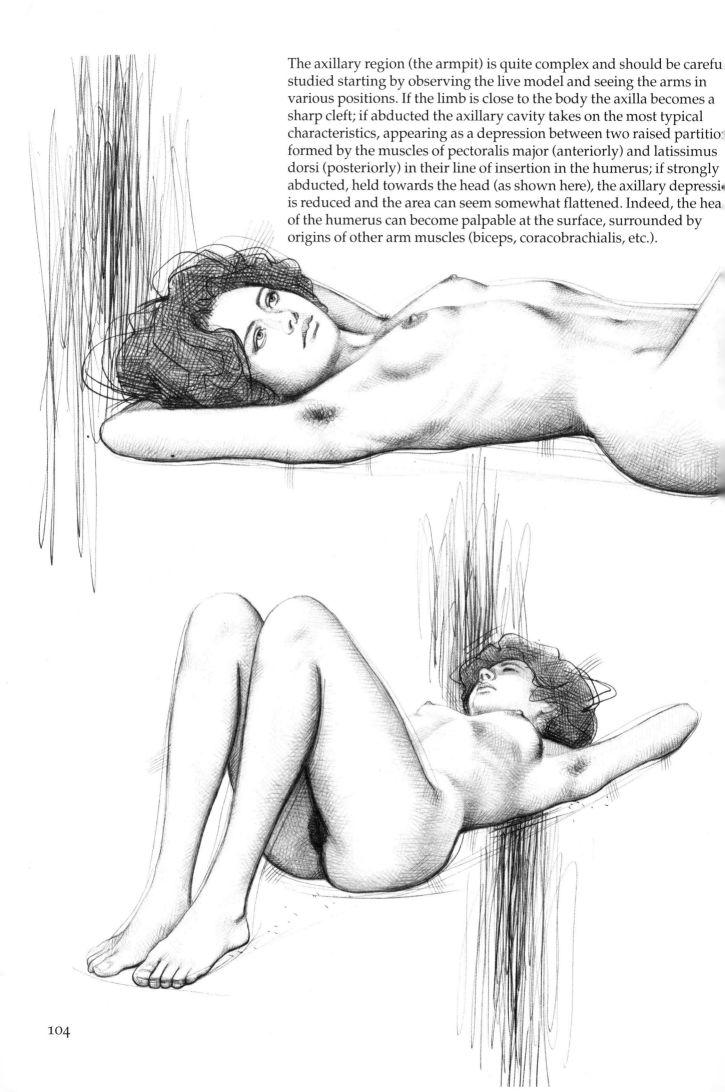

The axillary region (the armpit) is quite complex and should be carefu
studied starting by observing the live model and seeing the arms in
various positions. If the limb is close to the body the axilla becomes a
sharp cleft; if abducted the axillary cavity takes on the most typical
characteristics, appearing as a depression between two raised partitio
formed by the muscles of pectoralis major (anteriorly) and latissimus
dorsi (posteriorly) in their line of insertion in the humerus; if strongly
abducted, held towards the head (as shown here), the axillary depressi
is reduced and the area can seem somewhat flattened. Indeed, the hea
of the humerus can become palpable at the surface, surrounded by
origins of other arm muscles (biceps, coracobrachialis, etc.).

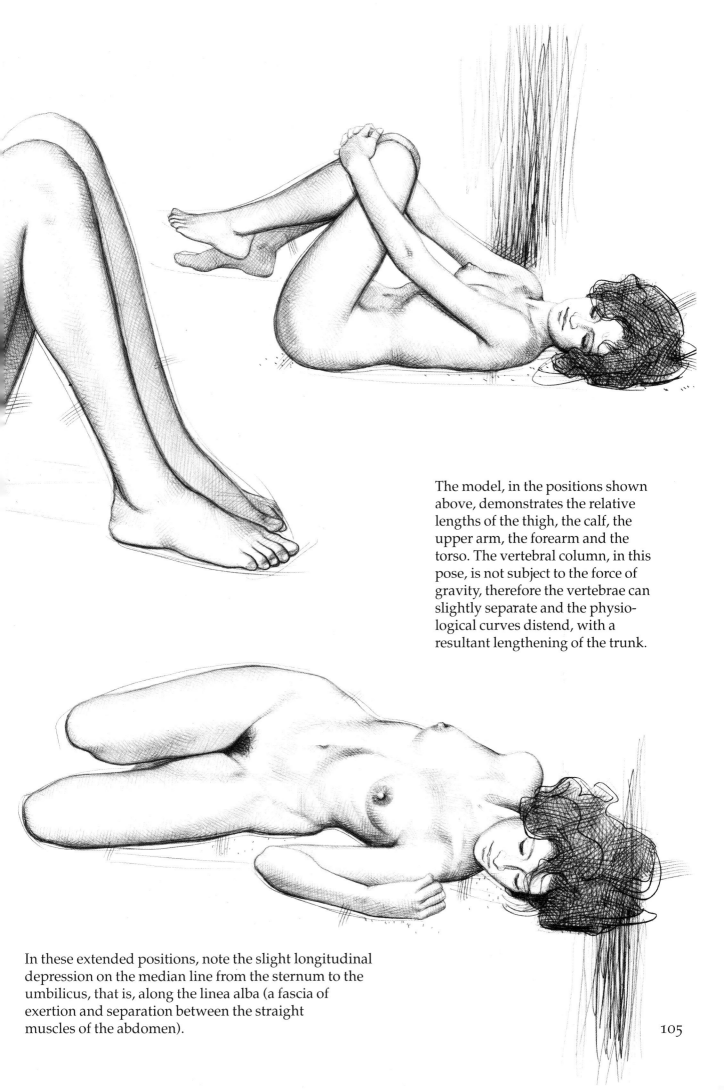

The model, in the positions shown above, demonstrates the relative lengths of the thigh, the calf, the upper arm, the forearm and the torso. The vertebral column, in this pose, is not subject to the force of gravity, therefore the vertebrae can slightly separate and the physiological curves distend, with a resultant lengthening of the trunk.

In these extended positions, note the slight longitudinal depression on the median line from the sternum to the umbilicus, that is, along the linea alba (a fascia of exertion and separation between the straight muscles of the abdomen).

105

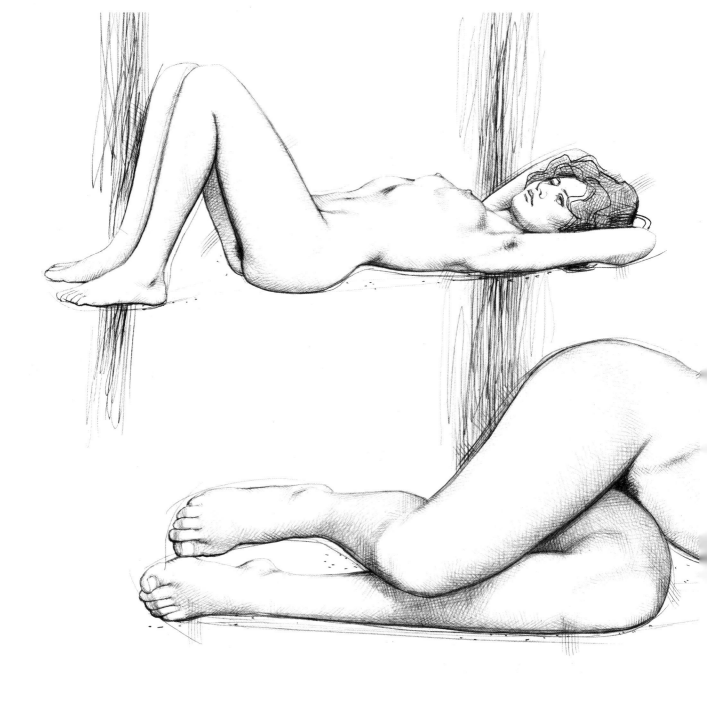

Contrary to what happens in a supine position (in which it sinks inwards), the belly, when the model is partially prone or lying on one side, now slightly protrudes, held only by the fasciae and abdominal muscles. The right flank, in the two illustrations here (centre and right), shows slightly emphasized hollows because, in this position, the small panniculus of fat covering the external obliques joins the iliac crest at the lateral wall of the trunk. Note the rigid angulation of the elbows and knees, which are made up of bony structures and mostly subcutaneous tendinous formations.

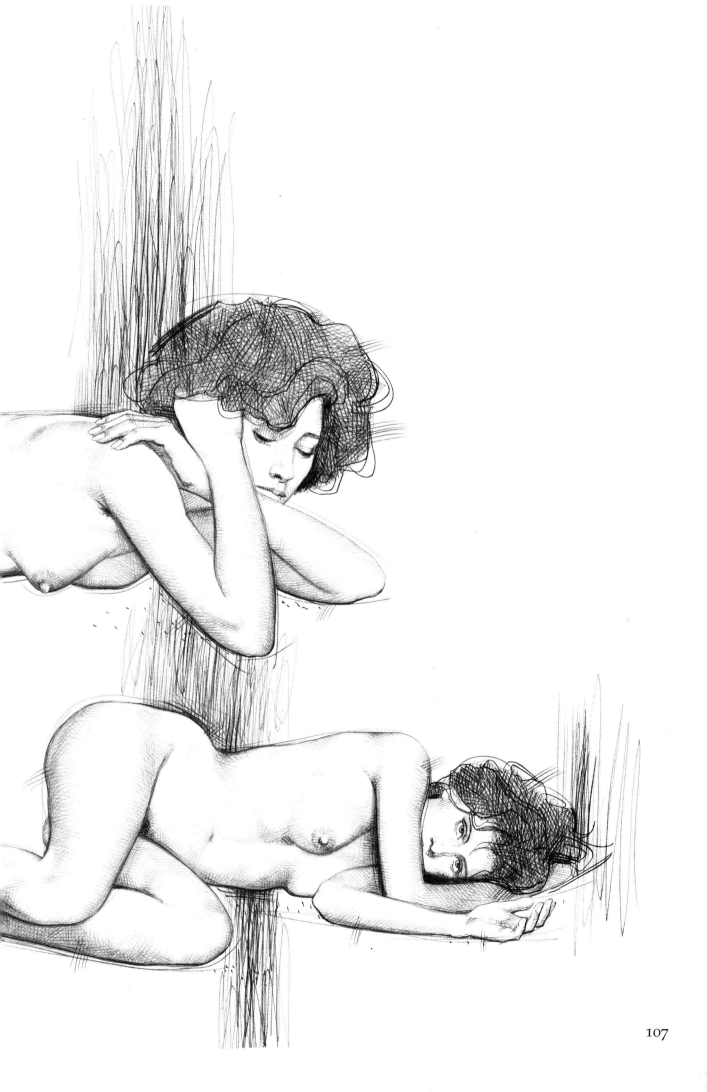

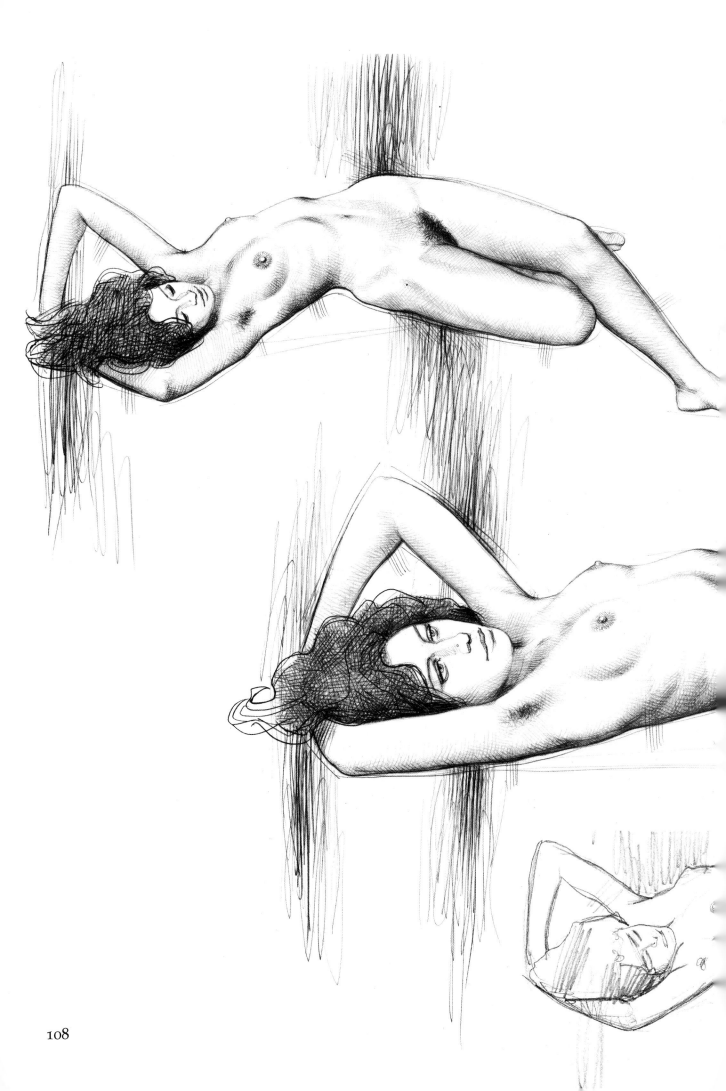

The poses drawn here and on the two following pages are fairly similar and recall the observations made on the preceding pages. Verify from life the small variations of the pose (for example, the raising or lowering of a leg or arm), by getting the model to make the movements several times. Note especially the muscular tensions which occur in the shift of position and the formal changes arising from the effects of the force of gravity on the relaxed tissues.

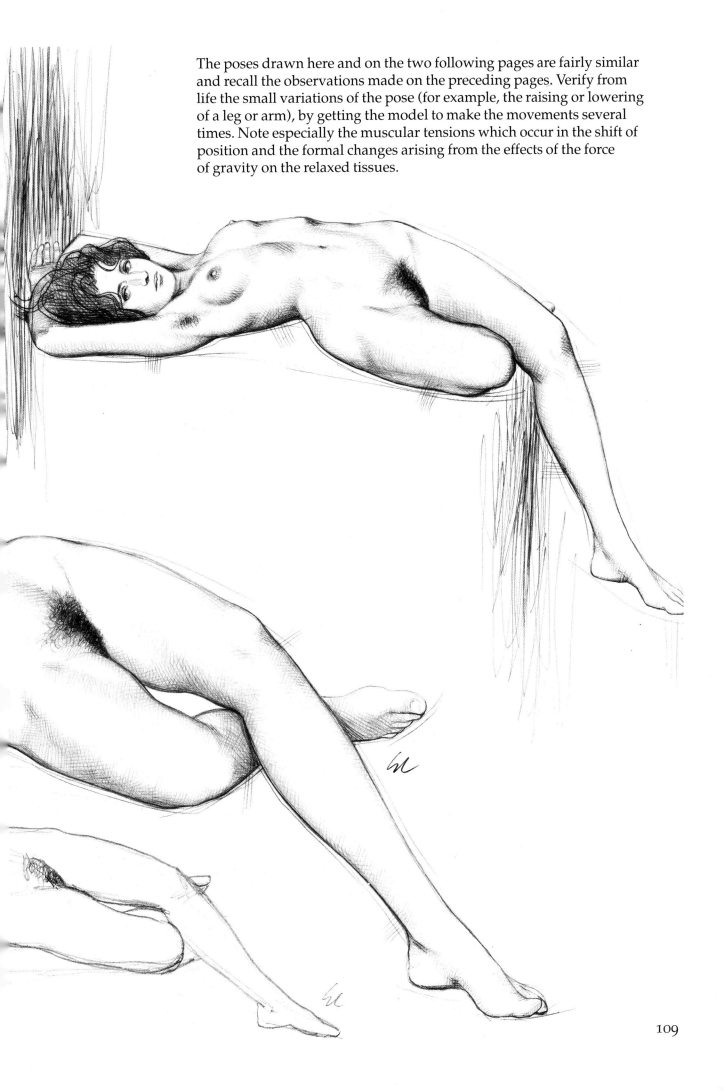

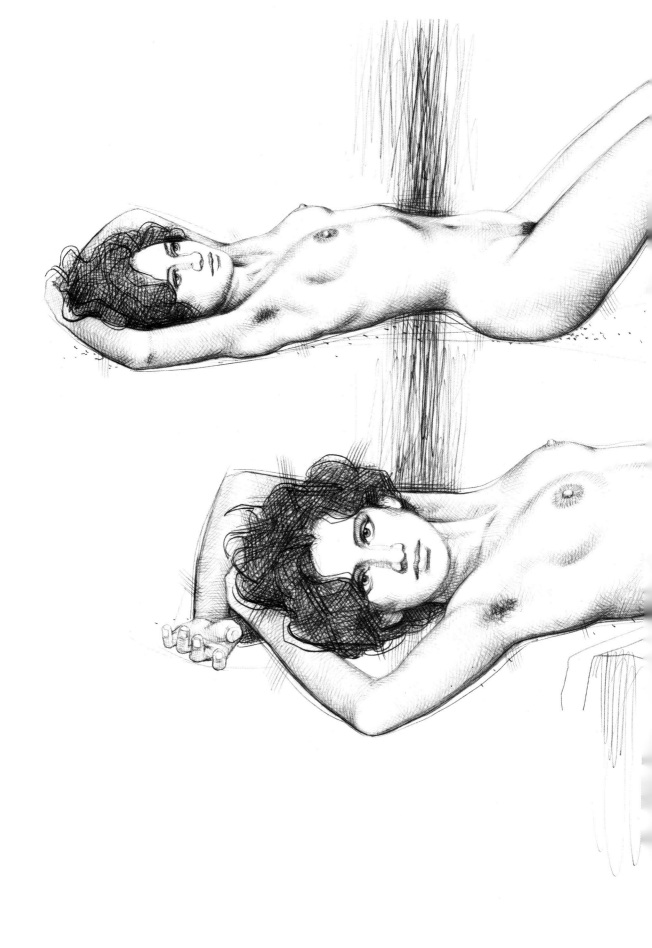

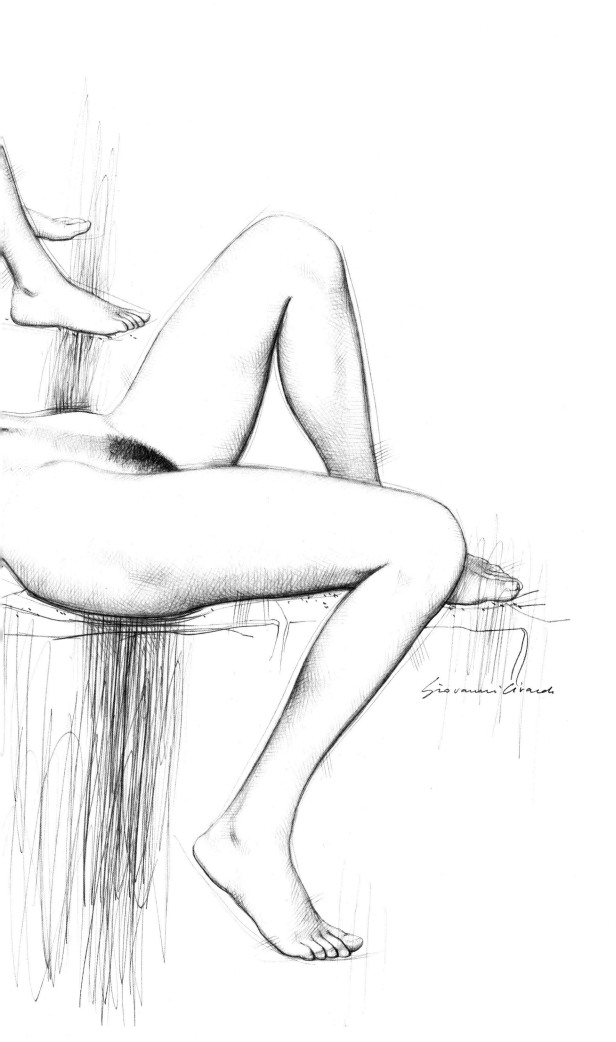

111

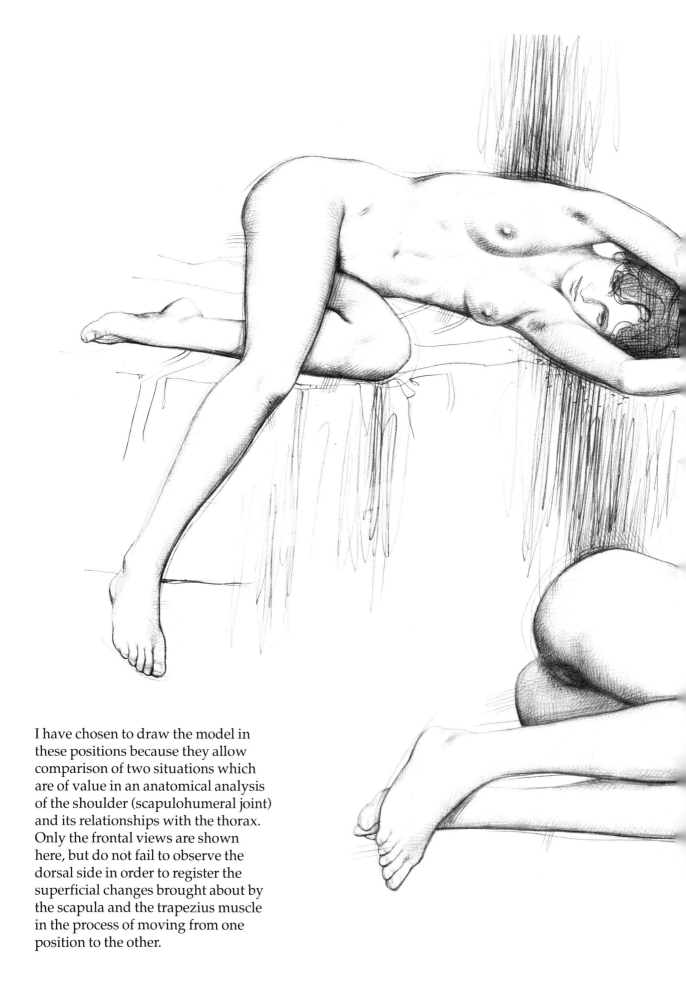

I have chosen to draw the model in
these positions because they allow
comparison of two situations which
are of value in an anatomical analysis
of the shoulder (scapulohumeral joint)
and its relationships with the thorax.
Only the frontal views are shown
here, but do not fail to observe the
dorsal side in order to register the
superficial changes brought about by
the scapula and the trapezius muscle
in the process of moving from one
position to the other.

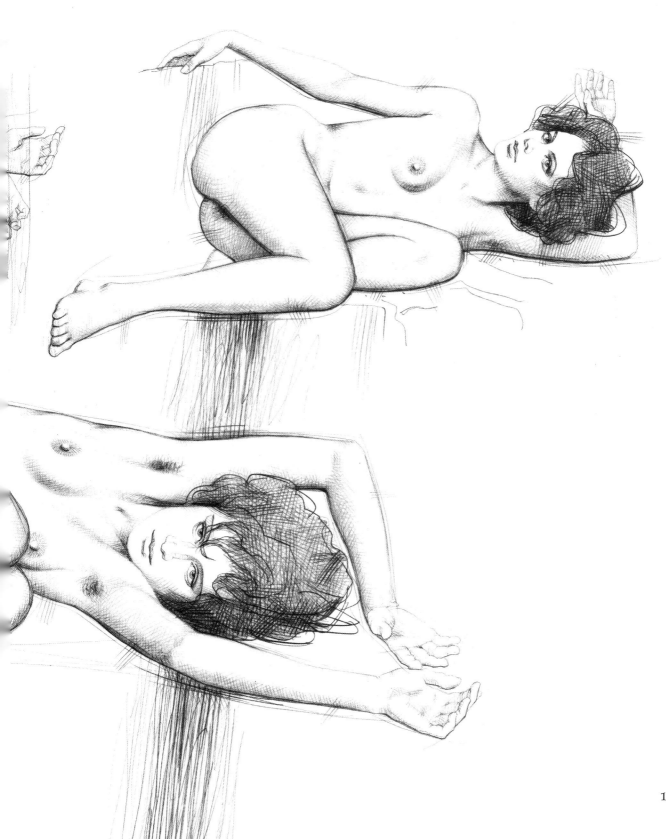

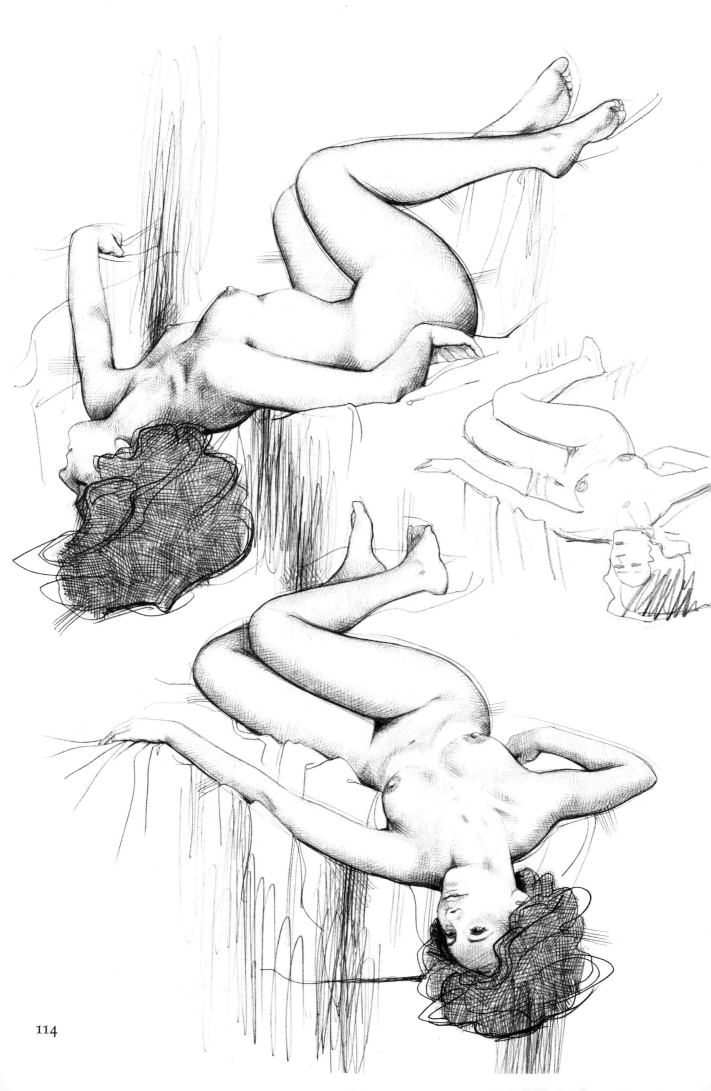

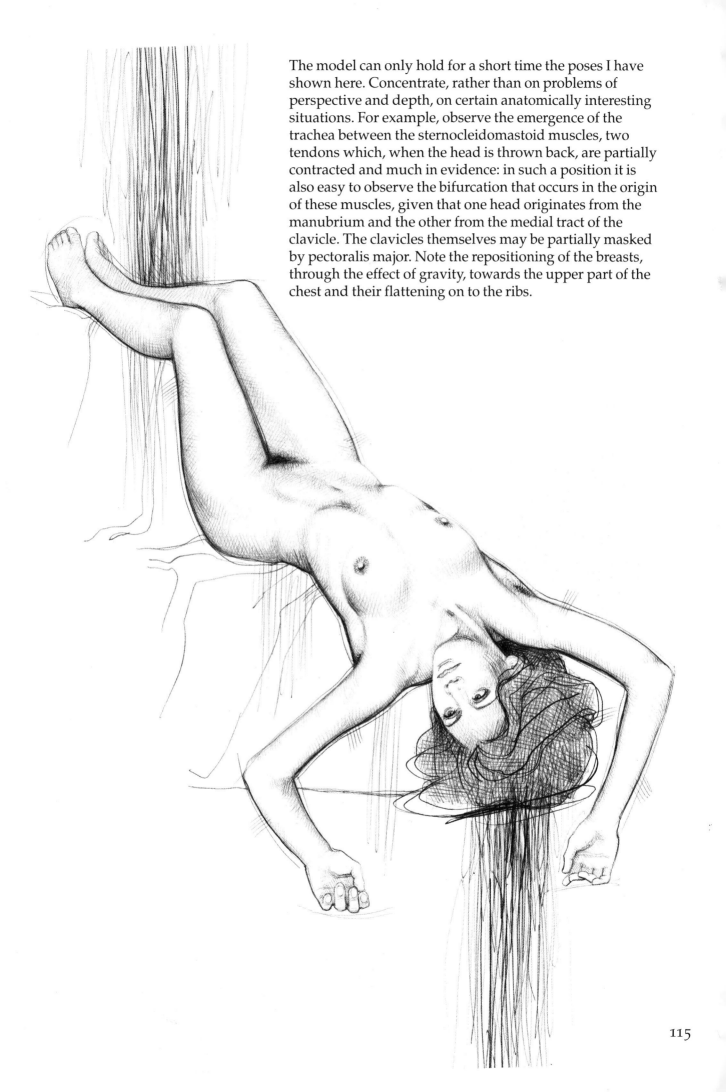

The model can only hold for a short time the poses I have shown here. Concentrate, rather than on problems of perspective and depth, on certain anatomically interesting situations. For example, observe the emergence of the trachea between the sternocleidomastoid muscles, two tendons which, when the head is thrown back, are partially contracted and much in evidence: in such a position it is also easy to observe the bifurcation that occurs in the origin of these muscles, given that one head originates from the manubrium and the other from the medial tract of the clavicle. The clavicles themselves may be partially masked by pectoralis major. Note the repositioning of the breasts, through the effect of gravity, towards the upper part of the chest and their flattening on to the ribs.

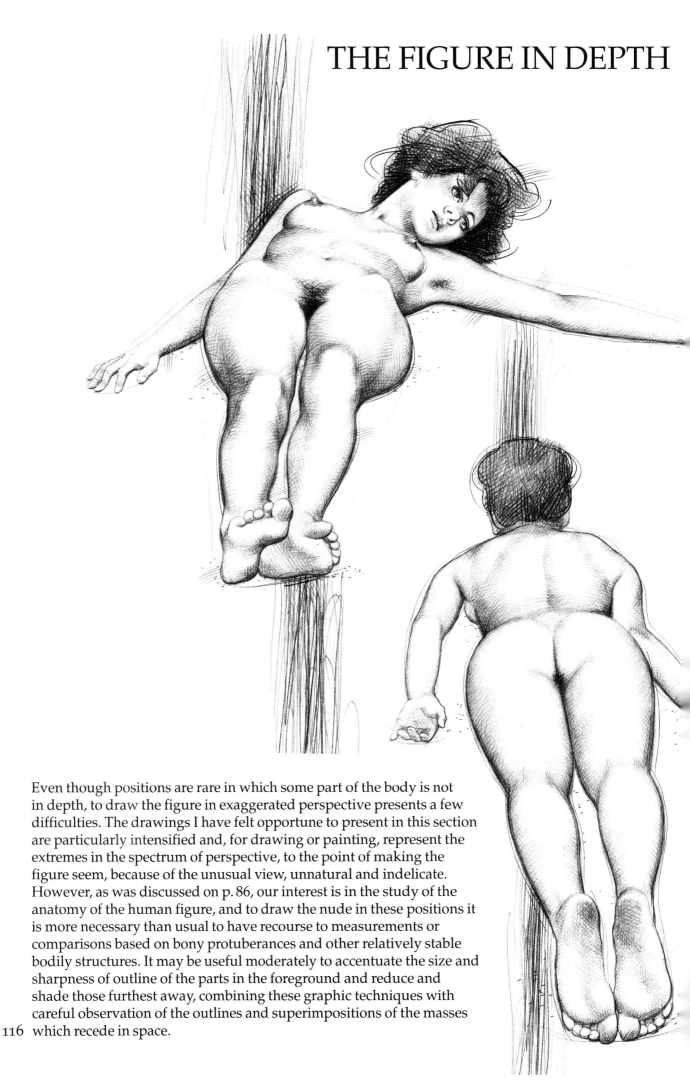

Even though positions are rare in which some part of the body is not
in depth, to draw the figure in exaggerated perspective presents a few
difficulties. The drawings I have felt opportune to present in this section
are particularly intensified and, for drawing or painting, represent the
extremes in the spectrum of perspective, to the point of making the
figure seem, because of the unusual view, unnatural and indelicate.
However, as was discussed on p. 86, our interest is in the study of the
anatomy of the human figure, and to draw the nude in these positions it
is more necessary than usual to have recourse to measurements or
comparisons based on bony protuberances and other relatively stable
bodily structures. It may be useful moderately to accentuate the size and
sharpness of outline of the parts in the foreground and reduce and
shade those furthest away, combining these graphic techniques with
careful observation of the outlines and superimpositions of the masses
116 which recede in space.

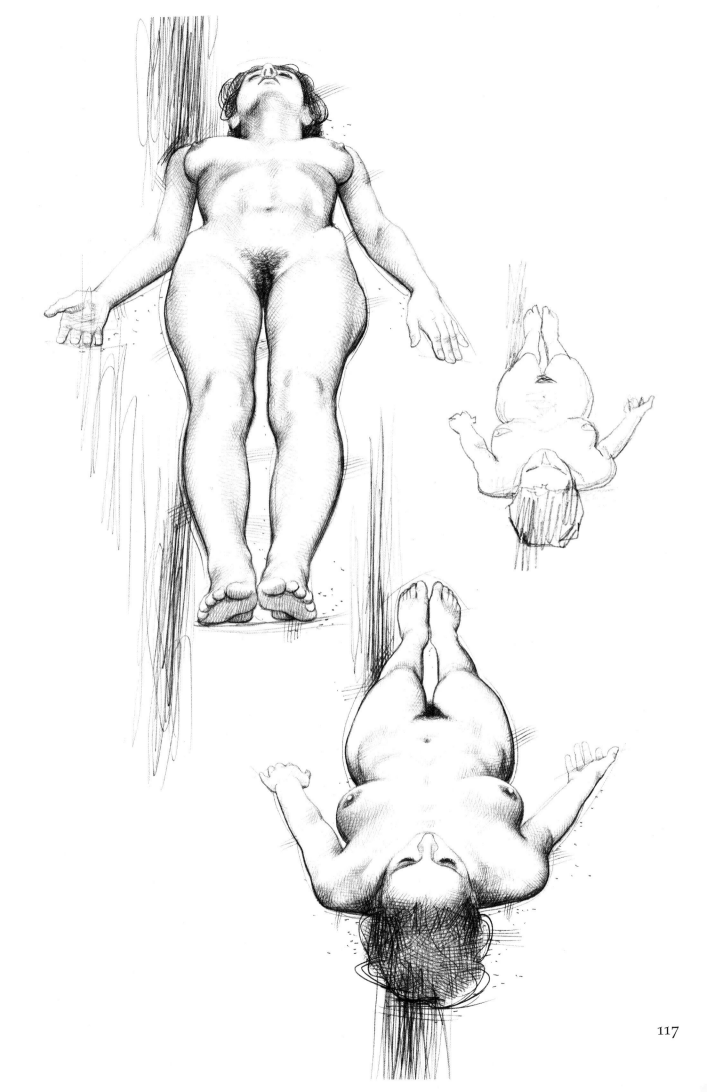

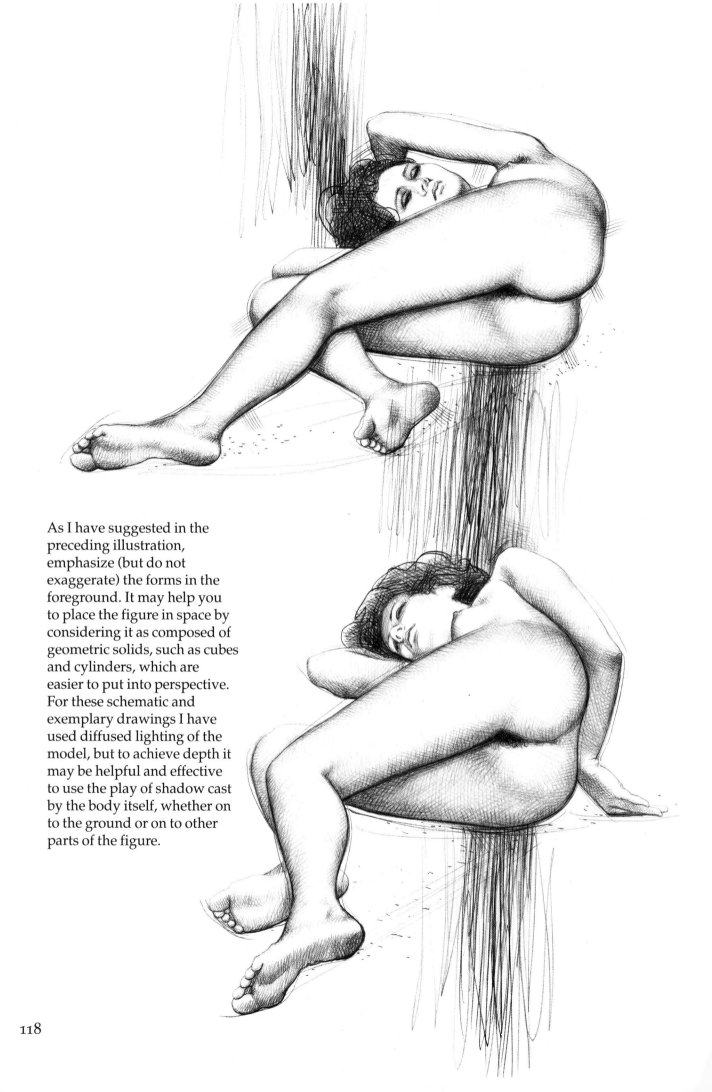

As I have suggested in the preceding illustration, emphasize (but do not exaggerate) the forms in the foreground. It may help you to place the figure in space by considering it as composed of geometric solids, such as cubes and cylinders, which are easier to put into perspective. For these schematic and exemplary drawings I have used diffused lighting of the model, but to achieve depth it may be helpful and effective to use the play of shadow cast by the body itself, whether on to the ground or on to other parts of the figure.

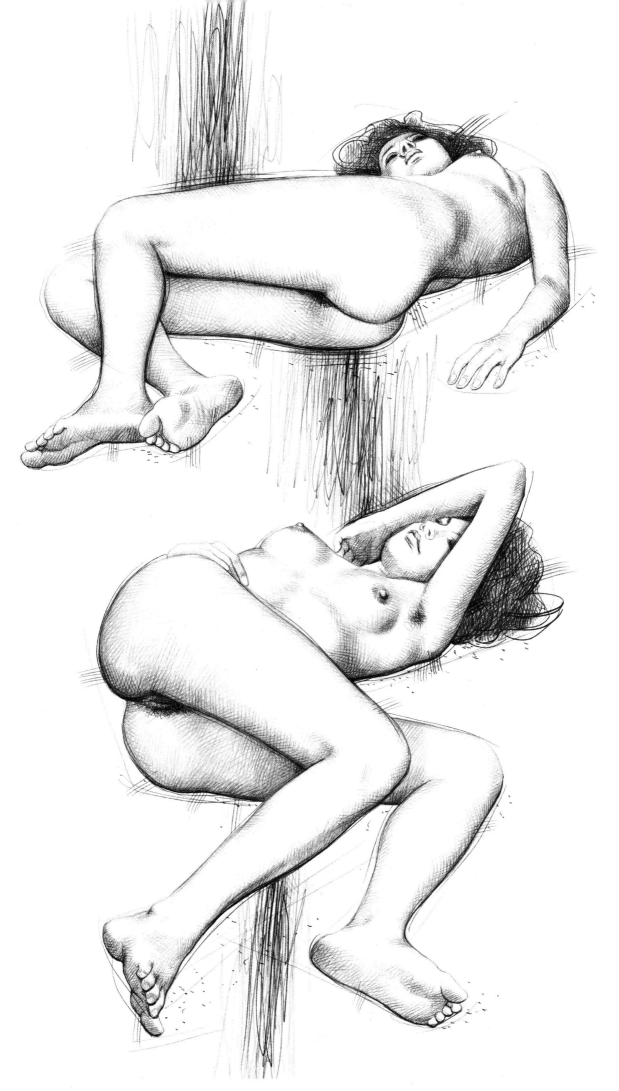

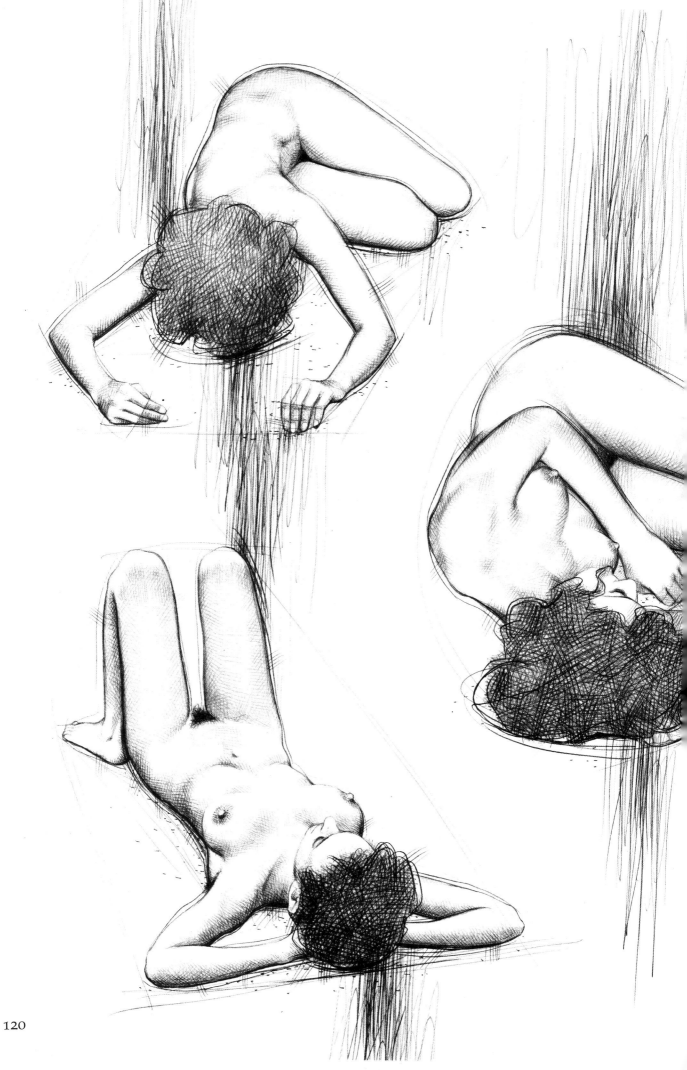

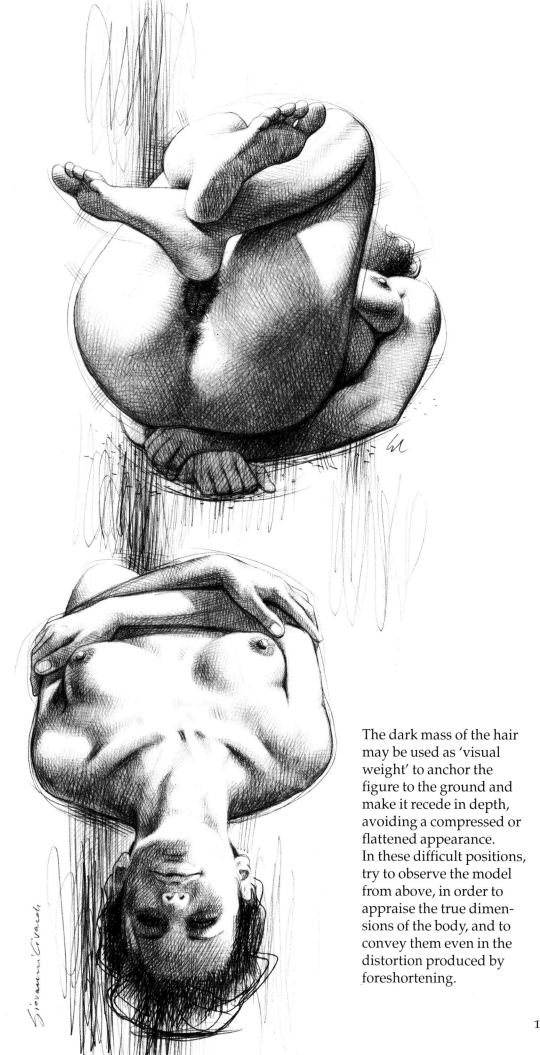

The dark mass of the hair may be used as 'visual weight' to anchor the figure to the ground and make it recede in depth, avoiding a compressed or flattened appearance.
In these difficult positions, try to observe the model from above, in order to appraise the true dimensions of the body, and to convey them even in the distortion produced by foreshortening.

PHOTOGRAPHIC REFERENCES

The photographs reproduced in this last section show bodily reality as registered by mechanical means: the camera. I took them in black and white, rather than colour, as being better suited to bringing out formal modulations, introducing also an element of abstraction that colour cannot suggest. In the diagrams accompanying the photographs I have indicated some anatomical elements clearly recognizable on the surface of the body. I advise you to study this line of enquiry carefully, just touched on here, by above all observing the model *in vivo* but also, in her absence, by making use of photographs on which you can trace figurative sketches indicating the most observable parts. In short, try to identify as many anatomical formations as possible, such as: subcutaneous bony tracts, muscles in action, tendons near the joints, superficial veins, etc., emphasizing those which will give reality to the figure. In this respect, note that much information registered by the camera can be ignored in drawing which, rather, requires a sensitive, intelligent selection of the aspects of the body. In pursuing your study, you may find useful guidance from the books suggested in the bibliography (such as those by De Dienes, Jennings, Civardi, Beverley-Hale, Goldfinger, Sheppard).

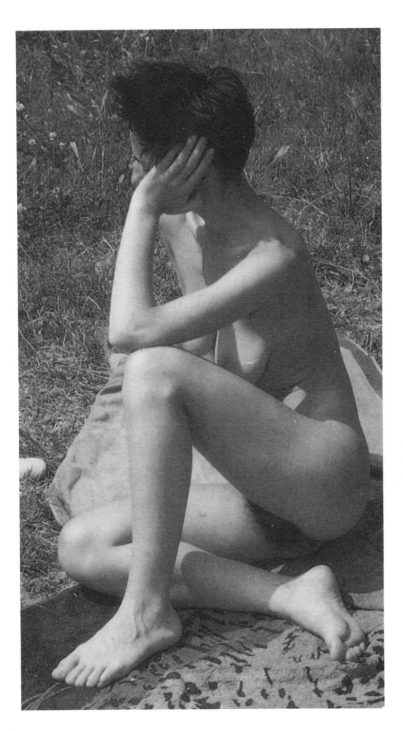

1 EXTENSORS
2 ULNA
3 PATELLA
4 HEAD OF FIBULA
5 VASTUS LATERALIS
6 TENDONS OF BICEPS FEMORIS
7 GASTROCNEMIUS
8 LATERAL MALLEOLUS
9 MEDIAL MALLOELUS
10 GREATER TROCHANTER
11 GLUTEUS
12 TENSOR FASCIAE LATAE
13 EXTERNAL OBLIQUE
14 LATISSIMUS DORSI
15 TRICEPS
16 DELTOID
17 BICEPS
18 STERNOCLEIDOMASTOID
19 CLAVICLE

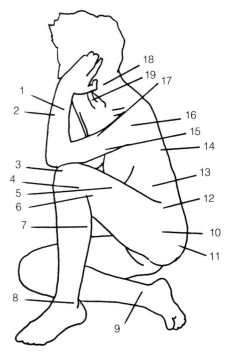

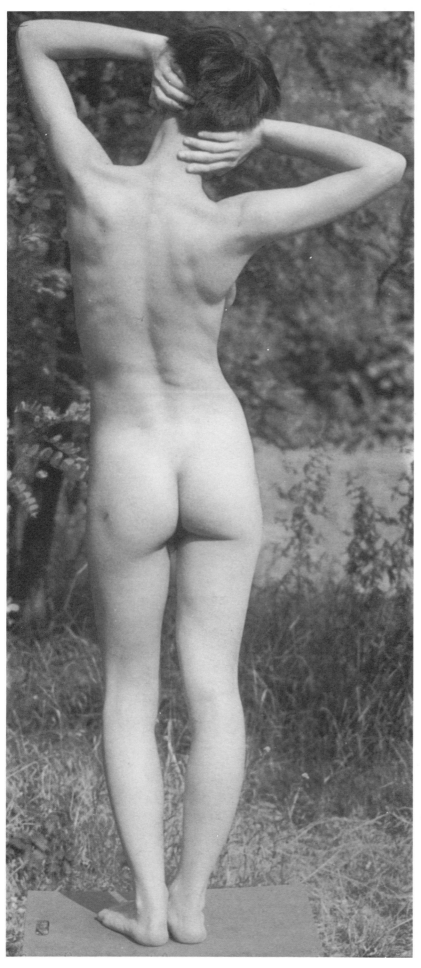

1 BRACHIORADIALIS
2 DELTOID
3 BORDER OF SCAPULA
4 MEDIAL BORDER OF SCAPULA
5 THORACIC VERTEBRAE
6 VERTEBRAL GROOVE
7 ILIAC CREST
8 TENSOR FASCIAE LATAE
9 FASCIA LATA
10 BICEPS FEMORIS
11 SOLEUS
12 ACHILLES TENDON (TENDO CALCANEUS)
13 HEAD OF LATERAL GASTROCNEMIUS
14 HEAD OF MEDIAL GASTROCNEMIUS
15 POPLITEAL FOSSA
16 MEDIAL CONDYLE OF FEMUR
17 SEMITENDINOSUS
18 GLUTEUS MAJOR
19 LUMBAR DIMPLE (SUPEROPOSTERIOR ILIAC SPINE)
20 SACROSPINALIS
21 LATISSIMUS DORSI
22 TRAPEZIUS
23 STERNOCLEIDOMASTOID

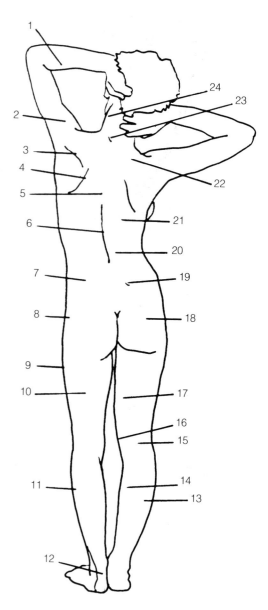

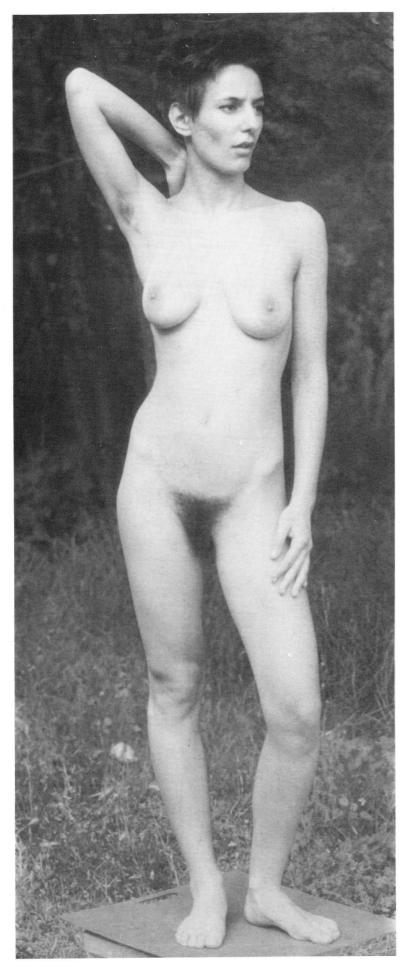

1 OLECRANON
2 EPICONDYLE OF HUMERUS
3 TRICEPS
4 BICEPS
5 AXILLARY CAVITY
6 PECTORALS
7 BREASTS
8 EXTERNAL OBLIQUE
9 ILIAC CREST
10 SUPEROANTERIOR ILIAC SPINE
11 GREATER TROCHANTER
12 SARTORIUS
13 RECTUS FEMORIS
14 VASTUS MEDIALIS
15 TIBIALIS ANTERIOR
16 LATERAL MALLEOLUS (FIBULA)
17 MEDIAL MALLEOLUS
18 TIBIA
19 GASTROCNEMIUS
20 ANTERIOR TUBEROSITY OF TIBIA
21 PATELLA
22 SYMPHISIS PUBIS
23 UMBILICUS
24 EXTENSORS
25 BRACHIORADIALIS
26 RECTUS ABDOMINIS
27 DELTOID
28 ACROMION
29 CLAVICLE
30 JUGULAR NOTCH

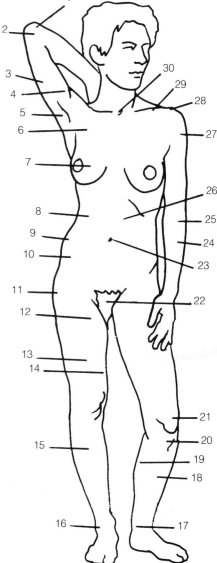

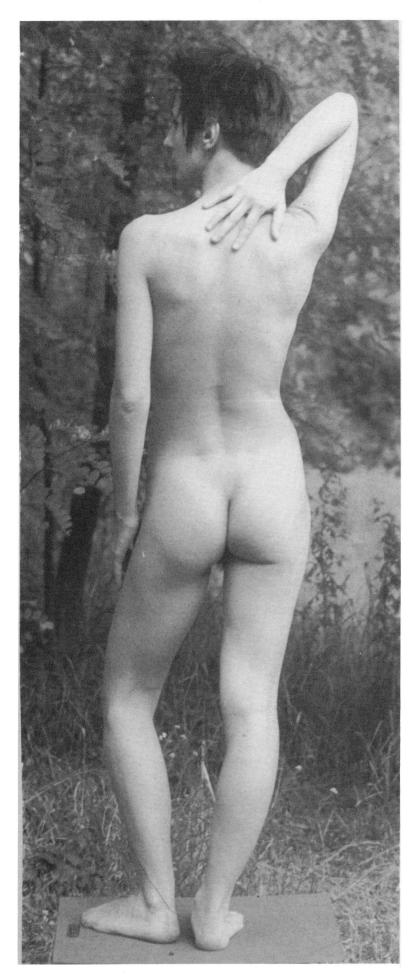

1 STERNOCLEIDOMASTOID
2 BORDER OF SCAPULA
3 TRICEPS
4 GREATER TROCHANTER
5 TENDON OF BICEPS FEMORIS
6 SOLEUS
7 LATERAL MALLEOLUS
8 HEEL
9 ACHILLES TENDON (TENDO CALCANEUS)
10 GASTROCNEMIUS MEDIALIS
11 GASTROCNEMIUS LATERALIS
12 SEMITENDINOSUS
13 BICEPS FEMORIS
14 GLUTEAL FOLD
15 GLUTEUS
16 LUMBAR DIMPLE
17 ILIAC CREST
18 SACROSPINALIS
19 LATISSIMUS DORSI
20 TRAPEZIUS
21 ACROMION
22 DELTOID
23 ULNA

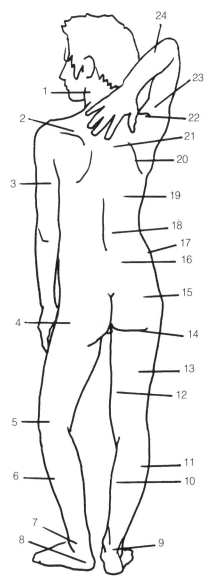

BIBLIOGRAPHY

Ableman, Paul, *Anatomy of nakedness*, Orbis: London, 1982

Bammes, Gottfried, *Figurliches gestalten*, Volk und Wissen Volkseigener Verlag: Berlin, 1978

Beverly-Hale, Robert, *Master class in figure drawing*, Watson Guptill: New York, 1985

Bridgman, George B., *Life drawing*, Sterling: New York, 1961 (1924)

Ciardi, Roberto, *L'anatomia e il corpo umano*, G. Mazzotta Ed.: Milan, 1981

Civardi, Giovanni, *Il nudo maschile*, Il Castello: Milan, 1991

De Dienes, André, *Best nudes*, The Bodley Head: London, 1962

Eisler, Georg, *From naked to nude*, Thames & Hudson: London, 1977

Fawcett, Robert, *On the art of drawing*, Watson Guptill: New York, 1958

Fawcett, Robert and Munce, Howard, *Drawing the nude*, Watson Guptill: New York, 1980

Gill, Michael, *Image of the body (Aspects of the nude)*, Doubleday: New York, 1989

Goldfinger, Eliot, *Human anatomy for artists*, Oxford University Press: Oxford, 1991

Jennings, Thomas, *The female figure in movement*, Watson Guptill: New York, 1971

Levy, Mervyn, *The artist and the nude*, Barrie Books: London, 1965

Loomis, Andrew, *Figure drawing for all it's worth*, Viking Press: New York, 1946

Lucchesi, Bruno, *Modelling the figure in clay*, Watson Guptill: New York, 1980

Richer, Paul, *Nouvelle anatomie artistique – Morfologie: la femme*, Librairie Plon: Paris, 1920

Saunders, Gill, *The nude: a new perspective*, Harper and Row: London, 1989

Sheppard, Joseph, *Drawing the female figure*, Watson Guptill: New York, 1975

Sheppard, Joseph, *Drawing the living figure*, Watson Guptill: New York, 1984

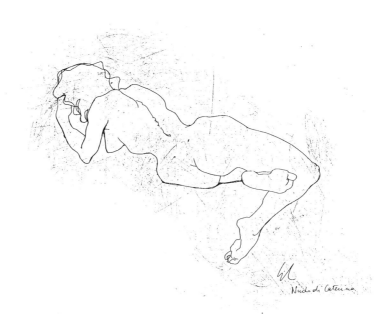

Nudo di Caterina